D1273642

THE GOLDEN AGE OF BRITISH PHOTOGRAPHY

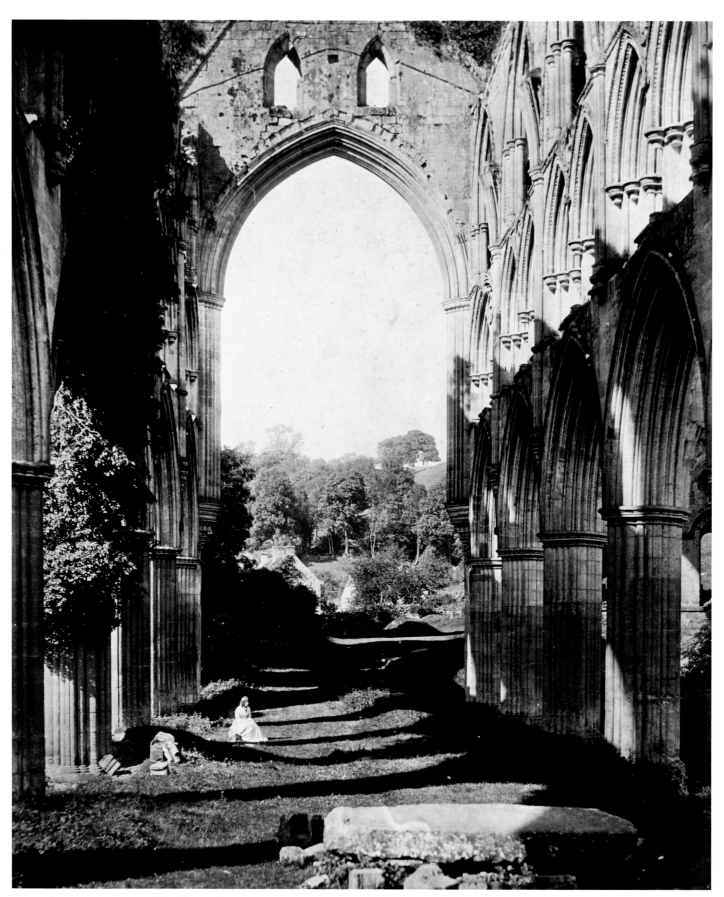

ROGER FENTON, *Rievaulx Abbey, Yorkshire*, 1854 (printed 1856–60), albumen print from waxed paper negative, 34.4 x 28.6 cm, VA

THE GOLDEN AGE OF BRITISH PHOTOGRAPHY 1839-1900

Photographs from the Victoria and Albert Museum, London
with selections from the Philadelphia Museum of Art
Royal Archives, Windsor Castle
The Royal Photographic Society, Bath Science Museum, London
Scottish National Portrait Gallery, Edinburgh

Edited and introduced by Mark Haworth-Booth

An Aperture Book

The Golden Age of British Photography, 1839–1900

AN EXHIBITION ORGANIZED BY THE VICTORIA AND ALBERT MUSEUM AND THE ALFRED STIEGLITZ CENTER, THE PHILADELPHIA MUSEUM OF ART

Victoria and Albert Museum, London
6 JUNE–19 AUGUST 1984

Philadelphia Museum of Art
27 OCTOBER 1984–6 JANUARY 1985

The Museum of Fine Arts, Houston
18 MAY–4 AUGUST 1985

The Minneapolis Institute of Arts
24 AUGUST–20 OCTOBER 1985

The Pierpont Morgan Library, New York
20 NOVEMBER 1985–2 FEBRUARY 1986

Museum of Fine Arts, Boston
5 MARCH–18 MAY 1986

THIS EXHIBITION AND PUBLICATION HAVE BEEN MADE POSSIBLE BY A GRANT FROM THE NATIONAL ENDOWMENT FOR THE ARTS, A FEDERAL AGENCY. ADDITIONAL FUNDS FOR THE EXHIBITION WERE PROVIDED BY THE PEW MEMORIAL TRUST.

Copyright © 1984 Aperture, a division of Silver Mountain Foundation, Inc. "Julia Margaret Cameron: Christian Pictorialist" copyright © 1984 Mike Weaver; "Roger Fenton and the Making of a Photographic Establishment" copyright © 1984 Valerie Lloyd.

"Julia Margaret Cameron: Christian Pictorialist" is based on selections from *Julia Margaret Cameron, 1815–79* by Mike Weaver, published by The Herbert Press and the New York Graphic Society in 1984.

All rights reserved under International and Pan-American Copyright Conventions. Published by Aperture, a division of Silver Mountain Foundation, Inc., in association with the Philadelphia Museum of Art and the Victoria and Albert Museum. Distributed in the United States by Viking Penguin, Inc.; in Canada by Penguin Books Canada Limited, Markham, Ontario; in the United Kingdom and Europe by Phaidon Press, Limited, Oxford; and Idea Books, Milan.

ISBN 0–89381–144–0 (Aperture)
ISBN 0–89381–145–9 (U.S.A. Museum Edition)
ISBN 0–905209–67–2 (Victoria and Albert Museum)

Library of Congress Card Catalogue Number 84–70357

Manufactured in the United States of America. Composition by David E. Seham Associates, Inc., Metuchen, New Jersey. Printing by Meriden Gravure Company, Meriden, Connecticut. Bound by Mueller Trade Bindery, Middletown, Connecticut, and Publishers Book Bindery, Long Island City, New York. Aperture, a division of Silver Mountain Foundation, Inc., a public foundation, publishes a periodical, portfolios, and books to communicate with serious photographers and creative people everywhere. A complete catalogue will be mailed upon request. Address: Aperture, Millerton, New York 12546.

Front cover: Peter Henry Emerson, *The Old Order and the New*, 1886, PMA

Back cover: William Henry Fox Talbot, *The Open Door*, 1844, SM

The Golden Age of British Photography exhibition was directed by Mark Haworth-Booth, Assistant Keeper of Photographs, Victoria and Albert Museum, and Michael E. Hoffman, Director, Alfred Stieglitz Center, Philadelphia Museum of Art, and cocurated by Martha Chahroudi, Assistant Curator of Photographs, Philadelphia Museum of Art, and Mark Haworth-Booth. The chapter introductions in the publication were written by Mark Haworth-Booth, and the biographies of the photographers by Alexandra Noble and Mark Haworth-Booth.

Staff for *The Golden Age of British Photography: 1839–1900*: Executive Director, Michael E. Hoffman; Editor, Carole Kismaric; Project Editor, Lauren Shakely; Production Manager, Charles Gershwin; Designer, Wendy Byrne; Consulting Designers, Betty Binns and Peter Bradford.

The Golden Age of British Photography, a portfolio of twelve hand-pulled, dust-grained photogravures, is published in association with the Victoria and Albert Museum and the Philadelphia Museum of Art, in an edition limited to 300 copies. The portfolio features works by such masters as Julia Margaret Cameron, Lewis Carroll, Peter Henry Emerson, Frederick H. Evans, Roger Fenton, Lady Hawarden, David Octavius Hill and Robert Adamson, Robert Howlett, and Benjamin Brecknell Turner. Wherever possible the plates have been made from the photographers' original negatives. Further information is available from Aperture, Millerton, New York 12546, or from the bookstores of the participating museums.

Preface

The earliest masterpieces of any art form possess a special attraction. This is certainly true of the art of photography and especially in Britain, where many of the most crucial steps in its invention and transformation were achieved. William Henry Fox Talbot's image of a latticed window at Lacock Abbey—the first photograph made in Britain—metaphorically admitted the light of a new creative medium of poetic contemplation and purposeful description.

The progress of photography in the nineteenth century was rapid and far-reaching: it moved almost instantly into all channels of human endeavor. The earliest photographs were spontaneous reflections of nature that belong to the Romantic consciousness as expressed in the pastoral poetry of William Wordsworth and the antiquarian novels of Sir Walter Scott. Within twenty years of its invention, photography became the ideal witness of the grand monuments in engineering design erected by the first great industrial power. Photography mirrored the magnitude of Britain's imperial possessions and, by contrast, the private pictorial quests of individuals, not only photographers—both amateur and professional—but also collectors, such as Prince Albert and Chauncy Hare Townshend.

As the century advanced, photography sought to find its identity in relationship with the fine arts and printing crafts while revolutionizing methods of societal self-examination. At its close the golden age looked forward to the modern era in Paul Martin's instantaneous snapshots, suggesting the interests and possibilities of the new century.

The Golden Age of British Photography reinterprets the history of nineteenth-century British photography and presents for the first time the full range and depth of its great achievements. The rarest and most remarkable early photographs have been assembled from the major collections in Britain, and the publication illustrates these original works with unprecedented faithfulness to their spirit and appearance. Reproduced with attention to the nuances of detail and tone unique to the early photographic processes, the more than 150 photographs here take their place in a new vision of the age in which they were created.

A major exhibition of international photography held in 1858 at the South Kensington Museum—the forerunner of the Victoria and Albert—included many of the masterpieces shown again here. On that occasion, a writer for *The Times* envisioned that "antiquaries now unborn will ask for the catalogue of a photographic exhibition as the best attainable index of the thoughts and tastes of the people who flourished during that particular year to which it belongs." Photography has always been deeply interwoven with its time and place, and nineteenth-century British photography is the visual expression of the sensibility that gave it life and nurtured it to maturity.

Great photographs both embody and transcend their immediate period. It is a privilege to make these photographs available to be seen and appreciated anew in this cooperative venture between the distinguished publishing foundation, Aperture, and our two institutions in Britain and the United States, each deeply committed to the art of photography. We are profoundly grateful to the lenders who have generously provided their photographs for the exhibition and for reproduction in this accompanying publication. We are especially pleased that this exhibition will be presented in five museums in the United States.

ANNE d'HARNONCOURT, DIRECTOR, PHILADELPHIA MUSEUM OF ART
ROY STRONG, DIRECTOR, VICTORIA AND ALBERT MUSEUM

Contents

8 WILLIAM HENRY FOX TALBOT, *Fronds of Leaves*, 1843, photogenic drawing, 22.9 x 18.3 cm, SM

Introduction

The varied objects to which Photography can address itself, its power of rendering permanent that which appears to be as fleeting as the shadows that go across the dial, the power that it possesses of giving fixedness to instantaneous objects, are for purposes of history . . . a matter of the deepest importance. It is not too much to say that no individual—not merely individual man, but no individual substance, no individual matter, nothing that is extraordinary in art, that is celebrated in architecture, that is calculated to excite the admiration of those who behold it, need now perish; but may be rendered immortal by the assistance of Photography.

Inaugural presidential address given by Sir Frederick Pollock at the Photographic Society of London, 5 April 1855

Great claims were made for photography by those who invented, improved, and fostered it during the nineteenth century. One of the glories of a glorious and inventive age, the new medium met four requirements: spontaneity, precision, permanence, and the capability of mass production. Furthermore the idea of photography was inseparable from Victorian Britain's idea of itself. No better symbol of that idea can be found than the Crystal Palace, the site of the Great Exhibition of the Works of Industry of All Nations of 1851, in which photography fully established itself as one of the wonders of the age. The Great Exhibition marked the turning point between the turbulent years of the 1840s and the more stable, prosperous, and expansive time that followed. The Crystal Palace year was one of euphoria; class divisions momentarily fell away as the nation proudly became host and spectator of the achievements in art, industry, and inventions of the modern world:

> *Then came that great event, the Exhibition,*
> *When England dared the world to competition. . . .*
> *But still, I hold, we were triumphant seen*
> *In iron, coal, and many a huge machine. . . .*
> *Peace men had then their beatific vision;*
> *And Art-Schools were to render earth Elysian*

—so wrote Philip James Bailey (*The Age: A Colloquial Satire,* 1858, pp. 27–28). Over 6,000,000 people visited the Crystal Palace, three times the length of St. Paul's cathedral. The iron and glass building symbolized confidence, a thin and transparent skin encasing some of the riches of the world, and opposing no barrier to the rays of the sun.

The Crystal Palace was perhaps such a powerful symbol partly because of the choice of objects shown in the most prominent positions in the central nave. In the focal position was a fountain made of more than four tons of elaborately worked crystal and measuring 27 feet high. Nearby was a huge astronomical telescope with a 12-inch lens, another fountain, and a giant lighthouse reflector. Elsewhere the central nave displayed the Koh-i-Noor diamond, or "Mountain of Light." The fountains brought emblems of nature into the interior of the building, where tall elms already stood. The giant lenses demonstrated utilitarian and speculative branches of invention, and embraced the study of distant stars and the saving of lives at sea. Light and the lens—these central symbols dominated the exhibition, at which photographs were first gathered in quantity to be seen by a large national and international audience. The Crystal Palace was itself a "glass house," the name given to early photographic studios, of giant proportions.

The Great Exhibition was crucially important for the Victoria and Albert Museum, since the exhibition's success, and the consequent ample profits, allowed the purchase of the site in South Kensington for the establishment of a cultural and educational center. The South Kensington Museum, one of the Prince Consort's favorite and far-sighted plans, opened its doors in 1856 and became the Victoria and Albert Museum in 1899. The new museum took a leading role in photography, setting up a service for the photographic reproduction of works of art, acquiring photographs from all parts of the world, and presenting an international exhibition of photography in 1858. Some items from that exhibition are shown here: the series by Robert Howlett on the construction of the steamship *The Great Eastern* and his portrait of its engineer, Isambard Kingdom Brunel; William Lake Price's *Don Quixote in His Study;* Dr. John Murray's large-scale Indian views; Lewis Carroll's portraits; Francis Frith's Egyptian views; photographs from the remarkable volume *The Sunbeam,* edited by Philip Henry Delamotte; landscapes by Benjamin Brecknell Turner, Roger Fenton, Francis Bedford, and John Dillwyn Llewelyn; and *The Two Ways of Life* by Oscar G. Rejlander.

The Golden Age of British Photography celebrates these pioneering years, when much of permanent value in British cultural life was imagined and established.

Photographers shared a profound fascination with precision that was a dominant characteristic of Victorian intellectual life. The lighthouse lens, the telescope, and the lenslike natural phenomenon of the Koh-i-Noor diamond had domestic parallels in the microscope, field binoculars, and the photographic camera. Focusing a lens is George Eliot's metaphor in *Middlemarch* (1872) for the thought processes of the scientist Lydgate, who "was enamoured of that arduous invention which is the very eye of research, provisionally framing its object and correcting it to more and more exactness of relation." As a specialist in precise observation, the professional photographer emerged as an important figure in society. Part of the importance attached to the new medium is that it belongs with other kinds of accurate perception of special social value.

Photography also belongs to a large pattern in the visual arts. The dream of an art that would spontaneously capture the fleeting impressions of common life and scenes occurs in the memorable and early example of Goethe's romantic young Werther, who draws rapid sketches of rustic scenery unaltered by the rules of art and rejoices in their simplicity, directness, and truth. The photographers of Britain in the 1840s and 1850s fulfilled Goethe's prophesy of the 1770s. Although they probably worked without direct knowledge of Goethe, they had the great example of J. M. W. Turner's paintings before them. The most opinionated but ultimately persuasive critic of the day, John Ruskin, found a connection between the two in a passage in *Modern Painters* (vol. 5, 1860, p. 366): "A delicately taken photograph of a truly Turnerian subject is far more like Turner in drawing than it is to the work of any other artist." And as an outdoor or natural-light medium, early photography had at least one feature in common with the art of the Impressionists, who in the 1870s began to take their easels to nature, painting directly in the fluctuating light of the day.

A brilliant and provocative book, *The Age of Equipoise* by W. L. Burn (1964), offers an insight into the place of photography in the mid-Victorian period of the 1850s and 1860s. Alert to the dangers of what he called "historical face-lifting" in considering the Victorian period, Burn, dramatizing, decided to imagine a somewhat faded but very interesting photograph from the 1860s. The imaginary photograph shows "a family group on the rectory lawn on one of those perfect summer afternoons of which the regretted past was so prolific." The rector—a scholar, a gentleman, head of the family, and father of his flock—stands beside his serene wife and daughters of the kind who might be planning a game of croquet but would easily forgo it to visit the poor and needy of the parish; a strapping young son, muscularly Christian, down from Oxford; an ancient retainer who minds the coach horses under some fine trees; and the butler, the cook, and the maids—"stiff and wooden and slightly out of focus . . . half-abashed, half-delighted at being photographed with the family. . . . It is as though the camera (developing a form of art which so quickly reached so high a degree of success) had caught, in one moment, all the peace, the deep security, the kindly and dignified affluence of English life" (*The Age of Equipoise*, 1964, pp. 25–30).

But Burn asks the reader to look again. It is lucky the photograph is not in color, he suggests, or we would see the dreadful clash of colors in which aniline dyes and fashion had clothed the daughters. If the photograph happened to have been taken in 1866, the summer would have been wet and gloomy, the harvest seriously deficient, and the situation complicated by sedition in Ireland, financial reverses, and a cholera outbreak that resulted in some 8,000 deaths. This rector was certainly a gentleman but never a scholar, had undergone no intellectual discipline since his mathematical studies at university, held few services, worked his curates to the bone, and was about to lose his fortune in a banking collapse. His wife had a serious illness but feared surgery because of postoperational sepsis. As for the spoiled and ignorant daughters, both were to die of typhus within a year: "defective drains were as dangerous to the upper classes as the absence of drains was to the lower." And so on, throughout the cast on the sun-filled lawn.

For the modern historian the positive scene suggests its negative counterpart, perhaps because photography and its terms have become second nature to us today. In 1851, as the catalogue of the Great Exhibition reveals, the meaning of the words *photograph, positive,* and *negative* had to be explained, even to a sophisticated audience. Photography enjoyed a golden age in the period prior to 1914 because the art attracted many individuals who wished to discover what kind of art photography might be, in times before its role had been defined or its powers tested. On surviving evidence it is possible to say, for example, that Horatio Ross—one of the great sportsmen of the century—is unlikely to have seen daguerreotypes of fishing and deer stalking before he made them himself. Nor, at the other end of the century, would Paul Martin have seen snapshots quite like those he was able to make with the technology available in the 1890s or night photographs like those he pioneered. Both pushed possibilities to limits. In photography, as in other fields, the primitives, who had little guidance except their promptings of what *might be* realized, remain among the purest and the best.

The Dawning of an Age Chauncy Hare Townshend: Eyewitness

Mark Haworth-Booth

Chauncy Hare Townshend was an accomplished man who made his name early with a Prize Poem at Cambridge University, moved in the highest social and literary circles of the day, became a classic case of hypochondria, took up the cause of mesmerism and demonstrated it to London society, and lived in one of the most beautiful houses in town. He was the dedicatee of *Great Expectations,* a clergyman who held no cure of souls, musician, painter, amateur of natural history, essayist, collector, and—undoubtedly—the most complete dilettante. His will named the richest woman in Europe, Angela, Baroness Burdett-Coutts, as executrix, the most richly endowed man of letters, Charles Dickens, as literary executor, and the South Kensington Museum as recipient of his art collections by bequest. He is the only identifiable British collector of early photographs, on any scale, apart from the Prince Consort.[1] He is especially interesting not only because he was a most unusual man—who was recorded by no less than three major novelists—but because he provides a lens through which to view the Victorian sensibility, of which photography is an expression.

Townshend was a connoisseur of early photography. He collected examples that were considered by informed opinion at the time to be of special merit. For example, Townshend acquired a paradigm of landscape photography, the *River Scene, France* (1858) by Camille Silvy. This photograph is a masterpiece in the original sense: it was sent to Britain for exhibition as an announcement of the mastery of its photographer, who settled in London the following year and became a notable portraitist over the next decade. This same photograph was shown at the Paris Salon in 1859, at which photography was shown as an art alongside the exhibition of painting. Without Townshend's collection historians would have only limited knowledge of the quality of the major achievements in landscape photography of Silvy and others. He also collected more topical items characteristic of mass-produced photographic imagery. His photographs belong in a logical manner to the constellation of his interests.

Townshend's poetry earned him a place in the *Dictionary of National Biography,* where the details of his life may be found. He was born to wealth and position, descended from Henry Hare, third Lord Coleraine (died 1749) and James Townsend, member

of Parliament and Lord Mayor of London (1772–73). He was born on 20 April 1798 at Busbridge Hall, Godalming, Surrey, only son of Henry Hare Townsend and his wife Charlotte (daughter of Sir James Winter Lake, Bart.). He grew up in one

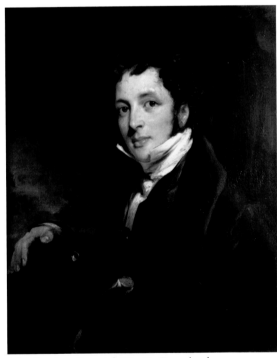

John Boaden, *Portrait of C. H. Townshend* (oil on canvas), ca. 1825, VA

of the most "picturesque"—a word born two years before himself, much used by Townshend, and of substantial importance to him—nooks of rural England, characterized by ancient buildings, traditional in construction and materials. These were to be the subjects of some of the finest photographs in his collection. The Palladian family mansion was later demolished, but a few yards away was erected Munstead Wood (1896), Sir Edwin Lutyens's first and richest essay in the reclamation of vernacular architecture, built under the patronage of Gertrude Jekyll. Through Lutyens and others the picturesque taste continued well into the twentieth century.

Townshend's parents were amateurs of the arts, wrote occasional verse, and encouraged the early verse-writing attempts of their son. They drew the line at Byron. When his father "would not let me be introduced to the author of the *Giaour* I meditated running away, and accomplishing the feat myself "—at the age of fifteen.[2] The youthful Townshend made himself known to the Poet Laureate, Robert Southey, and was received at Greta Hall, Keswick. There he met the Wordsworths and younger members of the Coleridge family, with whom he became lifelong friends. He was educated at Eton College and Trinity Hall, Cambridge, where he distinguished himself by winning the Chancellor's Medal for poetry. His *Jerusalem* (1817) elaborates the destruction of the city in fulfillment of the prophesy of Isaiah and its reconstruction under the covenant of the New Testament—a theme very much part of the period after the French Revolution and the Napoleonic Wars. The prize was later to be won by Macaulay, Edward Bulwer, Tennyson, and Winthrop Mackworth Praed. *Poems* (1821) celebrates the Lake District, the Lake poets, and John Clare, whom Townshend visited in 1820, leaving him a poem in his praise—wrapped in a pound note.[3] This first volume was revised and reissued as *The Weaver's Boy* in 1825. Bulwer (later created Baron Lytton, novelist and politician) met Townshend about this time and later wrote this reminiscence:

He impressed me with the idea of being singularly calm and pure. In spite of a beauty of face, which at that time attracted the admiration of all who even passed him in the streets, his manner and conversation were characterized by an almost feminine modesty. . . . Withal, he had a pervading sense of his own existence. With an egotism not uncommon to poets, he thought, wrote, and talked of himself—his own peculiarities and feelings. . . . He had visited Wordsworth, and he corresponded with Southey. Stars that before had been scarcely visible on my horizon, loomed near through his anecdotes, and their grand influence reached me.[4]

Bulwer also recalled that Townshend's "beauty of Countenance" as a young man was so spectacular that "those who knew Byron said it was Byron with bloom and health."[5] This is the Townshend painted by John Boaden about 1825.

Townshend married in 1826—Eliza Norcott, described by Bulwer as "handsome, clever, strange"—and succeeded to the family estates, when he added an *h* to the name, the following year. The estates, mostly in the locality of Wisbech, bordering Norfolk, made him a rich man. He had already taken holy orders and always referred to himself on the title pages of his later books as "Rev." but never practiced his vocation. Some time in the 1820s or 1830s Townshend succumbed to an illness, or many illnesses. Bulwer later wrote that "Chauncy Townshend's life has been my beau-ideal of happiness—elegant rest, travel, lots of money—and he is always ill and melancholy."[6] Surviving portraits show a decline from Byronic and Pushkinian splendor to marked melancholy. It seems doubtful that we can learn more about this

mysterious malaise than Townshend himself reveals in his first book of prose. *A Descriptive Tour in Scotland* (1840, 2nd edition 1846) was written in the same years that photography was developed, became practicable, and was finally announced to the world. Townshend tells us, in prose of the ease of Byron's, first of himself. The tour was undertaken "in the hope of procuring for the author that respite from self-contemplation which, in every nervous disorder, is the essential condition of cure."[7] He introduced the book as the work of "a decided hypochondriac" and himself as one who had suffered a "derangement" of the nervous system, "one of the most serious calamities that can befall a human being." Such sentiments echo the sensibility represented by the poet William Cowper. Townshend applied these lines by the "wise yet melancholy Cowper" to his own condition:

Man is a harp, whose chords elude the sight,
Each yielding harmony, disposed aright.
The screws revers'd—a task, which, if he please,
God in a moment executes with ease—
At once ten thousand strings go loose,
Lost, till he tune them, all their power and use.[8]

The *Descriptive Tour*, composed of Townshend's letters to his wife and journal entries, is, like the efforts of some other self-confessed hypochondriacs, delivered with sprightly dash. Townshend was a Romantic in the original sense of one who behaves as if in a novel—he explored the Highlands and Islands in the guise of a latter-day Edward Waverley. He traveled the landscape of Sir Walter Scott like the incognito hero of a hundred tales, thrown together with all sorts and conditions of humanity—such as the tobacco-smoking bagman who picks his teeth with a carving knife—eating in odoriferous, herring-ridden parlors, sleeping in cupboards in wayside country inns, riding in perilously small boats and bone-shaking country carts—and, by contrast, being entertained with regal splendor and ancient courtesy by Lord Macdonald and his dowager mother at Armadale Castle on the Isle of Skye.

For Townshend a line of hills was almost continuous with the lines of Scott. The cult was well established. Admirers of *The Lady of the Lake* made their pilgrimages to Loch Katrine and to Ellen's Isle, where a local nobleman, in emulation of the story, had erected a rustic cabin complete with a copy of the poem. Townshend wrote of the lake at evening, "with her softening vapours, aerial tints, and purple shadows, and the water . . . rich with the reflection of the golden West."[9] He took sketches for his wife but added, "How impossible it is by mere outlines to give an idea of the infinite detail of rock, wood and water." His frustration recalls that of William Henry Fox Talbot, drawing with a camera lucida on the shores of Lake Como in 1833, who despaired of his meager sketches and began to reflect on the "inimitable beauty of the pictures of Nature's painting, which the glass lens of the camera throws upon the paper in its focus" and wondered how these "fairy pictures, creations of a moment" could

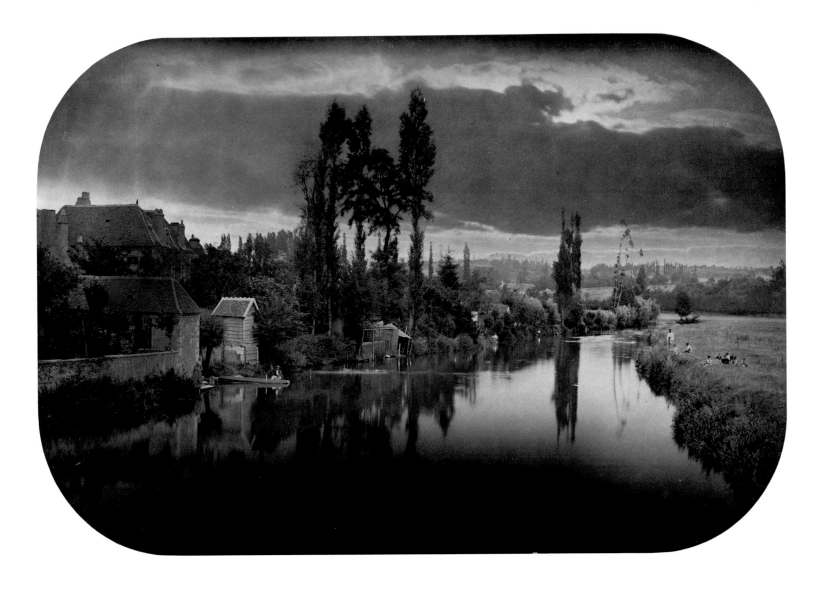

*Perhaps the gem of the whole exhibition is 'River Scene—France' by C. Silvy.
We have seen no photograph which has taken our fancy so much as that exhibited
under this unpretending title by Messrs Murray & Heath [London photographers,
suppliers, print publishers]. The natural beauty of the scene itself,
rich in exquisite and varied detail, with the broad, soft shadows stealing over the whole,
produce a picture which for calm, inviting beauty we have not seen equalled.*

Journal of the Photographic Society, 5 February 1859

13 CAMILLE SILVY, *River Scene, France*, 1858, gold-toned albumen print from two wet collodion negatives, 24.5 x 36.6 cm, VA

be made to imprint themselves durably.[10] After he had perfected the calotype process in 1841 Talbot captured the delights of Loch Katrine, one of the best-known subjects in his *Sun Pictures of Scotland* (1845). Recording the sights for the friends and loved ones at home became one of photography's earliest objectives, and Townshend's enthusiasm for its success in capturing "infinite detail" was at the heart of his appreciation for the new invention.

Townshend examined landscape with a keen eye and a memory well stocked with paintings and topographical illustrations. On the Isle of Skye Townshend made for the vantage point from which a watercolor in his own collection had been painted. *Loch Coruisk and the Cuillin Mountains* by George Fennel Robson is one of the largest watercolors in Townshend's collection and is based on another adventure in Scott. Townshend found it a true transcription of the scene:

> We at once recognised in Loch Corruish the original of Robson's glorious picture. One might have thought he had coloured it on the spot at the very same time of year and day as we now beheld it. There was the same purple hue over the cliffs, the same darkness upon the water, the same yellow light in the sky, and one might even have said the identical gray cloud hovering in air above the solemn peaks. We could have staid here for ever, and, in Wordsworth's beautiful words, have become
>
> as steadfast as the scene
> Whereon we gazed ourselves away:
>
> but although we could have remained stationary, time would not; neither (reflected we) could our host of the farm lie forever between the blankets taking snuff, nor were we sufficiently spiritualized to dispense with breakfast. So most reluctantly we turned our backs upon the sublimest scene on which, I verily believe, it is possible for man to look.[11]

The painting fulfills the notions of the sublime formulated by Edmund Burke in the mid-eighteenth century but shows how close to photographic realism watercolor painting was approaching. The quotation from Wordsworth—which contrasts the enduring qualities of nature with the transience of man—is of importance in relation to certain photographs Townshend was to acquire in the late 1850s, notably those that celebrate mobile clouds and tranquil reflections in water.

As an amateur geologist, painter of ability, and connoisseur, Townshend found ordinary methods of representation inaccurate. A drawing could only reduce; Townshend preferred to imprint his memory with the scene. For example, sailing out to Tobermory from Oban Bay, with a view of islands, old castles, bold headlands, and a glowing sea, Townshend watched a fellow passenger

> who, colour-box in hand, was trying to give the effect of this marvellous appearance by means of dots of blue, green and grey, which at length made his paper look like a bit of patchwork. . . . The evil of an imperfect memorial is that it must rather confound than assist the image in the mind, which else had been

faithfully recalled by memory. For my own part, I feel quite sure that the impression upon my mind, made by what I beheld yesterday, can never be effaced.[12]

His tour proceeded to Holyrood Palace near Edinburgh (it was to close at Scott's Abbotsford), and here Townshend found that

George Fennel Robson, *Loch Coruisk and the Cuillin Mountains, Isle of Skye* (watercolor), late 1820s, VA

actuality had been confounded by another form of illusionism, for Holyrood in the glare of midday held nothing of the "magic of light and shade" he had admired in Daguerre's diorama of the subject.[13]

A Descriptive Tour was but the beginning of a life of travel. Early in 1850 Townshend the wanderer came to rest—temporarily at least—at an imposing mansion at 21 Norfolk Street, Park Lane, London, which looks directly into Hyde Park. He remained there, when he was in England (he often wintered at Mon Loisir, his house overlooking Lake Leman, above Lausanne), until his death.[14] Dickens described it as "one of the prettiest houses in London" with "every conceivable (and inconceivable) luxury in it."[15] An obituary notice in *The Times*, describing Townshend as a "collector of rare judgement and exquisite taste," added that "every house in which he lived had, indeed, the interest of an art museum, though they will chiefly be remembered for the refined and gracious hospitality with which they were thrown open to his friends during the brief periods when they were occupied by their owner."[16]

Among the visitors to Townshend's Norfolk Street dining table was the young lawyer Frederick Pollock, whose father, the Lord Chief Baron, Sir Frederick Pollock, served as the president of the Photographic Society of London when photography was at its most ambitious during the late 1850s and early 1860s. The younger Pollock was well informed about new developments in photography. At Townshend's table he could have talked of the latest developments in science, politics, painting, literature, and medicine with Charles Dickens, the Prussian ambassador Baron Christian von Bunsen, John Everett Millais, Derwent Coleridge (lawyer son of the poet), Dr. John Elliotson, Bulwer Lytton, the

Rev. John Barlow (secretary of the Royal Institution, where Michael Faraday made his famous experiments and where Talbot first publicly showed his invention in January 1839), and the philanthropist Baroness Burdett-Coutts.[17]

At the time of his death Townshend's library numbered about 7,000 volumes.[18] He took great pains with the bindings of his books, many of which are marvels of binding art. The volumes included such disparate items as the novels of his friends, the philosophical writings of Montesquieu and Rousseau, historical studies from the French Revolution to the Crimean War, and writings on instinct, Darwin, and the science of language. The topics encompass art, science, philosophy, theology, history, antiquities, and contemporary literature and gossip. An item titled *The Memoirs and Remains of Alexis* documents the story of a "Magnetic Boy" with clairvoyant powers. Townshend was, after Dr. Elliotson, the chief English proponent of mesmerism (aspects of which have been rescued from oblivion under the more appropriate name hypnotism). He published two books on mesmerism, which he regarded as an example of the curative powers of unorthodox but undeniable divine providence, and he brought Alexis from Belgium to demonstrate its powers. The demonstrations were sensational. After being thrown into a mesmeric sleep by Townshend the youth would—eyes bandaged—read aloud from books presented to him; on another occasion Dickens's wife held her Geneva watch behind his head and Alexis read the name in a moment.[19] This sensational species of latent vision reached its zenith in the years in which "sun pictures," also latent, apparently spontaneous, natural, and new, were presented to a large public for the first time.

The effect of the interior of Townshend's house may well be best preserved in the description of "Limmeridge House" in *The Woman in White* by Wilkie Collins. Townshend probably knew the novelist from an early age; Wilkie was the son of the painter William Collins, who is well represented in the Townshend collection. In the novel the hero, Walter Hartright, recently arrived to take up a position as drawing master, is shown to the apartments of his employer. "Mr. Fairlie's" retreat is found behind a first door covered with dark baize, a second door, and finally two curtains of pale sea-green silk. Hartright finds himself in

a large, lofty room, with a magnificently carved ceiling, and with a carpet over the floor, so thick and soft that it felt like piles of velvet under my feet. One side of the room was occupied by a long bookcase of some rare inlaid wood that was quite new to me. It was not more than six feet high, and the top was adorned with statuettes in marble, ranged at regular distances one from another. On the opposite side stood two antique cabinets; and between them, and above them, hung a picture of the Virgin and Child, protected by glass, and bearing Raphael's name on the gilt tablet at the bottom of the frame. On my right and on my left, as I stood inside the door, were chiffoniers and little stands in buhl and marquetterie, loaded with figures in Dresden china, with rare vases, ivory ornaments, and toys and curiosities that

sparkled at all points with gold, silver, and precious stones. At the lower end of the room, opposite to me, the windows were concealed and the sunlight was tempered by large blinds of the same pale sea-green colour as the curtains over the door. The light thus produced was deliciously soft, mysterious, and subdued; it fell equally upon all the objects in the room; it helped intensify the deep silence, and the air of profound seclusion that possessed the place; and it surrounded, with an appropriate halo of repose, the solitary figure of the master of the house, leaning back, listlessly composed, in a large easy-chair, with a reading-easel fastened on one of its arms, and a little table on the other.[20]

This seems to have been the habitat of the valetudinarian Townshend, who wrote to his old friend Bulwer in the 1850s: "I mean to live a life within a life—keep my hours, continue my daily walks, see only my true and intimate friends—and not excite nerves or brain."[21] Elsewhere in the novel Hartright notices the priceless rings adorning Fairlie's white and delicate hands, the coin cabinets over which he fusses, and Mr. Fairlie minutely examining his Rembrandt etchings—in a trance of wonder—with the aid of a magnifying glass. No doubt Townshend viewed the photographs he acquired with the same intense aesthetic scrutiny. Mr. Fairlie was allowed by Hartright to be a good curator of the collections of watercolors that entered the house from the sale rooms, "smelling of broken fingernails," to be contemplated and conserved.

Townshend's collection of photographs was mainly formed in the years 1855–60 and covers war documentary, landscapes, and seascapes, for which the period is most notable. Townshend kept his photographs in several rooms: mounted exhibition photographs were kept in presses with his other fine prints; photographically illustrated volumes, of which he owned important examples, were shelved with his other books; elsewhere in the house Townshend kept stereographs and probably some photographic portraits. The inventory shows that a framed photograph of a waterfall hung in an upstairs room.[22] In the *Descriptive Tour* Townshend wrote that the waterfall was "an object which to my mind requires more contemplation than any other."[23] Nothing else is known of this photograph or its authorship.

The earliest mounted photographs in the collection are from Roger Fenton's series on the Crimean War, photographed, published, and exhibited in 1855. The set includes a portrait of *The Times* correspondent William Howard Russell, whose dispatches from the Crimean front were read with the greatest interest and concern. Townshend's circle overlapped with the then new Photographic Society of London. This editorial opinion from the Society's *Journal* on Fenton's Crimea series may well have reached Townshend's ears across a London dinner table: "This is a collection of national importance, and will of course be visited by everyone who can have the opportunity. Those who can and those who cannot will do well to secure some of these remarkable memorials of the war." The editorial described the range of subject

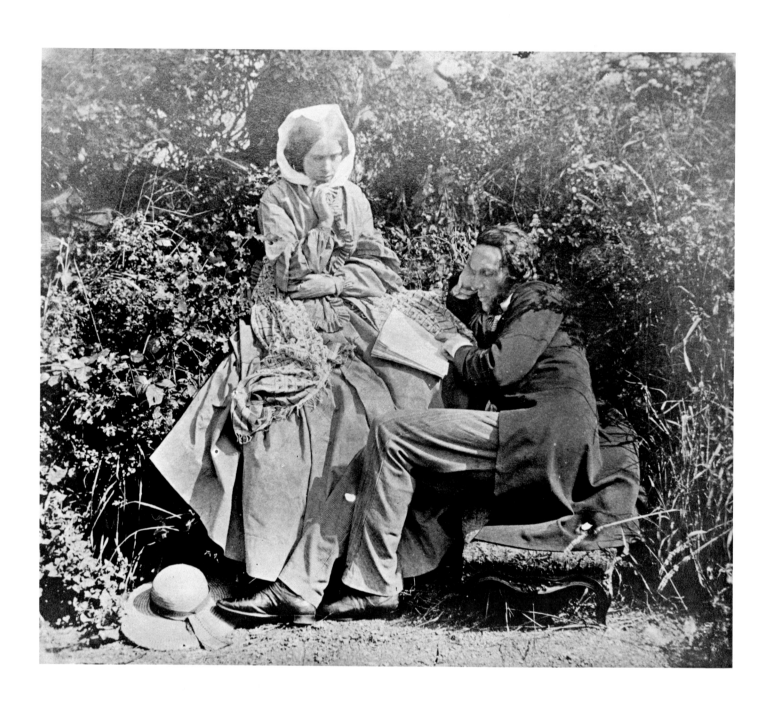

16 F. R. PICKERSGILL, *Sunshine and Shade* (from *The Sunbeam*, 1859), albumen print from glass negative, 16.8 x 19.5 cm, VA

matter—"views, groups, portraits, entrenchments, shipping—all that we have anxiously read about from day to day." Two photographs were particularly emphasized and both were acquired by Townshend: "*The Council of War Held at Lord Raglan's Headquarters on The Morning of the Successful Attack on the Mamelon,* portraits of Lord Raglan, General Pelissier, and Omer Pasha,—a *real* picture of a kind of subject not often attempted ideally by painters, . . ." and *The Valley of the Shadow of Death,* "with its terrible suggestions, not merely those awakened in the memory but actually brought materially before the eyes, by the photographic reproduction of the cannon-balls lying strewed like the moraines of a melted glacier through the bottom of the valley."[24]

Trees were one of the dominant picture subjects of the exhibitions of photographs held in London in the 1850s, and Townshend owned very good examples. The earliest photographs in Townshend's collection are tree studies from the Forest of Fontainebleau (negatives 1851, prints probably 1855 or later) by Gustave Le Gray. These were shown at the Exposition Universelle in Paris in 1855, at which Le Gray was awarded the gold medal for photography. Townshend visited the exhibition and may well have seen the photographs there.

All the other French landscapes in Townshend's collection are characterized by richly printed-in skies and are by Le Gray (his famous seascapes), Albert Giroux (bronze medalist in 1855), and Silvy. Le Gray's sea/sky combination photographs were much talked about because they were nearly instantaneous, a prime project of photography in the late 1850s and early 1860s. When one of his series was shown at the London exhibition in 1857, the *Journal of the Photographic Society* responded ecstatically:

> Among the landscapes we stop with astonishment before M. Le Gray's "Sea and Sky," the most successful seizure of water and cloud yet attempted. The effect is the simplest conceivable. There is a plain unbroken prairie of open sea, lined and rippled with myriad smiling trails of minute undulations, dark and sombrous and profoundly calm, over the dead below, smooth as a tombstone. Overhead is a roll and swell of semi-transparent clouds, heaving and breaking and going they know not whither. From the midst of this "pother" of dimness falls a gush of liquid light, flush and full on the sea, where it leaves a glow of glory. The delight and surprise of this descent is a new pleasure. It is as when Jacob's ladder of angels was but just withdrawn, and the radiance above and below, where it rested on earth and sky, had not yet melted out.[25]

Townshend owned the photograph described by the reviewer, and this splendid conceit may be close to his response to Le Gray's wonderful clouds. In a poem called "Evening Clouds," published in his 1851 volume *Sermons in Sonnets* ("at least they are the shortest sermons ever preached," Townshend wrote to Bulwer), he compared clouds to "Thousands of angels that catch light/ Upon their inner wings."

Townshend may have seen Le Gray's seascapes at an exhibition in London, but certainly he is unlikely to have missed the Art

Treasures Exhibition held at Manchester in 1857. It was the largest art exhibition held in Britain in his lifetime. The final department of this comprehensive exhibition was an international display of contemporary photographs arranged by Philip Henry Delamotte, F.S.A., professor of drawing at King's College, London. Five hundred ninety-seven photographs were shown, including examples lent by Prince Albert.

The Le Gray studies were sent for exhibition by the London firm of photographic suppliers and dealers in fine photographs, Murray and Heath, at 43 Piccadilly. Vernon Heath, partner in the firm, was a distinguished photographer who worked under royal patronage and was a nephew of the important collector of paintings Robert Vernon. The same firm was also responsible for

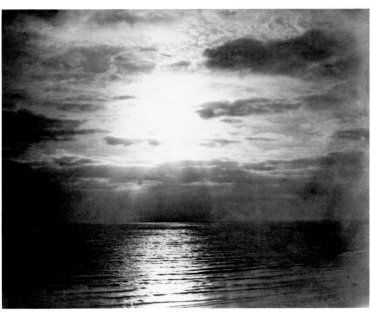

Gustave Le Gray, *Sea and Sky,* 1856, VA

exhibiting Camille Silvy's masterpiece *River Scene, France* at the Photographic Society of Scotland, Edinburgh, in 1858. Only one other print of this famous photograph survives, so far as is known, in the Société Française de Photographie, Paris. This picture of a family enjoying an afternoon beside a château and a fine river is paralleled by paintings in the Townshend collection, but the minute description offered by the photograph is a large part of its special quality. It is a photograph that can easily be imagined in the context of "Mr. Fairlie" at Limmeridge House: placed on a viewing easel by the gloved hands of a valet.

The Sunbeam: Photographs from Nature is a rare volume that unites visual images and poetry in a way that is reminiscent of Townshend's account of his Scottish tour. The anthology published under this title in 1859 is one of the most interesting of the photographically illustrated books in Townshend's collection. It was compiled and edited by Delamotte. Each plate is faced by a text, antiquarian or poetic. It is a mid-Victorian vision of earthly paradise. The purpose of the anthology is established by the first plate, *Woods at Penllergare* by John Dillwyn Llewelyn, facing lines

by John Mitford that evoke "a silent harmony of nature and man." Trees, twigs, ivy, and fallen leaves fill the plate; man's intrusion is limited to a rustic bridge and a tiny railway track—but we are far in this anthology from the Railway Age. The tour of reverie proceeds to monuments at Canterbury, Heidelberg, Oxford, and York, and presents St. Paul's Cathedral rising magnificently above the Thames and its warehouses—as if the city were a large cathedral town. Even St. Paul's is conjoined to northern myth by the chosen text: "St. Paul's high dome, amidst the vassal bands/ Of neighboring spires, a regal chieftain stands." Other favorite mid-century haunts are represented by *A Highland Watermill* by George Washington Wilson, *Cottages at Aberglaslyn, North Wales* by Francis Bedford, and *Lynmouth* by Lebbeus Colls.

The Sunbeam contains at its heart three chief general types of locus: *The Country Bridge, A Country Courtyard,* and *A Peaceful Village,* all redolent of the Surrey countryside in which Townshend grew up (and in which, in Godalming Churchyard, he asked to be buried). Three subjects feature rivers and reflections: *The River-side at Streatley, The Thames at Iffley Mill,* and Delamotte's own *Magdalen College, Oxford, from the Cherwell.* Here Delamotte's editorship becomes illuminating. Facing the first of the river photographs is an extract of poetry by Browne which invokes the clarity of the river. The lines ask—following Wordsworth's "Tintern Abbey"—that the pristine sensations of nature be stored up against future days of urban habitation and lesser grace. The poet describes a pure, reflexive, and accurate relationship with nature, including the "heavens." The river is a paradigm of untrammeled reflection, continued in Sir Thomas Noon Talfourd's lines facing *The Thames at Iffley Mill,* in which imagination plays like a sunbeam over the surface of the river, following its "crystal ways" until the mind's eye reaches the complex reflections of poplar trees in moving water; the imagination finds clarity and reverie simultaneously; the "ethereal maze" is a representation of the riverside woods, followed by the drawing in "clearest dream" of a course which is both peaceful and magical, a place of spirits. This is the world also sought by the photographer, used to regarding the world intently on a ground glass, upside-down and transposed. The linked photographs and quotations make of the book an apologia for photography as a natural poetics, spontaneous, directly imprinted by nature, a Wordsworthian art such as Townshend discovered in his first youth. Given Townshend's special love of gemstones it is hard to imagine him looking less intently at a photographic print than a photographer looking at a ground glass.

Among Townshend's notable treasures was a remarkable collection of gemstones, and the inventory shows that Townshend collected the most gemlike of Victorian photographs—stereographs. In the study in which Townshend read, wrote, studied his collections, and shared amusements with friends were ring cases, a hand glass, a brass kaleidoscope, five stereoscopes, seven music boxes, a large stereoscope, and cases of stereoscopic slides (both glass and mounted on card) which are listed as twenty-four stereoscopic slides, groups of thirty-six, fifteen, twenty-eight, and twenty-four glass slides, and 113 plain card slides.

The number of stereoscopes suggests that viewing the slides was an amusement enjoyed in company, with the stereographs being passed from hand to hand, while the large viewer may have allowed special effects through a choice of tinted lenses, but it too may have been designed for communal viewing. That Townshend particularly enjoyed stereographs is suggested by the presence at Gad's Hill of what Dickens called "the large Townshend stereoscope."[26] The range of subjects covered by stereographs included many of Townshend's interests, including British landscape, scenes "abroad," minerals and other natural phenomena.

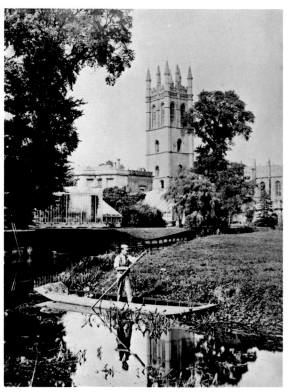

Philip H. Delamotte, *Magdalen College, Oxford, from the Cherwell* (from *The Sunbeam,* 1859), VA

Townshend contributed essays to Dickens's magazine *All the Year Round* and he might have read and endorsed this genial opinion expressed by a not yet identified but remarkable writer, published in an article on novelties of the day such as photography, steam, and gutta percha, an early type of rubber, in 1859. The writer commented on "this stereoscopic mania":

It is very good, I think, to look on marvellous transcripts of nature, to peep through two little holes at a scrap of cardboard, and say: There are the Grands Mulets, there is the Court of Lions, there is the Alameda of Seville, not to have seen which is not to have seen a wonder. There is Mount Hor, there is the Mount of Olives, there the church of the Sepulchre, there the place of Job's tribulation—not as painters and poets have imagined them, but in their actual, terrible reality—barren, sunburnt,

arid, desolate. See: that little speck among a thousand heads is Queen Victoria. By her side is Eugénie, in a white bonnet; that little dark streak is the real life-like twist of the moustache of his Imperial Majesty, Napoleon III. These are not phantoms; they are real, and the sun cannot lie. It is good, I say, to look into these magic mirrors, and the reflective man may glean many and salutary lessons from them, but how does it stand when we come to photograph humanity tortured into the similitude of an ape, or caricatured into sham angels and sham ghosts? What a cold, palled glare is thrown by the stereoscope on the deliberate indecencies that knaves have striven to perpetrate. Faugh! Take away this miserable wresting of sunbeams, this forcing them to irradiate dust-heaps and sewers.[27]

The article is entertainingly written; it also marks very clearly a moment in the appreciation of photography while it was still a wonder, but one liable to be traduced by vulgar, commercial exploitation, typified for the writer in *All the Year Round* by the low amusements offered in "semi-ribald stereographs." The writer has more to say about photography as a new utility medium.

Not to be denied, however, is this great fact of photography: very potent and various in its usefulness at this time. . . . It has taken giant strides from its little dim cradle, full of misty shadowings of corpse-like colour, and distorted parts called daguerreotypes. Photography is everywhere now. Our trustiest friends, our most intimate enemies, stare us in the face from collodionised surfaces. Sharp detectives have photographs of criminals of whom they are in search.[28]

The quality of photography celebrated in the essay is its objectivity as a new, neutral enhancement of life in all of its practical departments. Townshend's fascination with precise vision was shared by his great friend Charles Dickens. The two men met in 1840, drawn together by their mutual interest in mesmerism. In 1851 Townshend dedicated to Dickens his *Sermons in Sonnets*, a compliment overwhelmingly repaid by the dedication of *Great Expectations* to him in 1861, together with the gift of the original manuscript. In a humorous account of himself in verse, Townshend admitted:

Of Observation I've a bump enormous,
And that is why
I'm still observing, though like any dormouse
Upon the sly.[29]

But Dickens was the great eyewitness of the period. His scrutiny of Townshend produced this sketch, for example, which not only amply confirms Townshend's status as a hypochondriac, but also gives a burlesque but accurate portrait of the dilettante collector:

I found Townshend on board, fastened up in his carriage, in a feeble wide-awake hat. It was rather windy, and the sea broke pretty heavily over the deck. With sick women lying among his wheels in various attitudes of despair, he looked like an ancient Briton of weak constitution—say Boadicea's father—in his

war-chariot on the field of battle. I could not but mount the Royal Car, and I found it to be perforated in every direction with cupboards, containing every description of physick, old brandy, East India sherry, sandwiches, oranges, cordial waters, newspapers, pocket handkerchiefs, shawls, flannels, telescopes, compasses[30]

In a thoughtful contemporary assessment of Dickens, Walter Bagehot remarked in 1858 that Dickens could "go down a crowded street and tell you all that is in it, what each shop was, what the grocer's name was, how many scraps of orange peel there were on the pavement. . . . Mr. Dickens's genius is especially suited to the delineation of city life. London is like a newspaper. Everything is there and everything is disconnected."[31] For Bagehot these qualities were a phenomenon too natural for the good

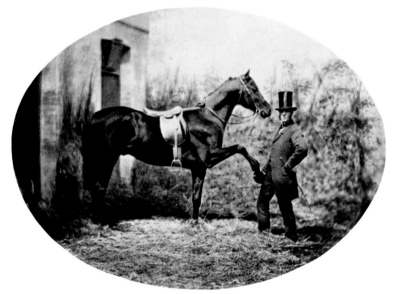

Caldesi and Montecchi, *Mr. Rarey and "Cruiser,"* 1858, VA

of Dickens's art, but such precise, disconnected details may well have been the feature of photography that inspired Townshend to collect them. Writing in 1857 in her justly famous essay on photography, Lady Eastlake found the same fault—of finely described details incoherently related—in the new art of photography. One of the notable characteristics of the calotype period, of approximately 1841–51, was a general lack of enthusiasm for it (despite glowing exceptions), amounting to a sense of bemusement as to what these early photographs really were. In 1845 a critic in *The North British Review* had condemned Dickens and photography in the same review: "Ludicrous minuteness in the trivial descriptive details induces us to compare Mr. Dickens' style of delineation to a photographic landscape. There, everything within the field of view is copied with unfailing but mechanical fidelity."[32]

This enumerative, all-encompassing sort of vision was exemplified in Dickens in his invention of Inspector Bucket, the first genuine detective in English literature, who makes his ap-

pearance in *Bleak House*.[33] Two characteristics that distinguish Mr. Bucket came to be shared by photographers: first, his social mobility—he can appear at all levels of society from opium den to ducal mansion, and second, the quality of his vision, which is instantaneous, but also permanent, or photographic. The lens of his regard is functional and asocial.

Townshend's interest in photographs was linked to Romantic conceptions of a spontaneous and natural art. It was also related to an urban functional vision typified by the modern detective.

George Newbold, *John C. Heenan,*
"The Benicia Boy," 1860, VA

Townshend was fascinated by contemporary popular or eccentric figures like Lord Brougham, the boxers John C. Heenan and Tom Sayers, the American horse trainer Mr. Rarey, figures who formed the stuff of popular legend. Their likenesses were modeled in Staffordshire pottery for the mantelpieces of the nation, photographed in London, and immortalized in hastily composed ballads. Townshend owned portraits of these heroes. Despite his reclusive tendencies he immersed himself in the topical doings of his day: Charles Allston Collins dedicated to Townshend his book on London's shows, called *The Eye-witness,* and Townshend himself produced a passable topical ballad, "The Burning of the *Amazon,*" based on a real-life adventure in the Bay of Biscay. The last photographs he acquired, by an anonymous practitioner, document a recent event that was not an adventure but an outrage. They have the appearance of forensic records, a photographic equivalent of a passage in Dickens.

The outrage was known as The Clerkenwell Explosion. It occurred on 12 December 1867. A group of three Fenians attempted to rescue one of their members who was confined on remand in the Clerkenwell prison. A barrel of explosives was placed by the prison wall and ignited, blasting a huge cavity in the wall and razing nearby houses. Over forty men, women, and children were injured, some severely, and seven killed. There were other ex-

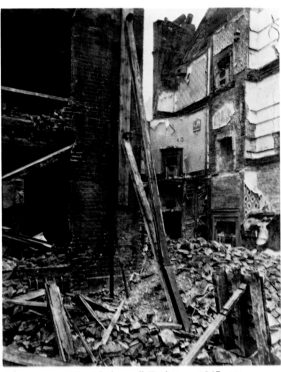

Anonymous, *The Clerkenwell Explosion,* 1867, VA

plosions and 30,000 special constables were sworn in. The Fenian Michael Barrett was convicted and hanged in May 1868. This was the last public execution in England. Eyewitness reports of the explosion appeared in the newspapers, one by Dickens's former colleague on the magazine *Household Words,* the immensely successful journalist George Augustus de Sala. He wrote of what was to be seen as "the strangest of spectacles. All the cells in the prison were lighted up; the wall in front was one great black mass, in the middle of which, low down, there was a huge cavity, through which you could descry the gas lamps in the prison yard."[34] The photographs record this spectacle; one shows the interior of a torn dwelling in which a framed picture is still incongruously suspended on the wall. It is the kind of arbitrary and impartially recorded detail characteristic of photography in its commonly used form, and of the element in photography loosely called "surreal," which is inherent in documentary or eyewitness records.

Townshend died a few weeks after the Clerkenwell Explosion, at 21 Norfolk Street, on 25 February 1868. Despite his chronic melancholia and sundry other complaints, he had achieved the age of nearly seventy. In due course parts of his collection went on exhibition at the South Kensington Museum and parts—including the library, the manuscript of *Great Expectations,* and

many of the precious objects noted by Wilkie Collins in the fictional Limmeridge House—made their way to the local museum at Wisbech. His gems and the paintings from his collection are catalogued and published, and he is remembered by Dickens scholars as the original of "Cousin Feenix" in *Dombey and Son*—good-natured, eccentric, quasi priestly, and rich.[35] A trust for the education of poor children was set up under the name of the Burdett-Coutts and Townshend Foundation and a school under its auspices still flourishes in Westminster. "Cousin Feenix" is an emblem of order contrasted with the sharp practice, hectic speed, and muddled lives of the Railway Age in which *Dombey and Son* is set. In a poem called *The Railway Garden* Townshend imagines a contrast between the cultivated but natural order of a garden and the "rush and grinding roar" of the railway:

> *Thy own quiet, like a dream,*
> *Wraps thy treasures. Touching thee,*
> *E'en the giddy human stream*
> *Calms its waves unconsciously.*[36]

The garden beside the railway is, perhaps, analogous to the sanctuary of a church or the contemplative calm of a perfectly ordered house, or of that relatively new thing, a public museum. It seems logical, given Townshend's constellation of interests, that he should have collected the photographs he did. His poetry suggests that it was also logical for him to present the fruits of his vision to public museums. The result is that we have in Townshend a rare and unlikely eyewitness to the sensibility of Victorian England, one whose collection adds another facet of understanding to the modern vision of Victorian life.

NOTES

1. Prince Albert's collection has not survived in entirety. A study of his collecting activities is in preparation by Frances Dimond. The albums he assembled in the 1850s are available for study on the microfilm Royal Archives at Windsor Castle (London: World Microfilms Publications, 1979). Some evidence survives of the enthusiasm for photography of the bibliophile Sir Thomas Phillips, but the extent of his collection is as yet unestablished. See A. N. L. Munby, *The Formation of the Phillips Library from 1841 to 1872*, Phillips Studies, no. 4 (Cambridge: Cambridge University Press, 1956), pp. 39–41. **2.** Townshend to Edward Bulwer, Lord Lytton, 11 February 1862 (Lytton [Knebworth] MSS, Hertfordshire County Record Office). **3.** J. W. and Anne Tibble, *John Clare: A Life* (London: Michael Joseph, 1972), p. 131. **4.** *The Life of Edward Bulwer, First Lord Lytton, by his Grandson* (Victor A. R. G. B. Lytton, Earl of Lytton) (London, 1913), vol. 1, pp. 70–71. **5.** This and the description of Eliza Norcott are from the Lytton (Knebworth) MSS, Hertfordshire County Record Office. **6.** Ibid. **7.** Townshend, *A Descriptive Tour in Scotland*, 2nd ed. (London, 1846), p. ix. **8.** Ibid., p. 40. **9.** Ibid., p. 41. **10.** William Henry Fox Talbot, *The Pencil of Nature* (London, 1844), n. pag. **11.** Townshend, *A Descriptive Tour*, pp. 213–14. **12.** Ibid., p. 96. **13.** Ibid., p. 377. **14.** Townshend describes fitting up the house in a letter to Bulwer dated 14 May 1850 (Lytton [Knebworth] MSS, Hertfordshire County Record Office). The house featured an open semicircular balcony which looked directly into Hyde Park. The balcony was later enclosed and glazed. See *Survey of London*, ed. F. H. W. Sheppard, *Volume 40: The Grosvenor Estate in Mayfair* (London: Athlone Press, 1980), pt. II, pp. 284, 285. The street was later renamed Dunraven Street. **15.** Charles Dickens, *Letters* (London, 1880), p. 7: Dickens to M. de Cerjat, 17 January 1857. **16.** *The Times*, 7 April 1868. **17.** Sir Frederick Pollock, *Personal Reminiscences* (London, 1887), 2 vols. See entries for 9 July 1851, and 9 April and 13, and 27 June 1854. **18.** The library is now part of the Wisbech and Fenland Museum, Wisbech, Cambridgeshire. **19.** Fanny Kemble, *Records of Later Life* (London, 1882), vol. 2, p. 77. Townshend's *Facts in Mesmerism with Reasons for a Dispassionate Inquiry Into It* (London, 1840) was also published in an American edition (ed. Robert Hanham Collyer, 1841). In January 1842 William Cullen Bryant wrote to a friend that "since the publication of the Rev. Mr. Townshend's book, animal magnetism . . . has made great progress in America. It is quite the fashion" (Parke Godwin, *A Biography of W. C. Bryant* [New York, 1883], vol. 1, pp. 392–93). **20.** Wilkie Collins, *The Woman in White* (Oxford: Oxford University Press, 1973), pp. 31–32. This identification of Mr. Fairlie as based on Townshend contradicts that of N. P. Davis in *The Life of Wilkie Collins* (Urbana: University of Illinois Press, 1956), p. 154, who suggests Collins himself as the model, but is supported by Bulwer's description of Townshend as effeminate and selfish in later life and the many correspondences between the possessions of Fairlie and the objects Townshend owned. **21.** Lytton (Knebworth) MSS, Hertfordshire County Record Office. **22.** Inventory of 21 Norfolk Street, Victoria and Albert Museum Registered Papers. The portraits are not listed as such in the inventory but in a letter to Bulwer dated 10 September 1852 (Lytton [Knebworth] MSS, Hertfordshire County Record Office), Townshend noted, "I value your daguerreotype so much." Whether any portrait photographs owned by Townshend have survived is not known. **23.** Townshend, *A Descriptive Tour*, p. 240. **24.** *The Journal of the Photographic Society*, 21 September 1855: 221. **25.** Ibid. **26.** Dickens, *Letters*, vol. 2, p. 95: Dickens to his daughter Mamie, 11 June 1859. **27.** *All the Year Round*, 19 November 1859: 80. **28.** Ibid. **29.** "T. Greatley, Esq.," *Philosophy in the Fens; or, Talk on the Times: A Poem in Twelve Chapters* (London, 1851), p. 77. Attributed to Townshend by the late W. L. Hanchant, "Chauncy Hare Townshend," *Twenty-third Annual Report of the Wisbech Society*, 1962, n. pag. As curator of the Townshend Collection at the Wisbech Museum, Hanchant was able to identify several Townshend publications issued under pseudonym. **30.** Charles Osborne, ed., *Letters from Charles Dickens to the Baroness Burdett-Coutts* (London: John Murray, 1931), pp. 170–71. **31.** In Philip Collins, ed., *Dickens: The Critical Heritage* (London: Routledge and Kegan Paul, 1971), pp. 390–401. **32.** Ibid., pp. 186–91. **33.** Ian Ousby, *Bloodhounds of Heaven: The Detective in English Fiction from Godwin to Doyle* (Cambridge, Mass., and London: Harvard University Press, 1976), pp. 80–110. There may have been a connection between the detective and the photographer in Dickens's mind. Inspector Bucket is introduced in these words in the original manuscript of *Bleak House* (chap. 22, pp. 2–4): He looks at Mr. Snagsby as if he were "about to take his portrait *and had already got it*" (Forster Collection, National Art Library, Victoria and Albert Museum). Dickens deleted the words in italics. **34.** *The Life and Adventures of George Augustus de Sala* (London, 1895), vol. 1, pp. 165–67. **35.** John Forster, *The Life of Charles Dickens*, ed. J. W. T. Ley (London: Cecil Palmer, 1928), p. 696, n. 463, in which Townshend is also suggested to be the model of Mr. Twemlow in *Our Mutual Friend*. **36.** *The Three Gates* (London, 1859). Townshend did not live to read all of Wilkie Collins's *The Moonstone*, serialization of which was completed after his death. The novel brings together many of the interests of the Townshend circle, including detectives, experimental medicine, mesmerism, gemstones, and, as narrative method, the eyewitness.

1. The Daguerreotype
A New Wonder

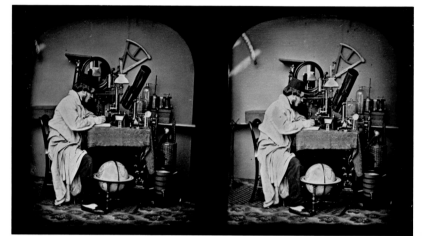

It is hardly saying too much to call [daguerreotypes] miraculous. Certainly they surpass anything I could have conceived as within bounds of reasonable expectation. The most elaborate engraving falls far short of the richness and delicacy of execution, even gradation of light and shade is given with a softness and fidelity which sets all painting at an immeasurable distance.

Sir John Herschel to William Henry
Fox Talbot, 9 May 1839

These are the words sent in a letter from Paris to his fellow scientist Fox Talbot by Sir John Herschel after Louis Jacques Mandé Daguerre had shown him examples of his new art of photography. Daguerreotypes were welcomed as a wonder. Rightly considered they remain a wonder, especially those created by practitioners of the 1840s and early 1850s who best understood the procedures of manipulation and rendered the most difficult or spectacular subjects. The invention provided a new synonym for minute exactitude made permanent.

Although Daguerre's name is attached to the process, it became a successful and widely practiced portraiture medium as the result of advances made by others. In London in 1841 the French scientist Antoine François Jean Claudet introduced the use of accelerating agents that cut exposure times to manageable proportions, and in Paris Hippolyte Fizeau made the discovery that the delicate bloom of particles that form the daguerreotype could

be permanently fixed by a thin coating of gold. This allowed the surface to bear the addition of hand coloring.

During its brief heyday the daguerreotype fulfilled hopes for a new unity of science and art, technology and nature. Inventors used the process, added to its potential, recorded other inventions. J.B. Dancer in *The Scientist in His Laboratory,* 1851–52 (above) pictured all the apparatus he made or sold and included two of his inventions—a porous pot for Daniel cells and a magnetic Make and Break for a variable voltage induction coil, seen on the shelf to the rear right. This daguerreotype is a kind of scientific achievement made for the inventor and his friends.

Daguerreotype portrait studios operated under license in the 1840s and 1850s, and results varied from the commonplace to the elegant. Claudet's, one of the earliest, was also the most fashionable and skilled. To take best advantage of natural light, the portraitists installed their studios in "glass houses" fitted with blue-tinted glass, which filtered as well as maximized the illumination. In a letter to a friend, the Gothic novelist Maria Edgeworth vividly described the effect of these precautions, as well as the unfamiliar experience of sitting for the camera: "It is a wonderful mysterious operation. You are taken from one room into another up stairs and down

and you see various people whispering and hear them in neighboring passages and rooms unseen and the whole apparatus and stool on a high platform under a glass dome casting a *snapdragon blue* light making all look like spectres and the men in black gliding about . . . " (*Letters from England, 1813–44,* ed. Christine Colvin, 1971, pp. 593–94).

In January 1839, prior to the publication of his process, Daguerre drew up a brochure intended to attract wealthy subscribers. The outline he published is a prophesy of photography as it is practiced today: "By this process, without any idea of drawing, without any knowledge of chemistry and physics, it will be possible to take in a few minutes the most detailed views, the most picturesque scenery, for the manipulation is simple." The world did not become a paradise for amateur daguerreotypists in the 1840s, however. Manipulation of the process out of doors with an unpredictable brightness range and other factors was evidently too complicated, and landscapes are rare. The newly attributed and perhaps unique family sporting scenes taken by Horatio Ross in Scotland in the 1840s are possibly the closest daguerreotypes ever came to resembling the family snapshots of today.

The daguerreotype dominated portraiture for just ten years. The word *daguerreotype* continued in the language for decades after its lapse from major commercial use in the mid-1850s. By the early years of the twentieth century daguerreotypes

had become heirlooms, old faces dressed in the somewhat corpselike gray tones associated with the process. T. S. Eliot caught and made poetic use of this attribute in "A Cooking Egg" (*Poems*, 1920) in which he conjured up the interior of a genteel, serviceable, sunless life.

Pipit sate upright in her chair
 Some distance from where I was sitting;
Views of Oxford Colleges
 Lay on the table, with the knitting.
Daguerreotypes and silhouettes,
 Her grandfather and great great aunts,
Supported on the mantelpiece
 An Invitation to the Dance.

Thereafter, the daguerreotype became a curiosity, dimly discerned, often miscatalogued even in museums, an odd deadend of technology, social history, and language.

ANTOINE FRANÇOIS JEAN CLAUDET (1797–1867)

Antoine Claudet began his business life in banking, transferred to a glassmaking firm south of Paris, and in 1829 came to London to expand the business. He returned to Paris ten years later to study the new daguerreotype process with its inventor, and acquired a license from Daguerre to operate in London. In June 1841 Claudet opened a studio in competition with Richard Beard's (the first professional photography studio in Britain), in a glass structure on the roof of the Adelaide Gallery behind St. Martin's-in-the-Fields. Claudet made stereo-daguerreotypes for Sir Charles Wheatstone and, in the summer of 1842, a series of views from the top of the Duke of York's Column that were used in designing a panorama of London (*The Illustrated London News*, 7 January 1843).

In 1851 Claudet moved to 107 Regent Street, his "Temple to Photography." This celebration of the art and science of the medium featured medallion portraits of Roger Bacon, Leonardo da Vinci, Isaac Newton, Jo-

siah Wedgwood, Nicéphore Nièpce, Jean François Arago, and others. Allegorical paintings by the French artist August Hervieu, in a Renaissance setting designed by Sir Charles Barry, depicted "statuary, painting, the application of the camera obscura to photography, and photography to the stereoscope, emblems of the discovery of photography, chronological records of the inventions and discoveries whereunto photography is indebted" (Helmut and Alison Gernsheim, *L. J. M. Daguerre*, London, 1956, p. 155). In 1853 Claudet became "photographer-in-ordinary" to the queen, and a fellow of the Royal Society. His contributions included the introduction of painted backgrounds for portraits, the photographic darkroom light, instantaneous portraits—of dancers at the Italian Opera "in postures that could be retained but for an instant, such as poising on one foot with the other leg extended" (Gernsheim, p. 155)—and the use of rock crystal and topaz lenses.

It is likely that Claudet was linked professionally with the subject of one of his portraits, Andrew Pritchard (1804–1882), who was an inventor, entrepreneur, and maker of jewel lenses operating an optician's emporium for scientific instruments in Ludgate Circus. The Pritchard microscope was in general use in the 1850s and was highly praised by Sir David Brewster. The Claudet portraits of Pritchard and his wife were presented to the Victoria and Albert Museum by Miss E. M. Spiller.

Claudet became a member of the Photographic Society of Scotland at the invitation of Horatio Ross, and in his acceptance discussed "Photography in Its Relation to the Fine Arts."

PHILIP HENRY DELAMOTTE (1821–1889)

Philip Delamotte was one of the sons of William De La Motte, landscape painter watercolorist, and lithographer. William De La Motte studied at the Royal Academy under Benjamin West and was drawing master at Sandhurst Military Academy. Philip is thought to have been tutored by his father, which led to his teaching drawing and perspective at King's College, Cambridge (1855–

87), where he was ultimately professor of drawing. Examples of his work include watercolor drawings used as plate illustrations for *The Industrial Arts of the Nineteenth Century at the Great Exhibition* (volume II, by Sir Matthew Digby Wyatt), published in 1851–53. An engraving of his watercolor of fabric displays in the Halifax and Kendal courts of the Great Exhibition of 1851 appeared in *The Illustrated London News* (5 July 1851).

Delamotte's career in photography began in the late 1840s, and he worked with the nascent calotype, waxed paper, and later, wet collodion processes. In 1855 he first advertised his services as a printer of calotypes, and the first issue of the *Journal of the Photographic Society* carried his advertisement for instruction in wet collodion technique. In the same year he wrote *The Practise of Photography, a Manual for Students and Amateurs* and taught photography at the Photographic Institution in New Bond Street, London. Delamotte's work is found in the two Photographic Exchange Club albums of the mid-1850s, and his photographs often served as book illustrations, including *A Photographic Tour among the Abbeys of Yorkshire* by J. Cundall (1856), *The Sunbeam: Photographs from Nature* (1859), and *Holland House* by Princess Marie Liechtenstein (1874).

Delamotte's major commission was to document the reconstruction of the Crystal Palace at Sydenham in 1854. At the opening on 10 June 1854, several photographers were positioned on a viewing platform facing the royal dais. This early example of indoor news photography was only possible in an interior like the Crystal Palace, which had sufficient natural light. In the view on page 29 attributed to Delamotte (T. R. Williams may have been the operative, working for Delamotte's studio) Queen Victoria, Prince Albert, and the royal party are shown listening to the inauguration prayer given by the Archbishop of Canterbury. Three orchestras and a choir of 1,800 can be seen, and a "Miss Clara Novello, the only female standing in front of the orchestra" (Jonathan Steele, "Collecting Stereographs, Part II," *Photographic Collector* 1, no. 2 [1980]: 18). This and another 3 x 5-inch daguerreotype in the Victoria and Albert Museum may be those exhibited the same evening at the Royal Society's celebration of the event. An albumen print of the identical composition of the Crystal Palace daguerreotype appears in one of Prince Albert's albums, described as by Delamotte (Royal Archives, Windsor Castle).

The Progress of the Crystal Palace, Sydenham,

was first published in 1855, and a large portfolio of these views was printed by the scientific instruments firm of Negretti and Zambra and published by the Crystal Palace Art Union in 1858. After this period Delamotte's position at King's College demanded more of his resources, and his output in photography dwindled.

HORATIO ROSS (1801–1886)

Horatio Ross was named in honor of Horatio, Lord Nelson, an intimate friend of his father, Hercules Ross. Horatio Ross served as a member of Parliament for Aberdeen in 1832–34, but is remembered especially as an extraordinary sportsman. His amateur interests led him in 1849 to master the calotype process, under the tutelage of the (unrelated) Edinburgh photographer James Ross, and in 1856 Ross was a founder and vice-president of the Photographic Society of Scotland. He was a regular exhibitor, and in 1860 judged the society's exhibition, awarding medals to *Waterfall near Coniston* by James Mudd and *Here They Come* by Henry Peach Robinson. In a paper to the society in 1873 James Ross remarked that "since the days of the daguerreotype this gentleman has always stood in the foremost ranks of amateur photographers" (Helen Smaills, "A Gentleman's Exercise," *The Photographic Collector* 3, no. 3 [1982]: 269).

The eight daguerreotypes attributed to Ross in the collection of the Victoria and Albert Museum comprise three sporting scenes and five portraits, including a self-portrait. The outdoor images were taken near his estate, Rossie Castle, Forfarshire. The fishing scenes are slightly underexposed in the lower sections, and the relative brightness of the skies has resulted in their solarization to sky blue. Daguerreotypes of this genre are very rare. "Though amateurs could buy a license for five guineas, the process was evidently too complicated and the outfit too expensive for anyone to daguerreotype for amusement only. We have not in fact seen any English daguerreotypes other than professional portraits, though it is known that a few landscapes were taken. Scotland and Ireland were not included in [Daguerre's] patent, but amateurs there mostly used Fox Talbot's calotype process, which besides being simpler and cheaper was not patented there either" (Helmut and Alison Gernsheim, *L. J. M. Daguerre*, p. 154). The Victoria and Albert daguerreotypes are attributed to Ross in part because he is one of the very few identifiable amateurs of the process in Scotland, and these daguerreotypes are not professionally packaged but are simply bound in paper, sometimes of a tartan pattern. Most significantly the subjects correspond with later photographs known to have been taken by Ross.

These photographs, albumen prints made from wet collodion negatives in the 1860s, are found in an album that records Ross family stalking excursions and trophies. (Ross's passions included sculling, riding, long-distance walking, and grouse and deer hunting; his sons followed his lead, representing Scotland in the National Rifle Association championships in 1863.) The children seen in the earlier daguerreotypes are recognized in the album as grown men, confirming that the earlier outdoor scenes are probably also from Ross's hand.

T. R. WILLIAMS (1825–1871)

T. R. Williams was one of Antoine Claudet's first assistants, "before Daguerreotype had ceased to be a wonder and a novelty. His reputation as a skillful photographer and gifted artist was rapidly acquired after he had established himself in premises of his own in Regent Street. In some branches of the photographic art he stood unrivalled" (*The Photographic Journal* 15 [1871]: 115). The enlargement of small daguerreotypes and the copying of works of art and articles of *vertu* were specialties of his studio. Williams himself was also practiced in genre subjects (*The Basket Weaver*) and still life, but today he is best known for his stereo-daguerreotypes of the Crystal Palace.

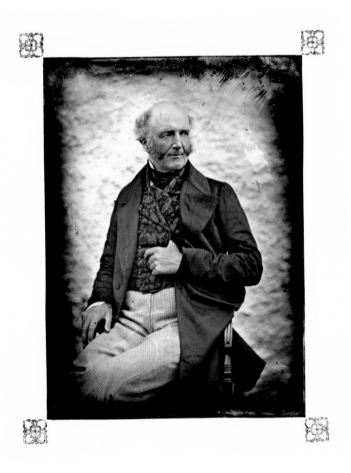

Do you know anything about that wonderful invention of the day,
called the Daguerrotype [sic]? Think of a man sitting down in the sun
and leaving his facsimile in all its full completion of outline and shadow,
stedfast on a plate, at the end of a minute and a half! The Mesmeric disembodiment
of spirits strikes one as a degree less marvellous. . . . It is not merely the
likeness which is precious in such cases—but the association and the sense of
nearness involved in the thing . . . the fact of the very shadow of the
person lying there fixed for ever! It is the very sanctification of portraits.

Elizabeth Barrett to Mary Russell Mitford, 1843

HORATIO ROSS, *Self-Portrait*, ca. 1850, daguerreotype, 9.5 x 7.0 cm, VA

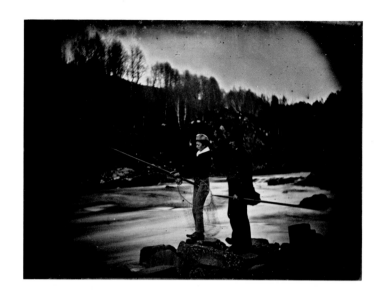

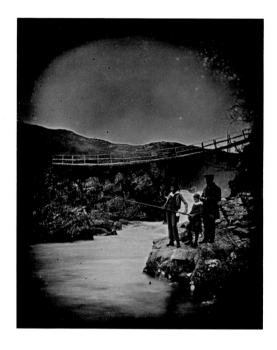

HORATIO ROSS, *Hoddy [Horatio Ross, Jr.] and John Munro Fishing at Flaipool*, 1847, daguerreotype, 6.9 x 9.4 cm, VA (top)

HORATIO ROSS, *Horatio and Colin Ross and Old David Dear Fishing at the Falls of Rossie*, April 1848, daguerreotype, 8.2 x 6.8 cm, VA (bottom left)

26 HORATIO ROSS, *Craigdarcort*, ca. 1850, daguerreotype, 8.2 x 6.9 cm, VA (bottom right)

HORATIO ROSS, *Portrait of a Lady*, ca. 1850, daguerreotype, 9.5 x 7 cm, VA (left)

HORATIO ROSS, *Hercules Ross, Balfour*, January 1850, daguerreotype, 5.8 x 4.6 cm, VA (top right)

27 HORATIO ROSS, *Portrait of a Lady*, ca. 1850, daguerreotype, 8.8 x 6.3 cm, VA (bottom right)

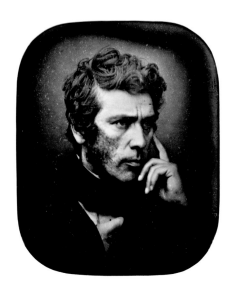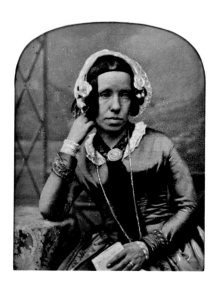

ANTOINE CLAUDET, *Andrew Pritchard*, 18 July 1843, daguerreotype, 6.6 x 5.7 cm, VA
ANTOINE CLAUDET, *Mrs. Andrew Pritchard*, 23 September 1847, daguerreotype, 6.7 x 5.7 cm, VA

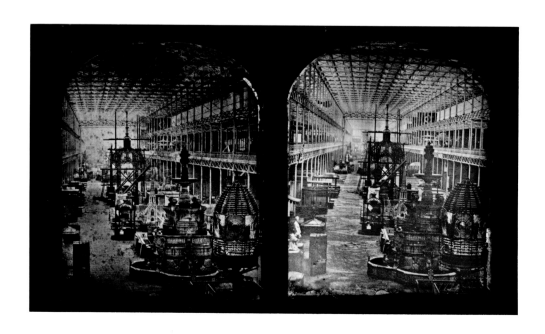

28 Attributed to T. R. WILLIAMS, *The Crystal Palace*, 1851, daguerreotype, 8.2 x 17.1 cm, VA (bottom)

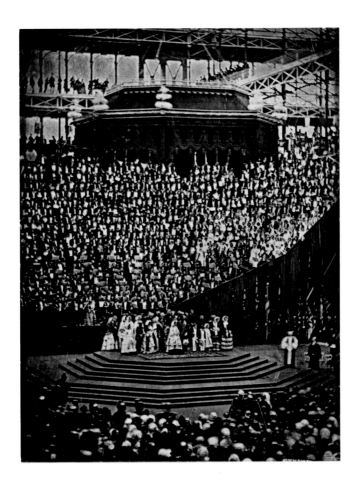

The self-delineated landscape is seized at one epoch of time, and is embalmed amid
all the co-existing events of the social and physical world. If the sun shines, his rays throw
their gilding upon the picture. If rain falls, the earth and the trees glisten with its reflections.
If the wind blows, we see in the partially obliterated foliage the extent of its agitation. The objects
of still life, too, give animation to the scene. The streets display their stationary chariots,
the esplanade its military array, and the market-place its colloquial groups—while the fields
are studded with the various forms and attitudes of animal life. Thus are the incidents
of time and the forms of space simultaneously recorded; and every picture
becomes an authentic chapter in the history of the world.

Edinburgh Review, January 1843

2. The Calotype Era

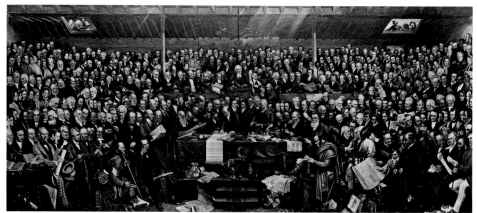

While the daguerreotype portrait entered nearly every household in Britain in the 1840s to mid-1850s, the paper photograph, perfected by its inventor, William Henry Fox Talbot, enjoyed a fitful life, known to relatively few outside his circle. Spurred to bring his creation before the public by the 7 January 1839 announcement of the daguerreotype, Talbot exhibited the earliest form of his invention, which he called "photogenic drawing," in January 1839. The most notable feature of his process was the reversed image, which showed the shadows light and the highlights dark. Termed by Sir John Herschel the *negative,* this feature led to the development of photography as a medium of multiple production of positive prints, thereby giving it an intimate kinship with the graphic arts. In the autumn of 1840 Talbot discovered by accident that his negatives stored information from the subject in latent form, which could be made visible by chemical development. This important refinement, patented as the "calotype" in 1841, reduced exposure times and made Talbot's method more commercially viable. In his own best-known commercial venture, *The Pencil of Nature,* published in six installments beginning in 1844, Talbot linked the meticulous realism of his medium to Dutch painting of the seventeenth century.

Aside from Talbot and his associates, among them Calvert Richard Jones and John Dillwyn Llewelyn, the most ambitious use of his process occurred in Edinburgh. There David Octavius Hill and Robert Adamson established a prototype of the modern portrait studio. Hill and Adamson's collaboration began as the result of a tumultuous moment in Scottish history. On 23 May 1843, 396 ministers and professors of the Church of Scotland publicly signed an Act of Separation and deed of demission, which signified their secession from the church. Hill, an established Edinburgh painter, received the commission to commemorate the event, and Sir David Brewster, in the interests of promoting his friend Talbot's method in Scotland, suggested Hill use calotypes as his preliminary cartoons. In *The Disruption,* as the schism of May 1843 came to be called, Hill painted many of the foreground details in the style of Sir David Wilkie and of the Dutch school. The figures seen in the skylights are painted in a looser style, which indicates aerial perspective and the illumination of daylight, closer to the style of the calotypes. The calotypes were the first portraits of the leading characters in a contemporary event, and both painting and photographs have a realism that matched the urgent historical significance of the subject. The copy of the painting illustrated here once hung, like many hundreds of other copies, in a Scottish manse.

Like the daguerreotype the calotype ultimately gave way to newer processes—and to a modern sensibility that favored crisp technique over the soft tones and luxuriant chiaroscuro of the paper negative. During the 1920s, when the harsh Neue Sachlichkeit style of portraiture prevailed in Europe, the art historian Heinrich Schwartz discovered an equally serious realism, more delicately presented, in the portraits of Hill and Adamson (which he credited to David Octavius Hill alone). Convinced that Hill's calotype style was informed by his knowledge of mezzotints, Schwartz wrote of the myriad textures the photographer had coaxed from his medium: "black lace gloves cover fine, intellectual hands; lace collars of dazzling white are spread over black silk, or frame a shadowed countenance; a gossamer lace nestles into the lines and folds of a sharp crinoline" (*David Octavius Hill: Master of Photography,* trans. Helene E. Fraenkel, 1932, p. 39). This subtle modulation of light, which preserved mystery even as it defined forms and textures, is the signature of the calotype era.

DAVID OCTAVIUS HILL (1802–1870)
ROBERT ADAMSON (1821–1848)
In 1841 Sir David Brewster (1781–1868), a physicist and friend of Fox Talbot's, introduced the calotype to Scotland, with the collaboration of Dr. John Adamson (1810–1870). Brewster, who probably knew David Octavius Hill through the latter's position as secretary of the Royal Scottish Academy, wanted to illustrate that calotype portraits could help him achieve likenesses for his painting of the Disruption. Hill visited the calotype studio of Robert Adamson, younger brother of John Adamson, at Rock House, Edinburgh, in June 1843. One month later the two began a partnership that would last from 1843 to 1847.

By February 1844 Hill had moved his studio from Inverleith Row into Rock House with Adamson. Hill—who was well established in Scottish society and more familiar with the practical aspects of business—wanted to publish calotypes in bound volumes, a project that was never realized. The year 1845 was nonetheless a productive one for the pair. They exhibited ten calotypes at the Royal Scottish Academy and took photographs to commemorate the completion of the Sir Walter Scott monument. In 1846 Hill again tried a publishing project, but by the summer the volume of work produced by the partnership had declined, perhaps because of Adamson's ill health. He died in January 1848.

Hill wanted to market the prints left in stock; at the Great Exhibition of 1851 his calotypes were offered for sale at five shillings each. The venture was not successful and Hill was deeply disappointed that the jurors awarded the partnership only an honorable mention. In 1856 Hill helped found the Photographic Society of Scotland and showed seventy-seven calotypes in its first exhibition. Five years later he formed a partnership with Alexander Macglashon, an engraver and printer, but their work as published in *Some Contributions towards the Use of Photography as an Art* never equaled Hill and Adamson's. In 1866 Hill completed his painting of the Disruption begun twenty-three years before. He died of rheumatic fever in 1870.

CALVERT RICHARD JONES (1804–1877)

Calvert Jones was born into a wealthy family in Swansea, south Wales. He was educated at Oriel College, Oxford, took holy orders, and in 1829 became rector of Loughan. Jones was in addition an able mathematician, musician, marine painter, and enthusiastic practitioner of Talbot's "photogenic drawing" calotype process, to which he had been introduced by Christopher Rice Mansell Talbot, a cousin of Talbot's.

In December 1845 Jones began an extended tour of Malta and Italy. On his return to England in July 1846 Jones sent Talbot twenty-two small calotypes and 102 larger ones made during his tour; Talbot agreed to sell them on commission. Because they were often produced by a single printer, Jones's pictures have at times been mistaken as work by Talbot or other colleagues. Yet his photographs are usually easy to identify, not only by their illusionistic depth but by an accidental circumstance as well: his negatives generally have a strip along the edge

caused by a peculiarity in the plate holder of his camera.

In 1847 Jones inherited the family estate, Heathfield House. Although Jones had continued to travel and photograph in the late 1840s, and had subsequently become one of the first members of the council of the Photographic Society of London, by the late 1850s his membership had lapsed and Jones had disappeared from photography.

WILLIAM HENRY FOX TALBOT (1800–1877)

William Henry Fox Talbot was born in Melbury, Dorset. His father was the Reverend William Davenport Talbot, and his mother second daughter of the Earl of Ilchester, Lady Elizabeth Fox-Strangways. Throughout his education at Harrow and Trinity College, Cambridge, Talbot was a brilliant student, with intellectual interests ranging from etymology, mathematics, crystallography, and astronomy to botany and chemistry, the last of which led him to the invention of the photographic process still in use today. Talbot was elected to the Royal Society in 1831 and met other notable scientists including Sir David Brewster and Sir John Herschel. His *Researches in the Integral Calculus* of 1836 earned him the Royal Society's medal in mathematics.

Like others before him, Talbot realized the potential for fixing the reverse image projected by the camera lucida. He began experimenting with salt and silver nitrate and by 1835 had managed to stabilize camera lucida images on light-sensitive paper. On 25 January 1839 he showed these "photogenic drawings" at the Royal Institution and a week later delivered "Some Account of the Art of Photogenic Drawing" to members of the Royal Society.

During the winter of 1843–44 Talbot opened a printing works, the Reading Establishment. The first project, John Walter's *Record of the Deathbed of C.M.W.*, featured as its frontispiece the first photograph used in a printed publication. *The Pencil of Nature* followed in six installments beginning in June 1844. Talbot then made a working tour of Scotland, and in 1844–45 published a portfolio

of twenty-three *Sun Pictures of Scotland*. Talbot also made a photographic tour, with Calvert Jones and Nicholas Henneman, of York, Bristol, and Devon. In 1846 he traveled to the Rhine Valley and Switzerland and on his return made Henneman responsible for Sun Picture Rooms, his studio in Regent Street, London. Henneman and his partner bought the business from Talbot in 1848.

During the 1850s Talbot vigorously enforced infringements of his patent. In 1854, in *Talbot* v. *Laroche*, it was decided that Talbot was indeed the inventor of the negative/positive process, but that the wet collodion process discovered by Frederick Scott Archer was not covered by the calotype patent. In 1855 Talbot received the Grand Medal of Honor from the Exposition Universelle in Paris for his contributions to photography. His photographic engraving process was awarded a prize at the Berlin photographic exhibition in 1865, but Talbot had for the most part withdrawn from photography by that time to devote himself to mathematical theory. He was made an honorary member of the Photographic Society in 1873 and before his death in 1877 had begun an appendix to George Tissandier's *History and Handbook of Photography*.

JOHN WHISTLER (1830–1897)

John Whistler lived in the village of Sherborne St. John, Hampshire. He was a successful builder and decorator, and a man of property. During the 1850s Whistler was an amateur photographer, as evidenced by salted paper prints surviving from that period. An album belonging to William A. Tollemache and another belonging to James C. Hook, the brother-in-law of F. R. Pickersgill (1820–1900), included Whistler photographs. In the 1870s and 1880s Whistler's building business prospered. He documented his restoration of the village church spire in 1885 and the construction of many houses in the area. His grandsons Rex and Laurence Whistler both became well-known artists.

The Circle of
William Henry Fox Talbot

Carolyn Bloore

By the public these "sun pictures" are still misapprehended—still "misnomered"; we shall accordingly, in this notice, show what they are not, and endeavour to explain what they are, as it is yet far from generally accepted that they are the result of the action of light alone, and are not reproduced by some leger-de-main of Art.[1]

This notice, published in *The Art Union* of June 1846 with an explanation of the calotype process and accompanied by an original photographic print, was one of William Henry Fox Talbot's several attempts to bring his invention of 1835 to the attention of the public. When Talbot first exhibited his photogenic drawings and positive copies of engravings in January 1839, they were generally considered to be produced by some form of watercolor washing or "some modification of lithography" or, more probably, of the mezzotint process.[2] Seven years later these beliefs were still extensively held. After taking out calotype patents in 1841 and 1843 and issuing professional and amateur licenses for his process, Talbot had set up the first photographic printing establishment at Reading, where his photographs were printed for the first commercially published book with photographic illustrations, *The Pencil of Nature.* Yet outside his own learned circle, Talbot received little recognition, and, unlike the French inventor of photography, Louis Jacques Mandé Daguerre, received no pension or any public honor for his achievement. In 1846 the calotype process, the basis of modern photography, was still relatively unknown, even by Talbot's fellow countrymen.

Most of Talbot's business contacts remained little more than acquaintances. Scientific colleagues curious about the new art of photography, fellow members of learned societies—in particular the Royal Society, the Royal Institution, and the Astronomical Society—corresponded with him about his process. Immediately after Talbot announced his photographic invention in January 1839, Sir John Herschel began independent experiments and was generous in sharing his discoveries with Talbot, including the use of "hypo" (sodium thiosulfate) as a fixing agent. Sir David Brewster was probably Talbot's closest professional colleague. As early as February 1839 Brewster advised Talbot: "You ought to keep it perfectly secret until you cannot advance further in the matter and then it would be advisable to secure your rights by

patent. I do not see why a gentleman with an independent fortune should scruple to accept benefit he has deserved from his own genius."[3] Nevertheless he also suggested that it was unnecessary for Talbot to patent his process in Scotland, and Talbot apparently heeded his advice: the calotype was never patented in Scotland. Although Talbot's scientific colleagues were instrumental in promoting photography, they generally had a greater personal interest in the theory of photography than in its practice. Apart from the few professional calotypists, those of Talbot's circle who were concerned with making photographic images, rather than making scientific experiments, were known to him through his family.

Talbot's regular correspondence with his relations and his habit of enclosing "specimens of photography" are important aspects of his association with these photographers. His south Wales cousins in particular shared their knowledge of his invention with their close friends and neighbors. Those most closely associated are Christopher (Kit) Rice Mansell Talbot, Emma (née Talbot) and her husband John Dillwyn Llewelyn, and Calvert Richard Jones. (The Jones, Llewelyn, and Talbot families owned neighboring country estates.)

The level of interest and excitement created among these relations by Talbot's new art is suggested by a letter to Talbot from another of his south Wales cousins, Charlotte Traherne:

John Llewelyn has been making some paper according to your process and they have all been trying little scraps of paper and succeeding very well before breakfast but the day is clouding over. Mr. Calvert Jones is quite wild about it. John Llewelyn's paper turns browner than your piece, not so dark. We put a piece in the camera obscura but only got a faint outline or rather shadowing of the trees, but the sun was not so strong or steady.[4]

A few photographers outside of Talbot's circle were as important as his friends. During the 1840s the most influential of these was the scientist Robert Hunt. A member of the Royal Society and an independent experimenter, Hunt wrote the first treatise on photography in 1841. About the same time he became estranged from Talbot, perhaps in response to Talbot's patenting his work, and throughout the rest of the decade derided Talbot's photographic work and complained about his calotype patents.

Peter Wickens Fry, a lawyer responsible for the formation of the Photographic Club, or Calotype Society, in 1847, also opposed the patents.[5]

Throughout the 1840s Talbot strove to obtain recognition, but he had little success in marketing his process. He did not publish a manual to instruct new calotypists, for example, although even those who had received reliable practical instruction had problems with his process. Added to the publicity and practical problems was the competition from the daguerreotype and its promoters. Photography had its greatest popular appeal in portraiture, and as early as 1842 the daguerreotype had captured this market, partly as a result of the efforts of the highly successful entrepreneur Richard Beard, who had purchased the daguerreotype rights for England, Wales, and the colonies, and partly because public taste favored the intimate detail of the daguerreotype over the broad chiaroscuro of the paper print.

In 1841, the year in which Richard Beard and Antoine Claudet set up daguerreotype studios in London, Talbot began a business relationship with a miniature painter, Henry Collen. Talbot licensed Collen as a calotype portraitist in August, and Collen agreed to pay Talbot 30 percent of his takings.[6] But at a time when the daguerreotype studios of Beard and Claudet took in £60 a day,[7] the first yearly return to Talbot from Collen was only £70 2s. 9d. While protecting Collen's license, Talbot also proposed that Richard Beard should act as his agent in the same way in which he acted for the daguerreotype. Regrettably, agreement was not reached, and Talbot, never astute at business and heavily committed elsewhere, failed on more than one occasion to follow up promising inquiries from potential licensees.

With the termination of Collen's license in 1844, Talbot sold an exclusive calotype license to Antoine Claudet. Unlike Collen, who by his own admission needed "sufficient explanation of both theory and practice" in photography, Claudet already possessed the necessary photographic skills and expertise, and his own daguerreotype business was highly successful. Despite his skills, his friendship with Talbot, and his regular publicizing of "The Talbotype," however, he failed to make a commercial success of calotype portraiture.[8]

Whatever its professional standing, the calotype process did appeal to amateurs. Like Talbot, the photographic amateur of the 1840s was educated and had sufficient means and time to experiment with the new art. Furthermore amateur calotypists were only minimally restricted by Talbot's patent; from July 1846 a calotype license "for amusement only" cost 1 guinea, and Talbot's own Reading Establishment issued free licenses with orders in excess of 3 guineas for iodized paper.[9] In view of this and the fact that amateur daguerreotype licenses cost 5 guineas,[10] it seems odd that calotype patents caused such conflict in England.

During the first years of the 1850s Talbot's attempt to protect his patent rights led to a series of court cases. After a major case in December 1854,[11] he decided to relinquish all rights on the process. Correspondence at the time of these trials indicates a division of attitude toward Talbot's patents even within his circle.

Claudet, witness for Talbot in the December trial, wrote in 1855 that "Mr. Talbot, like many other great men, has been shamefully and ungratefully treated by his countrymen and his age, and I have been happy to have been able to raise my voice, as feeble as it is, in endeavouring to support his noble and just cause."[12] In contrast, Llewelyn put forward a different point of view, in a letter to Fry: "I heartily grieve to hear of his present litigations—his first step to ensure himself an exclusive monopoly was a most unadvised one—it had put him in a false position and must terminate in an abundant harvest of trouble and loss. It seems however to be with him some kind of monomania—he must be a little insane on that point."[13] Apart from such isolated "insanity," Talbot was apparently a kind and responsible squire, sincerely attached to his family and committed to his friends. He took pains to reply to the many queries he received about his scientific research, particularly photography.

Talbot's *Pencil of Nature* appeared in six parts, the first installment in June 1844 with a note from Talbot expressing the wish that other British photographers would "come forward and assist the enterprise,"[14] although he made little use of the offers for assistance he received. The second section appeared in January 1845, and the following month Jones wrote that he and Llewelyn were "going to try to do some Marine Talbotypes in the Port of Swansea which we hope will perhaps be acceptable for the Pencil Nature."[15] Both specialized in "Marine Talbotypes." Llewelyn preferred the rocky shoreline of the Gower Peninsula and in the 1850s succeeded in capturing breaking waves and foaming sea in a series of "instantaneous pictures." Jones featured mainly harbors and estuaries with a profusion of beached boats, but also photographed a few details, such as a series of pulleys, coils of rope, and anchors, perhaps intended as studies for his marine paintings.

Striving to match Talbot's high standards, Jones and Llewelyn experienced numerous technical difficulties during 1845. In a letter to Talbot of 15 February, Jones remarked that his iodized paper was "in general without sufficient range in that gamut of Chiaroscuro"[16] and that the white part began to discolor before the blacks had darkened. Members of Talbot's circle kept Talbot informed of any experiments or accidents. In the same letter, Jones wrote: "I have mislaid a positive picture which I had wished to send to you: it was thus produced, happening to drop a little wax from a candle on a proof which had come out very weak after the Gallic acid wash, I laid it face upwards on a table in the sun, and soon after taking it up I found a positive picture on the underside."

At the end of the year Jones described a visit to the French inventor of positive photographic prints, Hippolyte Bayard, which he knew would be of special interest to Talbot:

I wrote in such haste last week that I forgot to tell you that when in Paris I went to see M. Bayard, who is succeeding very fairly in negative photography, and also in the copies. His system is of course a secret, but he told me it was much more simple and easy of manipulation than yours, this however is nothing to

the purpose which I meant to tell you and that is respecting his paper, which comes out very even and without spots; he was kind enough to give me a few sheets for you.[17]

And in a subsequent letter Jones described a useful technique:

M. Bayard wets his paper in the camera by having a flat pan containing the liquid and putting one side of the paper on it, after which he hangs the paper by one corner and lets the superfluous moisture flow back into the pan. I wish we could apply this or some other means, in order to obviate the cockling of the paper which must in some degree occur when we use brushes.[18]

From 1845 to 1847 Jones was probably the most influential member of Talbot's circle, maintaining a frequent correspondence with Talbot, supplemented by several meetings. Jones sympathized with Talbot's efforts to publicize and sell photographic prints, and to demonstrate the advantages of photographically illustrated books. Jones even suggested a far-sighted scheme of his own: regarding the tour of Germany that Queen Victoria and Prince Albert were to make in the autumn of 1845, he wrote, "It strikes me that a series of views following the Queen's steps would be a taking form of work just at present, but perhaps it would be too extensive a plan."[19]

During 1846 and 1847 Jones also made practical suggestions for selling photographs. One of these was an improvement to the appearance of the mounts and another, a technique of applying varnish to photographic prints. With the help of "Mr. Newton" of Winsor and Newton, the art material suppliers, he carried out several experiments, but disliked the sheen he achieved, writing that "by diluting the varnish it may be less shiny, though I don't know whether this is any advantage."[20] Photographic prints suffered from fading, especially in printsellers' windows, and here Jones was probably more concerned with the preservative potential of varnish than with its artistic effects. On another occasion he was unimpressed by Talbot's intention to employ an artist to "finish" the photographic prints: "I think it is a pity 'to gild refined gold, to paint the lily' which you have raised to such a state of perfection."[21]

In view of Jones's reluctance to retouch photographs, it is surprising that he entered enthusiastically into the hand coloring of photographic prints in 1846. In common with Robert Hunt, Jones must have considered that photographic prints, like other print processes of the time, lent themselves to the addition of color. Hunt publicly expressed this opinion in *The Art Union* in 1848, and in a footnote drew attention to Jones's work.[22] For his own part Jones described hand coloring as requiring "a great deal of trouble and artistic knowledge," but in the same letter he told Talbot: "I find I can improve continuously in the treatment of them and think they are capable and worthy of much art being expended in them, particularly if we could do them in a larger size."[23] The colored prints were put on view in the summer of 1847 at Talbot's newly opened studio, the Sun Picture Rooms in Regent Street.

Jones had cautiously endorsed Talbot's plans for a photographic portrait establishment, which Talbot had considered at least since the spring of 1846 and perhaps from late 1845, when Claudet admitted his failure. In June 1846 Jones wrote to Talbot, "A photographic portrait establishment would undoubtedly answer admirably in London provided that they would be done quick enough, which at present I rather doubt."[24] Nicholas Henneman, Talbot's former valet and between 1843 and 1847 manager of

John Dillwyn Llewelyn, *Caswell Bay*, ca. 1852, private collection, courtesy Richard Morris

Talbot's photographic establishment at Reading, on Talbot's suggestion opened a calotype portrait studio in Regent Street, London, in 1847. The following year he took over the Sun Picture Rooms studio in partnership with another former employee, Thomas Malone. The establishment was not confined to portraiture: Henneman announced, "Artists have visited and are still visiting every place of note in the United Kingdom, France, Italy, Malta, etc."[25]

The British photographs were made largely by Talbot himself with contributions from Henneman and Jones. Talbot was also responsible for the French views, but the Italian and Maltese views were made predominantly by Jones, who supplied several hundred negatives, over 100 of Malta, between the summer of 1845 and the autumn of 1847. About half the Maltese negatives were approximately whole-plate in size; the rest were considerably smaller, about 3 x 4 inches. The most-copied negatives are well-composed tourist scenes, readily recognizable as prototypes of the photographic postcard. Typically they include the harbor and the town of Valletta from an elevated viewpoint, the beach with distant seated figures and background cliffs, and street scenes.

Nine of the large Malta views were chosen to be printed and mounted at Reading, and a bill of April 1846 indicates that 500 labels of a *View in Malta* had been ordered.[26] It may therefore be assumed that the prints sold well or were expected to do so. In Naples Jones made the first of two panel panoramas, which may be the earliest example of this application of photography.

Jones made his winter tour in the company of his wife and his friends, Kit and Charlotte Talbot. The tour had been undertaken primarily to improve Charlotte's ailing health. Kit managed to take a number of photographs, which he dutifully forwarded to Talbot, but it is unlikely that his views would have been considered salable; technically and artistically they were inferior to Jones's photographs (although they have been considered experimental work by Jones). By his own admission Kit Talbot experienced a great many failures in photography, but Henneman's staff probably printed his negatives. He wrote to Talbot from Naples in May 1846, after the death of his wife: "Still I would like to see a few of my [negatives] reversed for this will serve to remind me of scenes connected with a portion of my existence which, however painful, I would not forget."[27]

Charlotte's death cut short the party's tour of the Mediterranean and prevented a proposed visit to Egypt, and Talbot was forced to look elsewhere for a photographer to make views of more distant countries. In January 1846 the Reverend George Bridges, whom Talbot had met through his half sister Caroline Mount Edgecumb,[28] had stayed with the Talbot family at Lacock. In addition to photography, the two men shared common interests in botany and antiquities. Soon after this visit, Bridges left for Malta, the first destination in a prolonged tour of Malta, Sicily, Italy, Greece, Egypt, and the Holy Land. There, through Talbot, he met Jones and the Talbots. Charlotte Talbot died in March, soon after his arrival, and almost immediately Bridges wrote to Talbot offering to continue Jones's photographic work. While he remained in Malta, Jones gave Bridges "every instruction" in photography.[29] During the first few months Bridges had numerous difficulties. Like Jones, he experienced delays in the shipment of paper and chemicals from England. Chemical proportions and exposure time were also problematic, but most frustrating was his inability to produce "good copies" from his negatives, problems shared by calotypists in England. Also like Jones, Bridges frequently had to seek Talbot's advice, and he adhered to the chemicals and techniques Talbot recommended. In addition, both Bridges and Jones sent many of their negatives to Reading to be printed. Because negatives by Talbot, Jones, and Bridges were frequently printed in the same place, on the same paper, and under Henneman's supervision, the prints are consistent in quality. Furthermore, Talbot probably had sole control over the choice of negatives.

The tourist views printed from negatives by Jones and Bridges have many similarities, but Jones invariably achieved an impression of depth and made use of standard artistic devices, such as the inclusion of a darker foreground object or figure, diagonal elements, and contrast. Bridges's early work suggests that he was unfamiliar with traditional compositions and light effects. Many of his negatives from 1846 and 1847 have few points of reference to indicate recession. For example, in *Taormina*, Bridges found

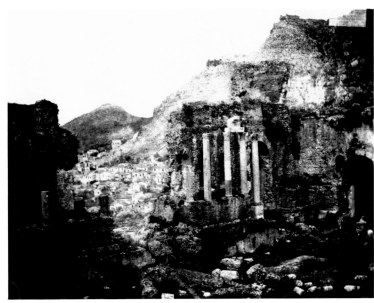

George Bridges, *Taormina*, 1847, Kodak Museum, London

it necessary to apply ink washes to the negative to differentiate between the ruined walls and the town on the hillside glimpsed through them.

By 1852, when Bridges returned to England, Talbot was no longer concerned with printing views. During his absence of nearly seven years, Bridges had made "seventeen hundred genuine photographs."[30] He hoped to sell some of his work, even though, by his own admission, his portfolio excelled "perhaps in number but not in works creditable to the art itself."[31] With Jones's encouragement he printed many of his photographs and made at least two attempts to publish his views. He made a prototype for *Illustrations of the Acropolis of Athens* and advertised *Palestine As It Is: A Series of Photographic Views Illustrating the Bible.* Neither work appears to have been published and it is doubtful that Bridges made any financial gain from his photography.

Bridges's greatest contribution to the popularization of the calotype was his role in introducing the process to America. In 1846 Bridges, concerned by the lack of enthusiasm for the calotype, interested a fellow traveler, the American R. K. Haight, in the process. Bridges introduced Haight to Talbot by letter from Paris, and although Haight did not take up the process himself, he recommended a fellow countryman, E. Anthony.[32] Negotiations began and in June 1847 Talbot took out a United States patent on his process. Anthony offered to act as license agent for 20 percent of the proceeds, but, as with Beard, agreement was never reached.[33] The calotype remained unexploited in America until 1849, when the Langenheim Brothers offered to act as agents for the process, paying Talbot 25 percent return. In April 1849 William Langenheim visited Talbot at Lacock and agreed to pay £1,000 for the United States patent rights. The Langenheims,

like Claudet, were successful daguerreotypists, but, since the daguerreotype was not protected by patent in the United States, their attempt to sell calotype licenses was a failure, and they never paid the remainder of the agreed-upon sum.

None of Talbot's circle gained financially from the calotype process, and Talbot himself lost heavily from his "photographic enterprise," spending over £5,000 on photography, of which he probably recovered less than half.[34]

By the early 1850s Talbot stopped making calotype experiments, turning his attention instead to the protection of his patents. Most members of his circle continued to photograph into the 1850s, and several were involved with the Photographic Society of London (after 1894 the Royal Photographic Society of Great Britain), which was inaugurated in January 1853. Jones, Bridges, and Llewelyn were all founding members, along with Hunt and Fry. Talbot had been offered the first presidency of the society but had declined the position. Specimens of his research, "photoglyphic" engravings, were exhibited at its fifth meeting, in 1853.[35] Talbot had invented the photographic screen—the method by which ink could be successfully held in the darker areas of the image—the basis for modern photome-

chanical reproduction. Photoglyphic engravings resemble other inked prints, notably mezzotints and lithographs, the print processes with which Talbot's calotypes had been confused a decade earlier. Talbot sent specimens of photoglyphic engravings to many old friends, including Brewster, Claudet, and Herschel, and even to Robert Hunt. A new acquaintance, Roger Fenton, already recognized, like Talbot, the need for a permanent photographic print that was not subject to fading and that would be "no slower or more difficult" than making impressions from engravings.[36] And he was optimistic that Talbot's far-sighted achievement in inventing a negative/positive process might be repeated in photomechanical reproduction: "I hope that the honour of finally solving this question will by your researches be won for this country. It would be rare good fortune for the same to have commenced and completed the structure of photographic art." Regrettably, Talbot's lack of business acumen prevented him from acquiring this distinction—photogravure was not invented until 1879, by Karl Klič—but his small circle contributed not only many fine photographs, but also a level of high standards in craftsmanship for the fledging art.

NOTES

1. In "The Application of the Talbotype," *The Art Union* 8 (1 June 1846): 143. 2. Ibid. 3. Brewster to Talbot, 28 February 1839, Lacock Abbey Collection, LA 39–7. 4. Traherne to Talbot, 28 February 1839, Lacock Abbey Collection, LA 39–16. 5. "The Calotype Society," *The Athenaeum* 1054 (18 December 1847): 1304. 6. Talbot's business activities have been well documented by H. J. P. Arnold, *William Henry Fox Talbot: Pioneer of Photography and Man of Science* (London, 1977), p. 139. Arnold assumes an initial payment to Talbot of 30 percent and later of 25 percent. 7. Gandin and N. M. P. Lerebours, *Derniers perfectionnements apportés au daguerreotype* (Paris: Lemercier, 1841), p. 43. 8. Arnold, *William Henry Fox Talbot*, p. 140. 9. Leaflet dated 22 July 1846, Lacock Abbey Collection, LA 46–84. 10. Helmut and Alison Gernsheim, *The History of Photography* (London: Thames and Hudson, 1969), p. 88. 11. The *Talbot* v. *Laroche* trial took place 18–20 December 1854. Proceedings had started in June 1854. The main witness against Talbot was Robert Hunt. Witnesses for him included Antoine Claudet, Humphrey Davy, William Crookes, and Neville Story-Maskelyne. 12. Claudet to Price and Burton, 27 November 1855, cited in *W. H. F. Talbot Scientist Photographer Classical Scholar 1800–1877* (Lacock, 1977). 13. Llewelyn to Fry, 6 July 1854, Sotheby's, Belgravia, 14 March 1979. 14. Talbot to the editor of the *Literary Gazette*, 23 June 1854, Gernsheim Collection, cited in H. and A. Gernsheim, *History of Photography*, p. 126. 15. Jones to Talbot, 15 February 1845, Lacock Abbey Collection, LA 45–22. 16. Ibid. 17. Jones to Talbot, 1 December 1845, Lacock

Abbey Collection, LA 45–154. 18. Jones to Talbot, 21 December 1845, Lacock Abbey Collection, LA 45–177. 19. Jones to Talbot, 25 August 1845, Lacock Abbey Collection, LA 45–118. 20. Jones to Talbot, 5 October 1845, Lacock Abbey Collection, LA 45–134. 21. Ibid. 22. Robert Hunt, "The Application of Science: Photography," *The Art Union*, 1 May 1848: 136. 23. Jones to Talbot, 20 March 1847, Lacock Abbey Collection, LA 47–37. 24. Jones to Talbot, 14 June 1846, Lacock Abbey Collection, LA 46–78. 25. Henneman to Talbot on opening of Sun Picture Rooms, Lacock Abbey Collection, LA 47–2. 26. Invoice J. S. H. Cox, Lacock Abbey Collection, LA 46–7. 27. Kit Talbot to Talbot, 9 May 1846, Lacock Abbey Collection, LA 46–57. 28. Arnold, *William Henry Fox Talbot*, p. 150. 29. Jones to Talbot, 15 March 1846, Lacock Abbey Collection, LA 46–40. 30. *The Illustration of the Acropolis of Athens*, "a folio of thirty photographs, from the series Selection from Seventeen Hundred Genuine Photographs (Views–Portraits–Statuary–Antiquities) Taken around the Shores of the Mediterranean between the Years 1846–52, with or without Notes, Historical and Descriptive, by a Wayworn Wanderer," Sotheby's, Belgravia, 1 July 1977. 31. Bridges to Talbot, 26 October 1852, Lacock Abbey Collection, LA 52–4. 32. Bridges to Talbot, 2 February 1846, Lacock Abbey Collection, LA 46–24. This letter is supported by an uncatalogued letter from Haight to Talbot, 14 March 1846, Lacock Abbey Collection. 33. Arnold, *William Henry Fox Talbot*, p. 166. 34. Ibid., p. 167. 35. *Journal of the Photographic Society* 6 (21 June 1853): 69. 36. Roger Fenton to Talbot, 4 February 1854, Lacock Abbey Collection, LA 54–7.

It is a little bit of magic realized: of natural magic. You make the powers of nature work for you, and no wonder that your work is well and quickly done. . . . But after all what is nature, but one great field of wonders past our comprehension.

William Henry Fox Talbot, *Literary Gazette,* 1839

37 WILLIAM HENRY FOX TALBOT, *Gamekeeper, Lacock Abbey,* ca. 1845, calotype, diam. 14.4 cm, SM

38 WILLIAM HENRY FOX TALBOT, *The Reverend Calvert Jones,* ca. 1845, calotype, 16.4 x 20.5 cm, SM

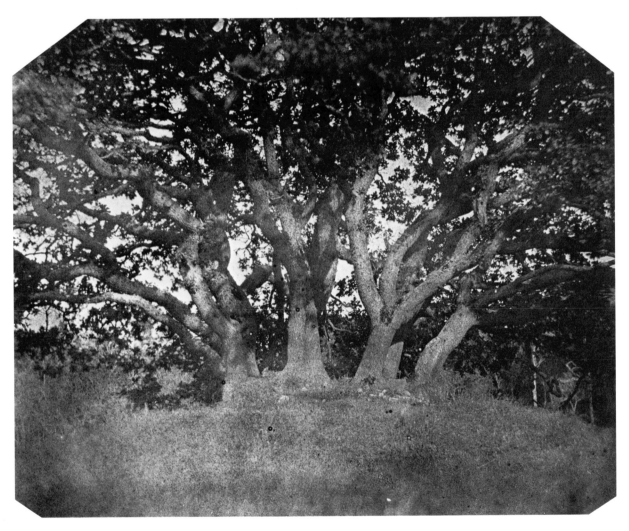

WILLIAM HENRY FOX TALBOT, *The Breakfast Table*, ca., 1840, calotype, 8.4 x 16.9 cm, SM (top)

39 WILLIAM HENRY FOX TALBOT, *Group of Trees*, 1 June 1840, calotype, 16.7 x 22 cm, SM (bottom)

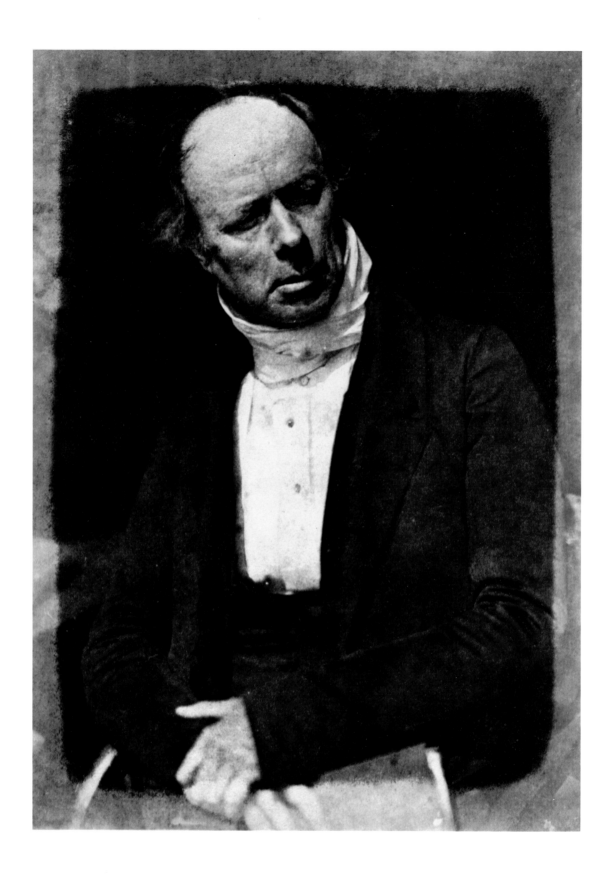

40 DAVID OCTAVIUS HILL and ROBERT ADAMSON, *The Reverend Thomas Henshaw Jones*, 1843, calotype, 21 x 15.2 cm, SNPG (VA)

41 DAVID OCTAVIUS HILL and ROBERT ADAMSON, *Lady Eastlake (née Elizabeth Rigby)*, 1843–47, calotype, 21 x 15.2 cm, SNPG (VA)

42 DAVID OCTAVIUS HILL and ROBERT ADAMSON, *Fence and Trees in Colinton Wood*, 1843–47, calotype, 21 x 15.2 cm, SNPG (VA)

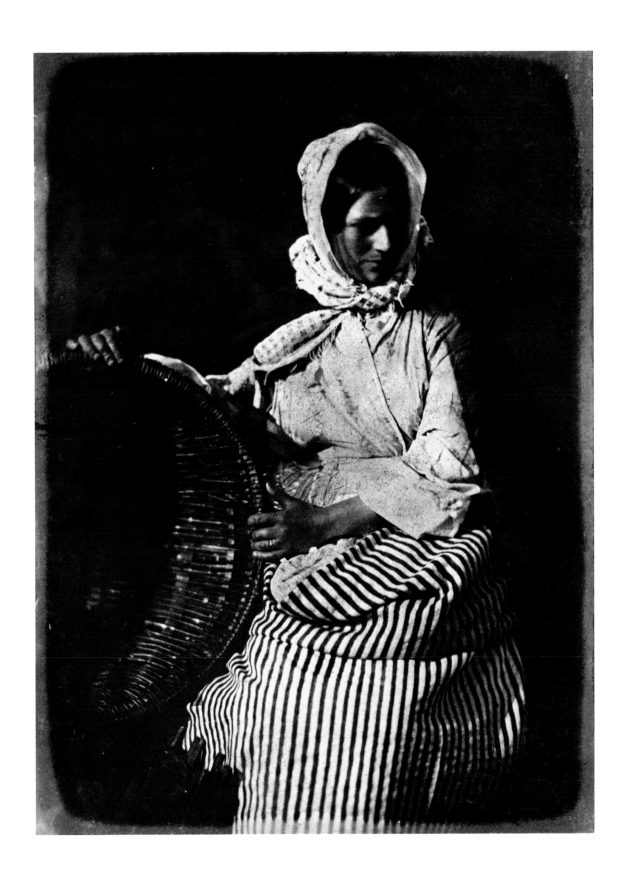

43 DAVID OCTAVIUS HILL and ROBERT ADAMSON, *Mrs. Hall, Newhaven*, 1843–47, calotype, 21 x 15.2 cm, SNPG (VA)

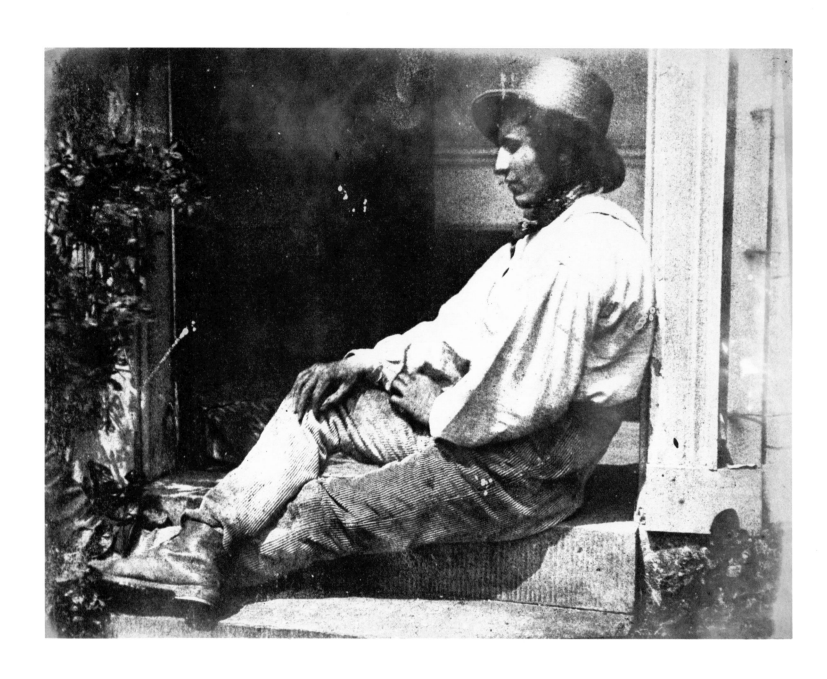

44 CALVERT RICHARD JONES, *Man Seated in Doorway*, 1843–47, calotype, 16.7 x 21.8 cm, VA

45 CALVERT RICHARD JONES, *Sailing Vessels in Harbor*, 1843–47, calotype, 17.4 x 22.5 cm, VA

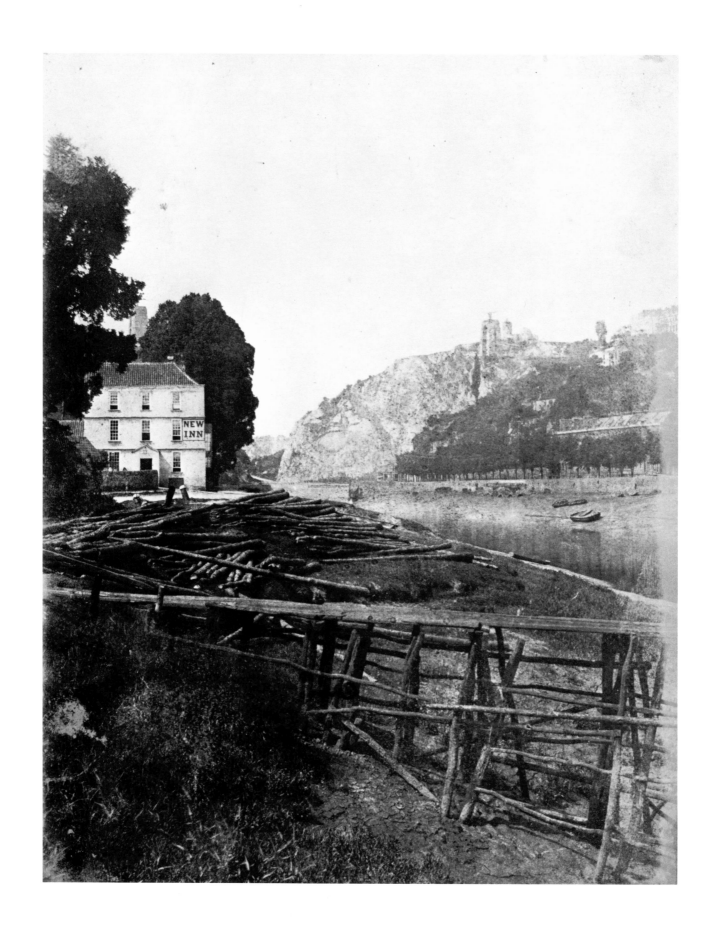

46 CALVERT RICHARD JONES, *The New Inn*, 1843–47, calotype, 21.8 x 17.3 cm, VA

47 JOHN WHISTLER, *Young Girl Standing by a Fence*, 1855–65, salted paper print, 27 x 22.4 cm, VA

3. Picturesque Britain and the Industrial Age

The public perception of photography in Britain changed decisively in 1851 and 1852. A new group of intensely serious photographers celebrated the native landscape, recorded achievements of engineering and construction, and documented a foreign war. At the time of the first substantial display of photographs at the Great Exhibition of 1851, the calotype and the daguerreotype processes were on roughly equal terms in quantity and prize medals. Most of the photographic exhibits were shown in Class X along with philosophical, musical, horological, and surgical instruments, and processes depending on their use. Photography was shown with, for example, telescopes and the latest marvel, the electric telegraph. Calotype landscapes by Samuel Buckle of Peterborough appeared in the Fine Arts section. Buckle's calotypes are typified by the view of Anne Hathaway's cottage (above), a photograph acquired by Prince Albert. The jury praised Buckle's works for "great delicacy of tint and exquisite *cleanness* of execution" and awarded him a major medal. Such pictures launched a decade in which rural and architectural subjects dominated photographic exhibitions.

The first purely photographic exhibition was arranged in 1852 by the Society of Arts in London and was subsequently shown throughout Britain. A review of this exhibition in *The Times* (31 December 1852) conveys the mood in which photography was practiced by the amateurs of the early 1850s:

Hundreds of ingenious and intelligent persons, some as amateurs, some as professional men, have eagerly and en-

thusiastically taken up a branch of study which promises so much to those who pursue it perseveringly. When the results achieved by photography in its very infancy are considered, one can hardly wonder that it has become so attractive. It secures precise and charming representations of the most distant and the most evanescent scenes—it fixes, by almost instantaneous processes, the details and character of events and places, which otherwise the great mass of mankind could never have brought home to them.

By this date the paper negative processes had begun to give ground to Frederick Scott Archer's collodion-on-glass invention (published in 1851), which dramatically cut exposure times, substantially enhanced detail, and made possible exhibition-scale prints. The subject Archer chose to demonstrate the powers of his discovery seems inevitable. He photographed the ivy-clad ruins of Kenilworth, redolent of Sir Walter Scott and earlier painted by all the masters of watercolor studies—J. M. W. Turner, Thomas Girtin, Peter De Wint, and their successors. Turner's anthology of model landscape compositions for students, the *Liber Studiorum*, was a work particularly mentioned in photographic criticism in the 1850s and became available in editions illustrating the original sketches by pho-

tographic reproductions. Writing of the *Liber Studiorum* in *Modern Painters* (vol. 4, 1856, p. 6), John Ruskin remarked that Turner "only momentarily dwells on anything else than ruin" and defined the picturesque as typified by an old cottage or mill containing "such elements of sublimity—complex light and shade, varied colour, undulatory form, and so on—as can generally be found only in noble natural objects." Photographers set up their tripods where the watercolorists had placed their easels—at Tintern Abbey, on the Usk, at Bettws-y-Coed, Burnham Beeches, and Ludlow—at every spot of Romantic enchantment or rural tranquility.

Photographers chose these traditional subjects with the conviction that their medium could master them; the new capacities of photography were thought of as superior in drawing to representation by hand. Architectural monuments and picturesque "bits" allied the complexities of masonry and nature. The railway boom of the 1840s had changed the landscape of Britain at an unprecedented pace. Centuries-old federations of villages began to solidify into modern cities. This sense of change is evoked by Anne Thackeray Ritchie, writing in 1872 (published in Winifred Gérin, *Anne T. Ritchie: A Biography*, 1971, p. 172):

In those days the hawthorn spread across the fields and market gardens that lay between Kensington and the river. Lanes ran to Chelsea, to Fulham, to North End, where Richardson once lived and wrote in his garden-house. . . . Close at hand, all around the old house were countrycorners untouched—blossoms in-

stead of bricks in springtime. . . . Sometimes in May mornings the children would gather hawthorn branches out of the lanes, and make what they liked to call garlands for themselves. . . . There was a Kensington world (I am writing of twenty years ago) somewhat apart from the big uneasy world surging beyond the turnpike—a world of neighbours bound together by the old winding streets and narrow corners in a community of venerable elm trees and traditions that are almost leveled away.

The Crystal Palace fascinated photographers because it provided a well-lit interior for their work, as well as a monumental symbol of Britain's leading role in world affairs and manufactures, but at this period their exhibitions scarcely acknowledged the large environmental changes that were leveling elm trees and traditions. Exhibition photography was linked with recreation, and summer provided a recognized season for photographic expeditions. The notion of photography as a spontaneous reproduction of reality, and its relationship to the sun as the direct means of printing the picture, may have a great deal to do with the choice of subject matter in the exploratory period of the amateurs. The early devotees of the "beautiful art of photography," as it was so frequently called, reserved their art for those canonically beautiful objects fit for a perfect mirror image.

ROGER FENTON (1819–1869)

Roger Fenton is perhaps best known for his series of photographs taken in the field during the Crimean War, but these represent only a small part of his output. He was born in Lancashire, the son of a banking family. In 1838 he went to University College, London, where he completed a Bachelor of Arts degree. After a period spent studying art

he moved in 1841 to Paris, where he was taught by the painter Paul Delaroche (whose other students included Gustave Le Gray, later to become a superb landscape photographer in France). Fenton enjoyed minor success as a painter and exhibited three works at the Royal Academy, but abandoned art for the law, qualifying as a solicitor in 1847. Fenton practiced law until 1864, but photography increasingly consumed his time.

In 1853 the trustees of The British Museum considered establishing a photography unit. Fenton was approached for advice, and then was appointed photographer. Under the terms of the contract the museum provided the facilities and Fenton the materials and staff, with the museum to be charged for the prints produced. Fenton photographed a variety of museum objects until 1860, when the museum chose to have the negatives printed by staff of the South Kensington Museum, which proved aesthetically and financially unacceptable to Fenton, who terminated the contract. Until that time Fenton had retained ownership of his negatives and had sold prints to the public.

For his work in the Crimea in 1855, Fenton is often described as the first war photographer, but in fact the War Office, anxious to gain public support for the campaign by allaying fears about conditions, had previously sent two photographic missions to the Crimea, neither of which had been successful. The government then joined forces with the publisher Thomas Agnew to commission a photographer under semi-official patronage. Agnew suggested Fenton because of his recent experiments with collodion, which was deemed the most suitable process then available. It is on the resulting images that Fenton's reputation has often been based. These prints of Crimean subjects were published by Agnew and offered for sale singly and in volumes, but when the war ended interest declined. Many unsold prints were auctioned in 1856.

Fenton's next venture was to produce photographs for the Photo-Galvanographic Company, which published an experimental form of photoengravings for sale to the public. The system, patented by Paul Pretsch, a printmaker from Vienna, had one advantage over similar processes: it included halftones. Fenton became Pretsch's chief photographer. *Photographic Art Treasures*, the first publication of the company, included four prints by Fenton, but though critical reaction was favorable sales were slow and the series was abandoned. Other projects including a photographic essay by

Fenton on Bolton Abbey, also did not materialize. The company was disbanded and Fenton turned to other work.

In 1858 Fenton was producing stereoscopic pictures in collaboration with the London publisher Lovell Reeve, who published a magazine devoted to stereoscopy illustrated with original photographs. Fenton, one of the first contributors, was also one of the most prolific. Reeve also sold boxed sets of Fenton's stereoscopic views, including *Stoneyhurst and its Environs*, typical of the Lancashire landscape and architectural subjects that were then Fenton's staple. In 1859 Fenton concentrated on architectural subjects, among them Harewood House, Haddon Hall, Hardwick Hall, Chatsworth, and Windsor, but by 1861 he had abandoned these in favor of a series of still lifes, most with the title *Fruit and Flowers*. These were much admired by fellow photographers and won a medal at the 1862 International Exhibition "for excellence in fruit and flower pieces and good general photography."

Yet in the same year it seems Fenton decided to leave photography and return to his original profession as a solicitor. He was discouraged by the vast increase of photographic business, fueled by the popularity of the carte de visite, which led to a lowering both of standards and prices. Fenton auctioned his equipment and remaining work. Much of his work was later published by Francis Frith and Company, after his death in 1869. A number of folios, *The Works of Roger Fenton*, appeared about 1870.

EDWARD FOX (active 1850s–1880s)

Edward Fox worked in Brighton and the surrounding Sussex countryside from the late 1850s until he sold his photography studio in June 1892. No details of his life are known, but his existing photographs demonstrate an extraordinary technical proficiency and versatility. Fox's documentary photographs of Victorian Brighton (now in a private collection in London) prefigure the beach scenes taken by Frank Meadow Sutcliffe thirty years later. His blind stamp identified him as a "Landscape and Architectural Photographer," and it was in landscape that he seems to have excelled. Fox's "studies of trees in and out of leaf" were exhibited at the Photographic Society on 7 June 1866. He also exhibited in 1869, 1876–78, and finally in 1880.

ROBERT HOWLETT (1831–1858)

Robert Howlett was one of the leading professional photographers of the mid-1850s and a partner of Joseph Cundall at the Photographic Institution. In 1856 alone, the partnership produced a series of portraits of Crimean War heroes commissioned by Queen Victoria, while Howlett photographed the frescoes of the new Drawing Room at Buckingham Palace; he produced studies of actors in seventeenth-century costume, made landscape views of the Valley of the Mole and rustic cottages in Surrey, and photographed groups of Derby Day racegoers that William Powell Frith used as studies for his 1858 painting of the same subject. Howlett also made fine photographic reproductions of the photographs of the moon taken by Warren De la Rue, and in 1858 experimented with a new landscape lens perfected by Andrew Ross. (His last exhibited works were architectural studies taken with this lens in Rouen in 1858.)

Nine engravings based on Howlett's photographs of the construction of the steamship *Leviathan* (later renamed *Great Eastern*), which appeared in a special issue of *The Illustrated Times* on 16 January 1858, successfully captured what the *Quarterly Review* had earlier called "the slow growth of a huge structure on the southern extremity of the Isle of Dogs" and the birth of new trades to master the new technology: "The ship carpenter is transmuted into a brawny smith, and the civil engineer takes the place of the marine architect" (*Quarterly Review*, 98 [1855–56]:433–34).

Following the report of Howlett's death in November 1858 his friend Robert Hardwich suggested that his death was likely to have been caused by exposure to the dangerous chemicals commonly used by photographers of the period, as typified in Howlett's own pamphlet *On the Various Methods of Printing Photographic Pictures on Paper: With Suggestions for Their Preservation* (1856).

JOHN DILLWYN LLEWELYN (1810–1882)

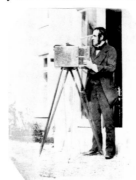

John Dillwyn Llewelyn was the son of Lewis Weston Dillwyn, a member of Parliament, and the heiress Mary Llewelyn. Through family connections and professional interests in physics, chemistry, and natural history Llewelyn became part of a close-knit circle of scientists, photographers, and painters including Henry Collen, Sir David Brewster, and the Reverend and Mrs. Calvert Richard Jones. His tutors included George Delamotte, uncle of the photographer and painter Philip Henry Delamotte, and in 1833 he married Emma Thomasina Talbot, a first cousin of William Henry Fox Talbot.

Llewelyn was elected to the Royal Society of Arts in 1837 and by 1839 had begun to experiment with the process Talbot had outlined in "Some Account of the Art of Photogenic Drawing." By 1846 Llewelyn was experimenting with both daguerreotype and calotype processes, and later with Talbot's "photoglyphic drawing." Correspondence between the families and Llewelyn's own notebooks reveal Talbot's active interest in the younger man's work. Though he continued to use calotype well into the 1850s, photographing family and friends, Llewelyn also adopted the collodion process after its introduction in 1851.

Llewelyn published his method for producing calotype paper in the *Journal of the Photographic Society* in 1854, and his letters to the journal in 1855 concern his experiments with glycerine as a substitute for honey to preserve collodion plates. In 1853 Llewelyn was elected to the Council of the Photographic Society of London, and exhibited in the society's first show, held at the Society for British Artists in 1854. He resigned from the society council in 1857 and in 1859 contributed to Philip Henry Delamotte's *The Sunbeam*. Llewelyn remained very much the amateur, photographing for pleasure rather than profit, documenting especially the south Wales countryside near his home at Penllergare.

BENJAMIN BRECKNELL TURNER (1815–1894)

Though an amateur, Benjamin Brecknell Turner has been called one of the great pioneer photographers of the 1850s. Having mastered Talbot's calotype process in 1849, Turner photographed the English countryside with a large camera throughout the 1850s. Turner married Agnes Chamberlain of the Worcester China family, and many of his photographs are of the Worcester-Hereford area. For the first eight years of married life Turner worked in the glass studio he had erected on the roof of the family commercial premises in the Haymarket, London, where he photographed family and friends.

At the Society of Arts in 1852, Turner exhibited his well-known *Photographic Truth*, and *Scotch Firs*, which according to family tradition was so admired by Prince Albert that Turner presented him with a copy. *The Times* in its review of the exhibition (31 December 1852) noted, "It might be supposed . . . that our practitioners would be far outdistanced by [the French]. Such, however, is not the case. . . . Among our best photographers are Turner, [Roger] Fenton, [Hugh] Owen, Dr. [Hugh] Diamond. . . ."

HENRY WHITE (1819–1903)

Solicitor and amateur photographer, Henry White joined the Photographic Society of London in 1855. In the same year he was awarded the highest medal for photography at the Exposition Universelle in Paris. His landscape photographs were also honored at the international exhibition of photography in Brussels in 1856: "English landscapes . . . are generally remarkable for their wonderful delicacy of detail and sharpness of outline, joined to artistic feeling and good taste in choice of subjects. The studies and landscapes of Mr. White . . . have particularly struck us, . . . they have elicited from connoisseurs an admiration without bounds" (*Cosmos*, 3 and 12 October 1856). White was much concerned with the activities of the Photographic Society and served as its treasurer for many years. His chief subjects were details of hedgerow foliage, cornfields, and the landscape of Bettws-y-Coed in north Wales, a frequently painted site during the 1850s and 1860s.

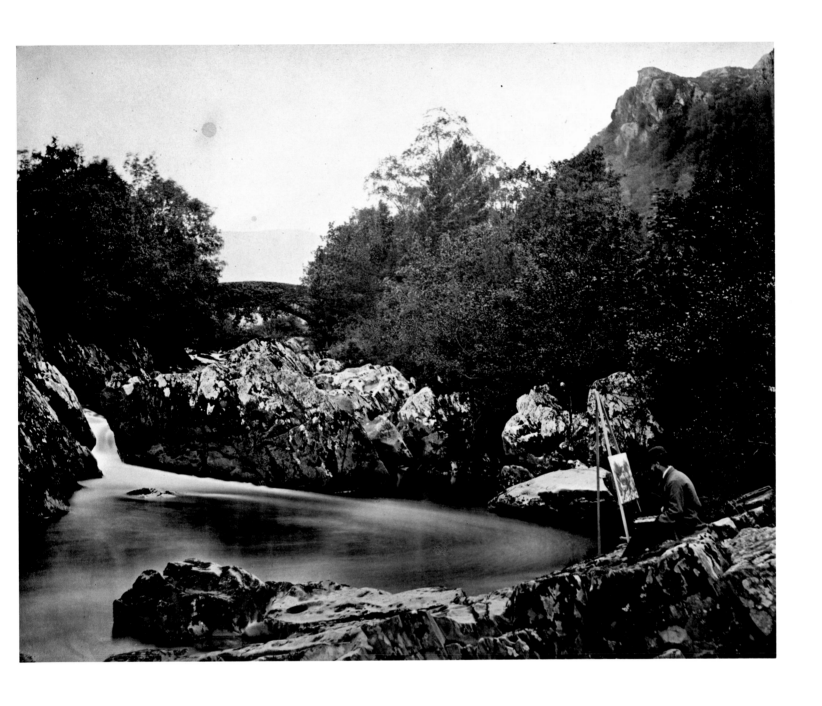

Photography revels in light; the old art was a black art. A brown midnight,
mellow, but artificial, melted into day when Claudet and Daguerre began their
magic. We, citizens by compulsion, rejoice in full daylight and golden expanses
of calm unruffled sun, broad, lustrous, gleaming, and tranquil. . . . What in painting
is a tiresome pedantry of observation, becomes in photography an inexhaustible
delight, a study, and a piece of instruction. What we cared not for in
nature, becomes a joy and wonder in the photographic picture.

Essay by "Theta," *Journal of the Photographic Society,* 21 January 1857

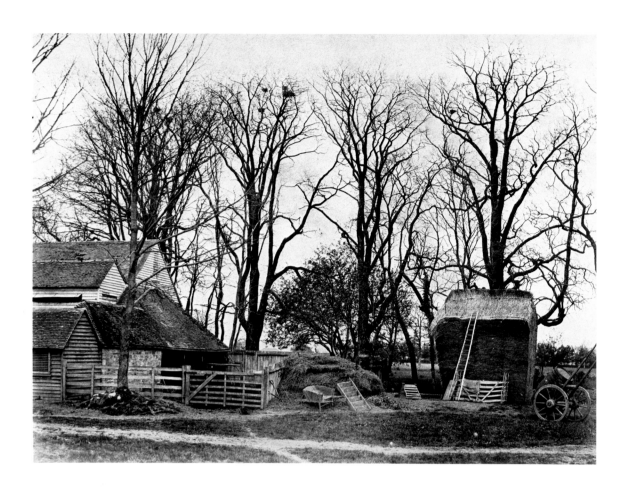

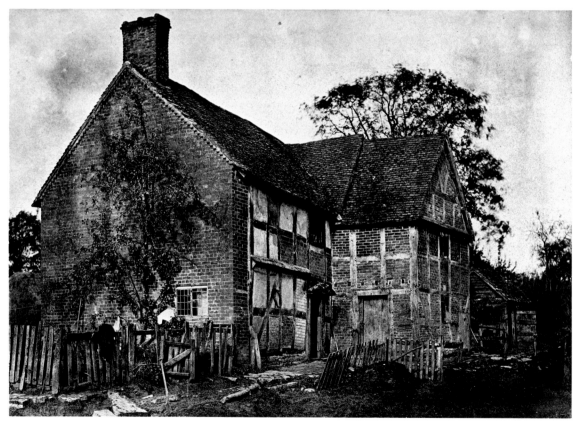

BENJAMIN BRECKNELL TURNER, *Farmyard, Elfords, Hawkhurst*, 1852–54, albumen print from waxed paper negative, 26.4 x 36 cm, VA (top)

52 BENJAMIN BRECKNELL TURNER, *Bredicot*, 1852–54, albumen print from waxed paper negative, 27 x 38.7 cm, VA (bottom)

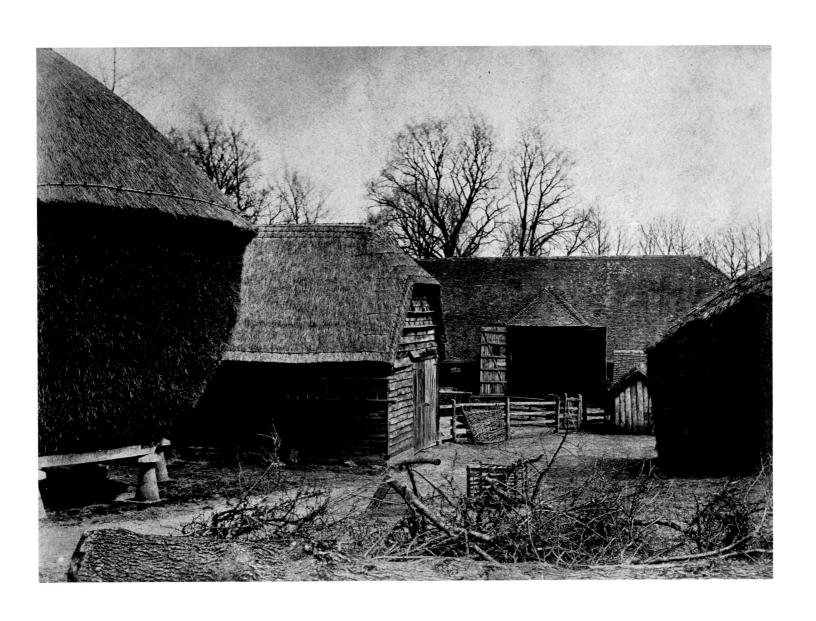

53 BENJAMIN BRECKNELL TURNER, *At Compton, Surrey*, 1852–54, albumen print from waxed paper negative, 26.9 x 38.5 cm, VA

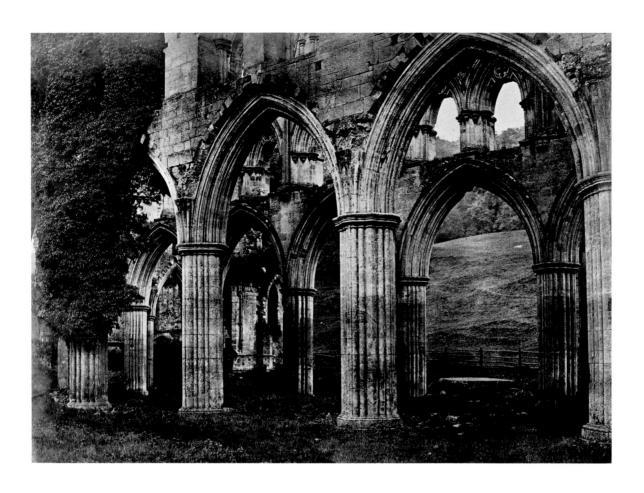

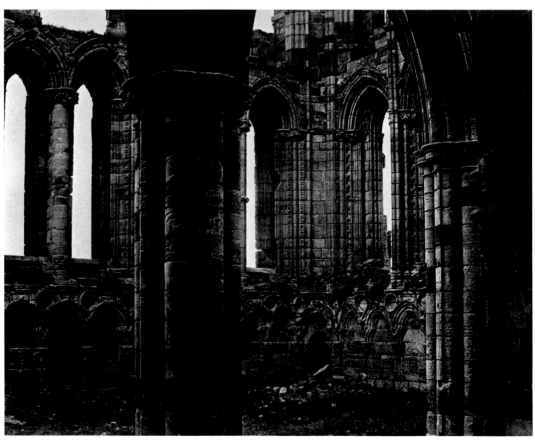

BENJAMIN BRECKNELL TURNER, *Rievaulx Abbey: Interior,* 1852–54, albumen print from waxed paper negative, 28.9 x 39 cm, VA (top)

54 BENJAMIN BRECKNELL TURNER, *Whitby Abbey: North Transept,* 1852–54, albumen print from waxed paper negative, 26.5 x 34.3 cm, VA (bottom)

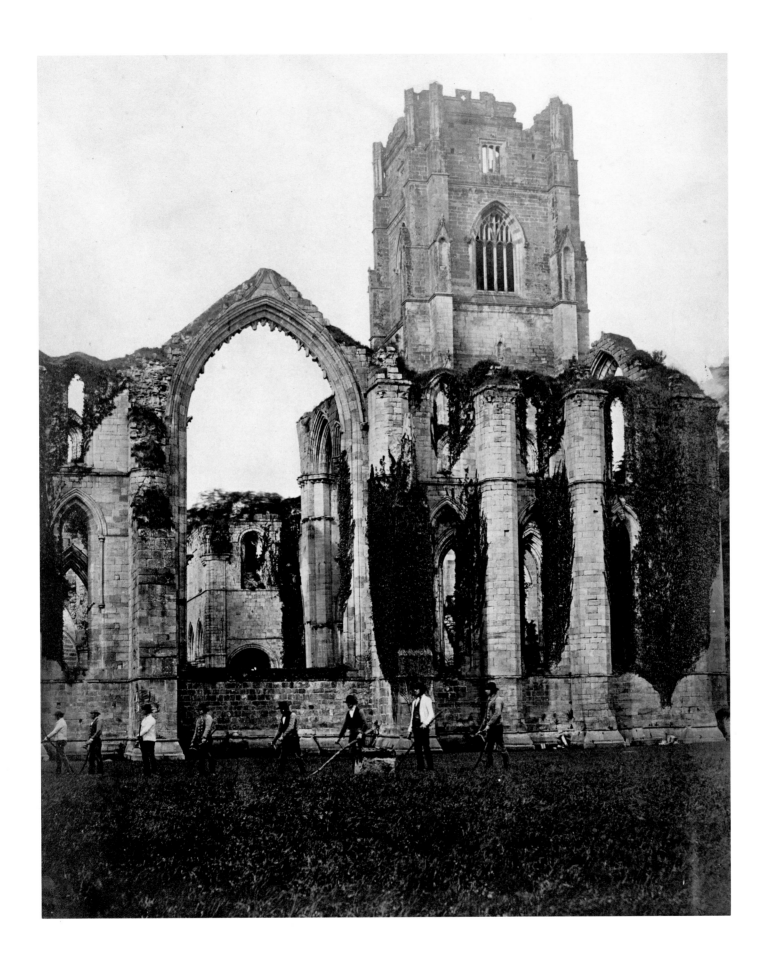

55 PHILIP HENRY DELAMOTTE, *Fountain Abbey: East Window and Tower*, ca. 1856, albumen print from wet collodion negative, 29.4 x 24 cm, VA

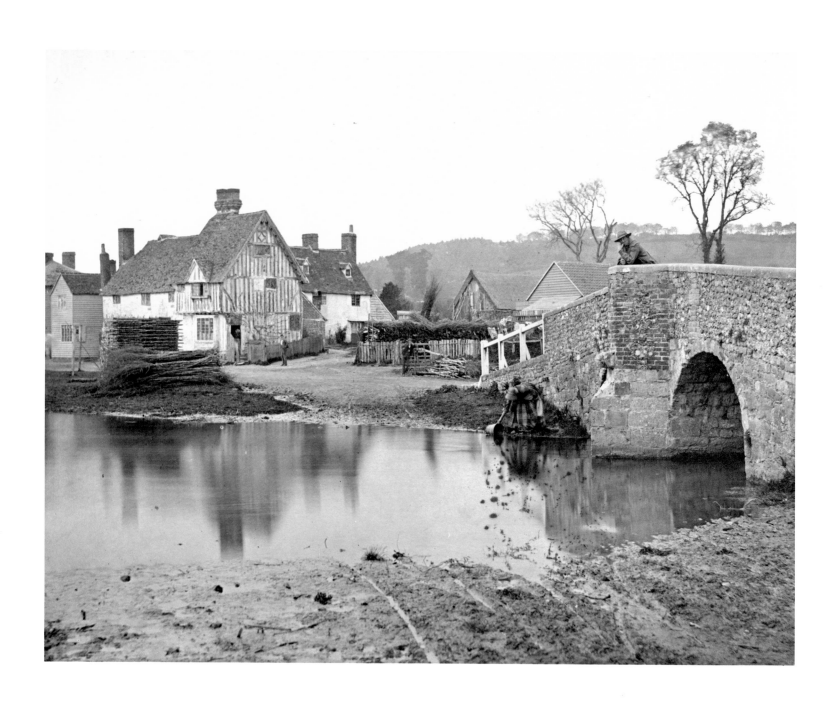

56 FRANCIS BEDFORD, *A Peaceful Village*, 1859, albumen print from wet collodion negative, 19.3 x 24.5 cm, VA

57 JOHN DILLWYN LLEWELYN, *The Woods at Penllergare*, 1859, albumen print from glass negative, 20.8 x 15.6 cm, VA

58 EDWARD FOX, *Oak (in Summer); Friar's Oak, Clayton, Sussex*, early 1860s, albumen print from wet collodion negative, 23.9 x 28.8 cm, VA

59 EDWARD FOX, *Oak (in Winter); Friar's Oak, Clayton, Sussex,* early 1860s, albumen print from wet collodion negative, 23.2 x 28.6 cm, VA

Terminating a long vista through lines of trees walled in by human beings,
with the grass, fresh from the late rains, stretching away in fine sheets of green,
except where it was patched and blotted by great masses of citizens of the world,
dressed in every garb from that of young France to that of old Gael, "the blazing arch
of lucid glass" with the bright hot sun flaming on its polished ribs and sides shone like
the Koh-i-Noor itself. Little flags fluttered cheerily along its entire length, their varied
colours catching new splendour from the glittering surface, and never did the
most fanciful of poets image a more glorious place than
plain, prosaic England, offered to the admiration of the world. . . .

The Times, 1851

BENJAMIN BRECKNELL TURNER, *Crystal Palace, Hyde Park: Transept*, 1852, albumen print from waxed paper negative, 26.4 x 39.4 cm, VA

61 ROBERT HOWLETT, *Portrait of Isambard Kingdom Brunel and Launching Chains of the Great Eastern,* 1857, albumen print from wet collodion negative, 28.6 x 23.2 cm, VA

62 ROBERT HOWLETT, *The Great Eastern: Isambard Kingdom Brunel Inspecting Checking Drum*, November 1857, albumen print from wet collodion negative, 28.5 x 36.1 cm, VA

63 ROBERT HOWLETT, *Robert Stephenson Standing by Hydraulic Press*, November 1857,
albumen print from wet collodion negative, 24.8 x 28.7 cm, VA

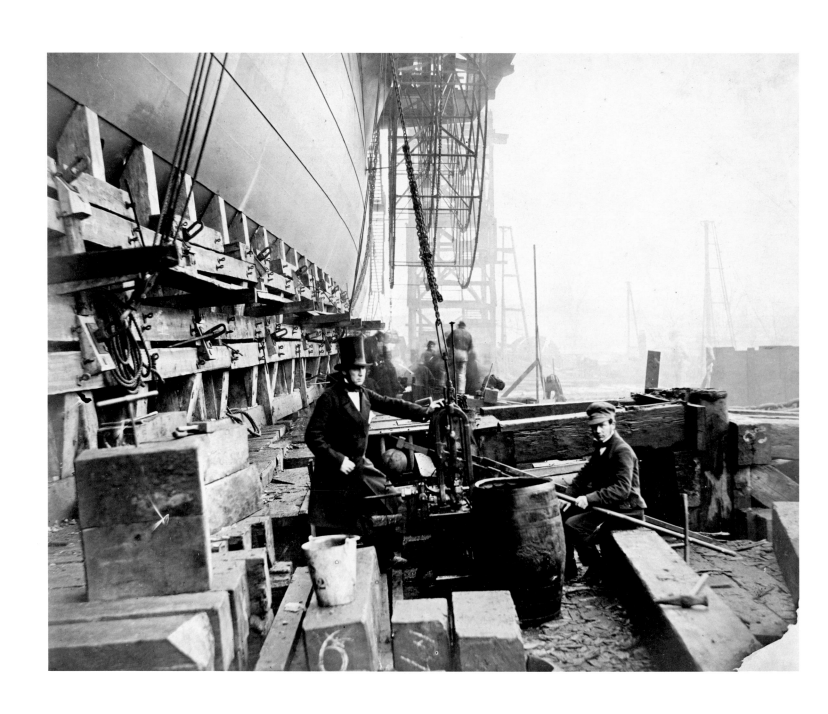

64 ROBERT HOWLETT, *The Great Eastern: Men by Cradles*, November 1857, albumen print from wet collodion negative, 28.6 x 35.7 cm, VA

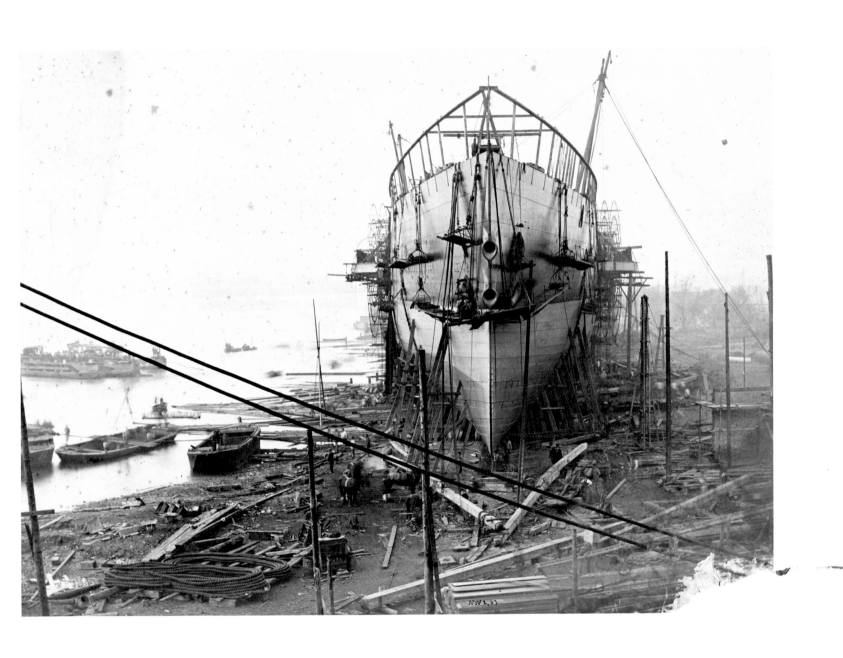

65 ROBERT HOWLETT, *The Great Eastern; Bow-on View*, 2 November 1857, albumen print from wet collodion negative, 19.2 x 27.6 cm, VA

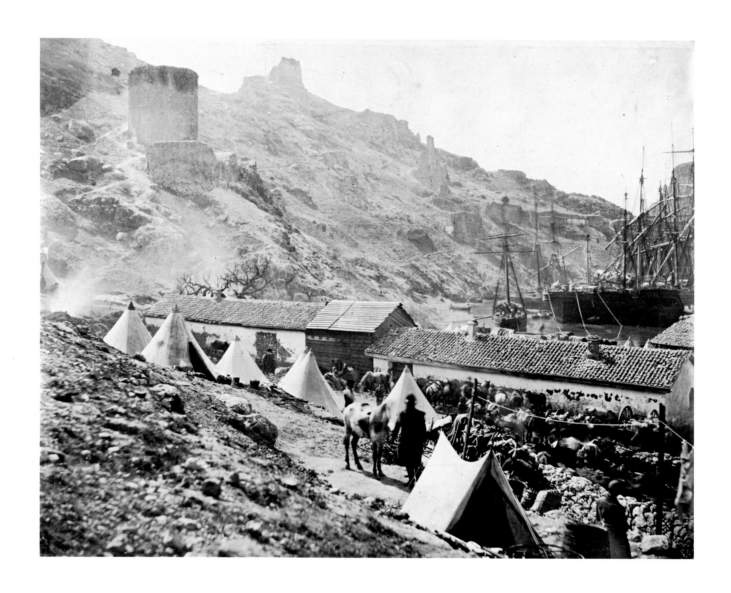

*The photographer who follows in the wake of modern armies must be content with
conditions of repose and with the still life which remains when the fighting is over.
[Yet,] whatever he represents from the field must be real,
and the private soldier has just as good a likeness as the general.*

The Times, 1856

66 ROGER FENTON, *The Harbor and Camps, Balaklava,* 1855, albumen print from wet collodion negative, 27.6 x 36 cm, VA

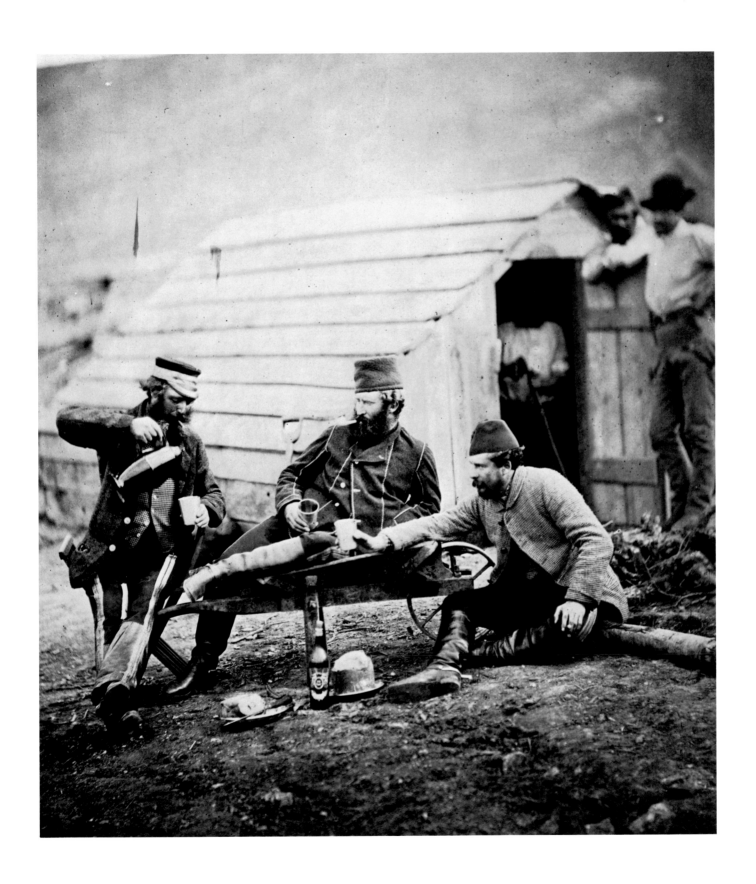

67 ROGER FENTON, *Hardships in the Camp (Colonel Lowe and Captains Brown and George)*, 1855,
albumen print from wet collodion negative, 17.3 x 16.6 cm, VA

ROGER FENTON, *His Imperial Highness Prince Napoleon,* 1855, albumen print from wet collodion negative, 29.6 x 23.1 cm, VA (top)

68 ROGER FENTON, *Lieutenant–General Sir William J. Codrington, K.C.B.,* 1855, albumen print
from wet collodion negative, 15.9 x 15.8 cm, VA (bottom)

ROGER FENTON, *Captain Turner, Coldstream Guards,* 1855, albumen print from wet collodion negative, 18 x 14.6 cm, VA (top)

69 ROGER FENTON, *Captain Hughes, Lately Employed on Special Service in Circassia,* 1855, albumen print from wet collodion negative, 19.1 x 14.5 cm, VA (bottom)

Roger Fenton and the Making of a Photographic Establishment

Valerie Lloyd

The invention of photography coincided with a turning point in the Industrial Revolution in Britain, and in many ways the early history of the medium reflects the intellectual struggle that accompanied the country's social and material upheaval; Roger Fenton was very much a product of this age. By the 1830s it became recognized that rapid commercial progress in the manufacturing trades had led to a loss of aesthetic standards in design and craftsmanship, and the British became anxious to regain leadership in international markets. The High Victorian age was one of materialism and of the rise of modern capitalism, but it was also a period when liberalism and democratization appeared as features of a changing class structure. Education in the arts and the sciences was acknowledged as a universal right, and learning became fashionable. Territorial gains abroad fostered exploration, excavation, and documentation, and the results were carried triumphantly back to Britain—as reports to learned societies and specimens to newly founded public museums.

Fenton was born into a Lancashire family of cotton manufacturers and bankers. His father, John Fenton of Crimble Hall, became the first member of Parliament for the new constituency of Rochdale in the First Reformed Parliament, in 1832, as a Liberal. In 1838 Roger Fenton went to London to study at University College for a general Bachelor of Arts degree, and then continued study for a further year under the historical genre painter Edward Lucy. Through Lucy, who had been a student of the painter Paul Delaroche, Fenton went to Paris in 1841 to finish his education in Delaroche's studio. Delaroche's interest in photography at that time is well documented, and Fenton may have become familiar with photography during his stay in Paris. Fenton may also have met three other students of Delaroche: Gustave Le Gray, Charles Nègre, and Henri Le Secq, all about Fenton's age and all later to become important photographers. In 1843 Fenton returned to England, clearly with no illusions about his ability as a painter, since he studied law and qualified as a solicitor in 1847. Called to the bar in 1851, he chose instead to join a firm of London solicitors, but continued to paint and in the 1840s regularly submitted to the Royal Academy; three of his paintings were hung.

Fenton's background was essentially upper middle class, educated, and successful rather than noble, and the milieu of his youth was the new industrial regions in the north of England rather than the more rural south. This background was to be significant in determining Fenton's professional relationship to photography. He went to London a year after Queen Victoria came to the throne and was there at the time of her marriage to Prince Albert of Saxe-Coburg, an event that introduced an entirely new mood and element into the court. Albert, lacking the constitutional power to participate in the political life of the country, invested his energy in the progressive committees and institutions that burgeoned in the optimistic atmosphere that pervaded the country. In 1835 a Select Committee reporting on the "Arts and their Connexion with the Manufactures" had concluded that the arts in Britain had received insufficient encouragement at all levels. In 1843 Prince Albert became chancellor of Cambridge University and president of the Society for Improving the Conditions of the Working Classes. It was to be his role as President of the Society for the Encouragement of the Arts, Manufactures, and Commerce (now the Royal Society of Arts), however, through which Prince Albert was to make his most important contribution. He transformed what was by then a lethargic and purposeless society into a powerful organization for promoting the application of art and science to the industrial process. As a result of his enthusiastic support, the society organized a series of exhibitions of manufactured goods, along the lines of the French *expositions*, and their success, together with the ambition and persistence of Henry Cole, a member of council and later to be the first director of the South Kensington Museum, led directly to the organization of the Great Exhibition of 1851. The Great Exhibition was a pivotal point in the history of the nineteenth century, important on many levels, not least to photography.

Photography was invented simultaneously in England and France at the time Victoria succeeded to the throne. In France photographers received support in the form of private and public commissions, while in Britain a small group of amateurs began, toward the end of the 1840s, to organize themselves into a group to facilitate the exchange of information and the exhibition of photographs. Various learned societies and journals had interested themselves in photography, particularly the Royal Institution, the Royal Society, and the Graphic Society. The exhibition of a few calotypes at the Graphic Society in December 1847 led

The Athenaeum to report on the newly formed Calotype Society.[1] Early members were Peter Wickens Fry; Robert Hunt, director of the Geological Museum; Joseph Cundall, a publisher; and Hugh Owen, who was to photograph the exhibits of the 1851 exhibition with Ferrier. Sir William Newton, miniature painter to the queen, joined the group in 1849. Other probable members were Edward Kater, Frederick Scott Archer, and Dr. Hugh Diamond. From 1848 this group seems to have been referred to as the Photographic Club. There is no evidence that Fenton was a member of this group, but when he began to play a leading role in the foundation of a formal society of photographers, it was this group, particularly Fry, Hunt, and Newton, who were to be his chief supporters.

In 1851 the dream of Henry Cole, supported fervently by the Prince Consort, was realized. *The Great Exhibition of the Works of Industry of All Nations* opened in Hyde Park on 1 May in the specially built Crystal Palace, and over 500,000 people gathered in the park. Manufactured goods of all kinds were on display, including, for the first time in England, photographs. The main ethic of the exhibition was that competition would breed higher standards through an awareness of the achievements of others. As far as photography was concerned the general public was able to see photographs by their own countrymen as well as the best examples from abroad. The exhibition provided the final stimulus to found a photographic society, and an organizing committee was formed, with Fenton as its honorary secretary.

The Société Héliographique had been set up in France the same year, and Fenton went to Paris that winter to report on the activities there. On his return he wrote a "Proposal for the Formation of a Photographic Society," which appeared in the March 1852 issue of *The Chemist:*

> *The Science of photography, gradually progressing for several years, seems to have advanced at a more rapid pace during and since the Exhibition of 1851. Its lovers and students in all parts of Europe were brought into more immediate and frequent communication. . . . In order that this temporary may become the normal condition of the art and of its professors, it is proposed to unite in a common society . . . all those gentlemen whose taste has led them to the cultivation of this branch of natural science. . . . It follows necessarily that it shall include amongst its members men of all ranks of life; that while men of eminence, from their fortune, social position, or scientific reputation, will be welcomed, no photographer of respectability in his particular sphere of life will be rejected.[2]*

Fenton went on to propose that premises be found with a darkroom and meeting room, that the proceedings be published in a journal, that a library be started, and that an album of members' work be published annually.

In September Fenton left on a trip to Russia with his friend and fellow advocate of photography, the engineer Charles Vignoles, who was constructing a bridge across the Dnieper at Kiev for the czar. The reason for the journey to Russia was ostensibly

the documentation of Vignoles's bridge under construction, but Fenton did not confine himself to that subject. He brought back views of Kiev, Moscow, and St. Petersburg, and exhibited two of them at the first major exhibition devoted solely to photography held at the Society of Arts. The *Exhibition of Recent Specimens of Photography*, which opened soon after his return, in December 1852, contained 779 framed exhibits, many of more than one photograph, and was widely reported in the press. Fenton again took the lead and read the opening address, "On the Present Position and Future Prospects of the Art of Photography," in

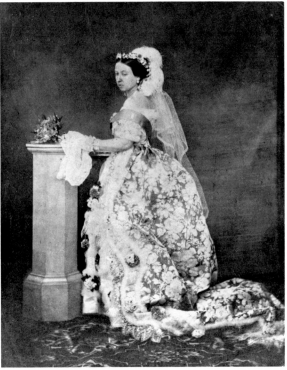

Roger Fenton, *Queen Victoria*, 1854, RPS

which he discussed recent improvements in technique, and remarked on the broad difference in subject matter between the French and British work. He thought that nothing could surpass the brilliance and harmony of the French prints from albumen on glass negatives or the delicate beauty and grandeur of the British paper negative work.[3]

As organizing secretary, Fenton issued an advertisement in early January 1853, for a public meeting to inaugurate the new Photographic Society, to be held at the Society of Arts on 20 January. At the meeting Sir Charles Eastlake was elected the first president, William Henry Fox Talbot having declined Fenton's invitation. When it was moved by Sir William Newton that the society be formed, Peter Le Neve Foster put forward a strong plea on behalf of the Society of Arts:

> *The Council of the Society of Arts are of the opinion that the objects contemplated by the proposed Society are intimately connected with those which for many years past have received the special attention of the Society of Arts; and that, therefore, it is desirable to suggest to the gentlemen engaged in this direction*

whether the progress of photography may not be as effectually advanced by means of the existing machinery of the Society of Arts.[4]

This offer, together with the exhibition held by the society during the previous two months, shows how far the art establishment had come toward embracing photography since the Great Exhibition. Despite this warm overture, Newton and Vignoles both advocated an independent photographic society, and the vote was taken with "only a few dissentients."

Fenton was made honorary secretary of the society and at its first ordinary meeting read a paper entitled, "Upon the Mode in Which It Was Advisable the Society Should Conduct Its Labours."[5] Fenton's administrative labors greatly facilitated the founding of the society; his legal experience, combined with his

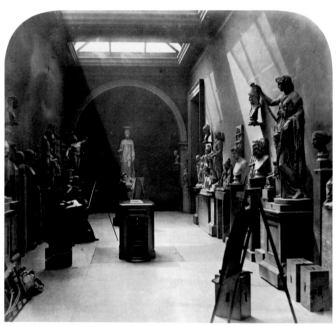

Roger Fenton, *At the British Museum*, 1860s, RPS

training as an artist and photographer, admirably suited him to the role. Most of his contributions to meetings address technical matters; he refrained from participating in the debates on the art of photography that figured in the society's business from the first ordinary meeting, when Newton delivered the paper "Upon Photography in an Artistic View, and Its Relations to the Arts."[6] In the late 1850s Fenton was instrumental in gaining photographers protection under the copyright laws as artists in their own right, at a time when photography was frequently regarded merely as a reproductive medium.

Along with the two Russian views submitted to the exhibition at the Society of Arts in 1852, Fenton had shown prints made during the previous summer: views of London, Windsor Forest, the west of England, and South Wales. No evidence suggests that he was a practicing photographer before this date: he apparently never applied to Talbot for a license to practice the calotype. A letter from Hunt to Fry, of March 1852, makes it

clear that at that point neither he nor Talbot had ever heard of Fenton. Fenton therefore quite likely took up photography as a direct result of the Great Exhibition, and his main body of work really dates from earlier in 1852, after his trip to Paris, when he presumably learned the waxed paper process. The pictures exhibited at the end of 1852, all from waxed paper negatives, do not seem like the work of a beginner. Views record a wide catalogue of subjects of engineering, architectural, and artistic interest. Fenton's breadth of subject matter over the ten years he practiced photography was to cover just about every category of picture, and in this way reflected what was new and constructive in the Victorian consciousness: the objective interest in recording the country's heritage in architecture, its beauty in terms of landscape and the new possibilities for travel, its engineering feats, the objects in the new museums, and the harrowing war in the Crimea. Fenton's landscapes, perhaps the most easily accessible of his pictures, are the most often discussed and admired.

In 1853, on Sir Charles Wheatstone's recommendation, The British Museum offered Fenton the job of official photographer; his appointment became final in March 1854. The first exhibition of the Photographic Society opened in January 1854, at the Suffolk Street Gallery of the Society of British Artists. The queen, who had agreed to become the Photographic Society's patron, attended the opening ceremony with Prince Albert, and was escorted through the galleries by Eastlake, Fenton, Hunt, Wheatstone, and Alfred Rosling, the society's treasurer. On show was a large three-plate panorama by Edouard-Denis Baldus, a French photographer much admired the previous year for his architectural views. The queen requested a copy of this work, along with six of Fenton's views of public buildings and of scenery in Russia, as well as calotype views by Rosling, which were admired for their fine detail. It was evidently Fenton who "explained" the exhibition to their majesties, and, probably as a consequence of this occasion, he was asked to photograph the royal children at Windsor Castle in the spring. The queen and Prince Albert learned photography, assisted by Ernest Becker, the children's tutor, and Albert later became an ardent collector of photographs and patron of the society. Fenton's pictures of the royal children are notable for their comparative informality: the presentation, direct and natural rather than imposing, reveals his subjects to be rather reticent children, who mostly avoided looking into the camera, and who were perhaps genuinely awkward in their public roles. Fenton continued to photograph at Windsor, and later also at Balmoral Castle in Scotland, and Albert collected many of Fenton's photographs in his "Calotype Albums."

From this time Fenton clearly became more and more heavily committed to professional photography, although he continued, at least in name, his legal practice. In 1856 his professional status led him into trouble with the Photographic Society. Shortly after Fenton had relinquished his post as honorary secretary, he and four other members of the society's council—Vignoles, Philip H. Delamotte, William Lake Price, and Hardwich—planned a separate photographic association of commercial photographers, with

the aim of promoting exhibitions of work for sale. The society saw the faction as a rival body, and declared its professional status to be incompatible with the society's aims. The five were forced to resign from the council, but remained members. Nothing further seems to have been heard of the new group, and apparently no long-term rift was formed, since in 1858 Fenton once more sat on the council as a vice-president.

Meanwhile Fenton's work for The British Museum reflected the increasing interest in disseminating information to scholars everywhere, the application of photography foreseen by Talbot in *The Pencil of Nature*. Fenton photographed sculpture, paintings, prints, drawings, manuscripts, and specimens of various kinds, including skeletons and stuffed birds, and made views of a few of the galleries in the museum. In 1856 the museum published *Photographic Facsimiles of the Remains of the Epistles of Clement of Rome*, from the unique *Codex Alexandrinus*. The facsimiles consisted of unmounted calotype pages bound together with a printed introduction. Prints of items in the collection were on sale at the museum and through their outlet, P. and D. Colnaghi. Later that year Fenton received the commission for which he is now best known, to photograph the Crimean War.

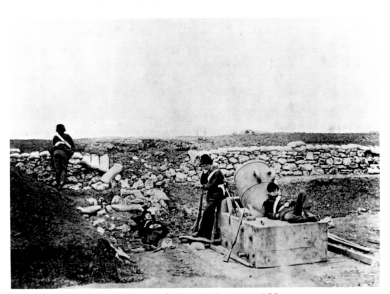

Roger Fenton, *A Quiet Day on the Mortar Battery*, 1855, RPS

In 1854, against increasing criticism of the government's administration of the war in the Crimea and evidently also in line with earlier demands, recorded in the *Literary Gazette*, to send a party of photographers to the war, Thomas Agnew of the Manchester firm of print dealers commissioned Fenton "to proceed to the Crimea, and to take such a round of portraits, scenic and personal, as should illustrate as perfectly as possible the aspects of the campaign."[7] Thus private enterprise was to satisfy a predominantly public demand. Earlier Fenton had purchased an old wine merchant's van, using it as his traveling darkroom during the summer of 1854 to tour Yorkshire, where he took pictures at Fountains, Bolton and Rievaulx abbeys, and other sites. Furnished with letters of introduction to all the commanding officers

by Prince Albert, Fenton set out, in December 1854, with his van and assistants, in a government vessel bound for Balaklava by way of Gibraltar. When his party arrived, the chaos at the dock rendered it impossible to unload the van, and Fenton, in the course of going for help, broke several ribs, thus facing enormous physical odds from the start. The real situation in the Crimea—mayhem compounded by military blunders—was immediately manifest. During the next six months he worked unceasingly and, as a highly visible target, frequently came under enemy fire, once losing the roof of his van to a mortar explosion. The pictures he managed to take do not record the action, and he did not portray corpses on the battlegrounds, as did his successor James Robertson, who arrived in September 1855 and photographed the Redan after the Siege of Sevastopol. His critics later noted Fenton's omissions: *The Observer* found it "a remarkable circumstance—one well worth mentioning—that in no instance has there been an attempt to photograph the armies in action, or even to give or represent a single incident of the bombardment or the defence."[8]

The resulting group of photographs—according to various reports up to 360 in all (Fenton took over 700 glass plates to the Crimea)—was exhibited very shortly after his return. Suffering from the cholera that had killed Lord Raglan, commander of British troops in the Crimea, and many others, Fenton probably only supervised the printing of his negatives. He was unable to answer the summons of Queen Victoria to show her his prints. Some 297 prints went on view at the Gallery of the Water Colour Society in Pall Mall East, on 20 September 1855. Published under the patronage of Napoleon III, Queen Victoria, and Prince Albert, the prints were mounted by Agnew & Sons on stiff paper with printed titles and credits. The model for the series was the set of drawings made earlier in the Crimea by William Simpson, and distributed by Colnaghi's as lithographs in a set entitled *Colnaghi's Authentic Series*. Although the medium had changed, the product was supposedly the same, and its provenance was certainly similar, but there was no real precedent for Fenton's pictures.

A member of the photographic establishment, commissioned by prominent fine art dealers at the behest of the government, with the blessing of royalty, Fenton had a difficult task. A sense of responsibility to his patrons and an eagerness to reassure an anxious public may have influenced what he chose not to photograph—scenes of elaborate suffering and distress or casualties—but his selectivity more likely derived from his own opinions on taste and human dignity. Nevertheless the subjects Fenton did photograph told a powerful story to those with eyes who wished to see. The portraits do not reverberate with drama or rhetoric: these are not Victorian statesmen posed carefully and photographed from a heroic viewpoint, but ordinary men. The very ordinariness of the photographs may suggest why Fenton's pictures were the first of their kind.

Before the exhibition of Fenton's Crimean work, most people had never seen a photograph of Lord Raglan, or any other British or French commanding officer, but had to rely instead on written

descriptions or artists' interpretations to convey their characters. Fenton's simple, direct, and unassuming portraits were revelations to many. Over thirty journals reviewed the exhibition within a few days of its opening, and *The Leader*'s description of a portrait of Lord Raglan, about whom many political doubts had been expressed, shows that the photograph had influenced the reviewer: "There is no spectacle more affecting than the countenance of Lord Raglan. . . . It not only reconciles us to the man, but to our own estimation; teaching us that after all there was no mistake in the respect paid to the character of Raglan. The

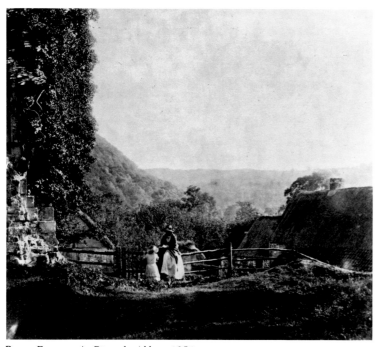

Roger Fenton, *At Rievaulx Abbey*, 1854, RPS

mistake lay in permitting a noble ambition to indulge itself, where a gentle force ought to have been used in making the aged man accept the repose which his patriotism spurned."[9] The one photograph that might be seen as a recognizable "moment in history"—*The Council of War* taken when Raglan, General Pelissier, and Omer Pasha met the morning of the capture of the Mamelon—was discussed at great length. Fenton's eleven-part panorama of the Plateau of Sevastopol was technically less than perfect, owing to the continual variation in the atmosphere caused by the intense heat and changing humidity, which affected the horizon from negative to negative, but it was much appreciated for its delineation of the terrain, the neighboring heights, and, as one critic wrote, "the entire ground occupied by the allied troops."[10]

Like the great nineteenth-century realist novels, the photographs demand to be "read" for the detailed observations they provide. The *Literary Gazette*, virtually alone, read the evidence most accurately:

> The views of Balaclava Harbour and the adjacent plain, with the
> unloading of the transports and the arrival of the materials for

the railway, the quays everywhere covered with cattle for sustaining life, and piles of shot and shell for annihilating it, illustrate in a variety of scenes the stirring and deadly business of the period. . . . It is obvious that photographs command a belief in the exactness of their details which no production of the pencil can do. . . . [11]

The photographs of the Crimea have the same context as the portraits and views, but the meaning is transformed by the gravity of the situation. Many lesser critics failed to comprehend Fenton's grave message and commented endlessly on the quaintness of the uniforms of the *cantinier* and the foreign troops, and the perfection of the prints: *The Art-Journal* even found *The Valley of the Shadow of Death*—strewn with cannonballs—"a most exquisite photograph."[12]

Perhaps more than anything else, the photographs convey the tedious sameness of the soldiers' existence: *A Quiet Day on the Mortar Battery* seems innocuous enough, but in conjunction with Leo Tolstoy's opening paragraph to *Sevastopol* it takes on a new dimension:

> Six months have passed since the first cannonball went whistling from the bastions of Sevastopol and threw up the earth of the enemy's entrenchments. Since then bullets, balls, and bombs by the thousand have flown continually from the entrenchments to the bastions, and above them the angel of death has hovered unceasingly.[13]

Aesthetically, Fenton's landscapes taken in the Crimea have much in common with his Russian views taken in 1852: horizontal lines dominate the compositions, horizons are low, and constructed pictorial space, in the mid-Victorian painterly sense, is absent. This simple, perhaps even documentary approach continues throughout Fenton's work, continually alternating with accomplished excursions into the picturesque, like the Yorkshire views in the first annual exhibition in January 1854: in the abbeys seen against a background of foliage or ivy, there are men, women, and children occasionally posed among the ruins, sitting on stones or gnarled wooden fences. The figures denote scale and introduce a narrative element, marking the site as a place to visit, to absorb as part of the British heritage.

Where in France the aesthetic qualities of the paper negative were discussed and understood, primarily by Le Gray in the 1850s, in England, particularly in professional circles, the collodion-on-glass negative became almost universally used by the mid-1850s. Clarity and detail, qualities Eugène Delacroix had derided in the daguerreotype, were ideal in terms of the British genre tradition, and in the use of photography as a documentary and portrait medium. Le Gray's early understanding that the intrinsic qualities of photographic technique must dictate a purely independent aesthetic really had no corresponding consciousness in Britain. Whereas Charles Nègre's genre scenes of organ grinders, chimney sweeps, and other tradespeople—"deliberately organized composition[s] executed with all the qualities foreign to the daguerre-

otype"[14]—demonstrated the abstract use of broad areas of tone in composition, English genre scenes aimed at descriptive detail, clutter, and narrative. In all this Fenton is compelling by virtue of his reticence. His work is left to speak for itself.

In 1856 Fenton traveled north through Berwick and Edinburgh, and in the Valley of the Dee. The following year he photographed extensively in north Wales, and over twenty prints were exhibited by the Photographic Society early in 1858, together with views of York, Ely, Peterborough, and Lincoln cathedrals, and work for The British Museum. Until this time, although Fenton had changed to wet collodion negatives in 1854, he continued to make occasional salt prints, but his choice of medium seems to have been random rather than determined by subject; the Scottish work is mostly salt, and also various views of London, the latest of which are probably 1857. Fenton most

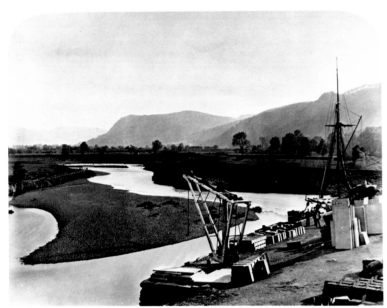

Roger Fenton, *Slate Pier at Trefriw*, 1857, RPS

likely alternated printing processes in an attempt to solve the fading problems that beset every photographer of the age.

Fenton contributed to the exposition of 1856 in Brussels, where his chief rival was thought by the French to be Henry White: "The collections of Mr. Fenton and Mr. White of London ought to fix the attention. Nothing can be finer in detail or clearer than *The Corn Field*, with the oats just being cut, the ferns, the brambles, and the edges of the ponds by Mr. White; and nothing is more remarkable in the photographs of Roger Fenton than the delicacy of foliage combined with the aerial perspective. It is landscape photography pushed to the ultimate degree of perfection."[15] The aerial quality of Fenton's landscapes often caught the attention of critics and was apparently the distinguishing feature of his work in his day. In 1858 a critic remarked of the Welsh views:

Of course, no one can touch Fenton in landscape: he seems to be to photography what Turner was to painting—our greatest

landscape photographer; not that there is any similarity between the aerial perspectives of Turner, and the substantial and real which we get transferred by Fenton. . . . There is such an artistic feeling about the whole of these pictures, the gradations of tint are so admirably given, that they cannot fail to strike the beholder as being something more than mere photographs.[16]

The views in north Wales illustrate the virtuosity of Fenton's vision and techniques by this time. *Slate Pier at Trefriw* demonstrates a feeling for the geography of the scene, in the curve of the river and the simple geometry of the machinery on the pier. His approach to this scene of industry, far from being picturesque, is almost classical, and is descriptive rather than narrative. Two views higher up the valley, *Gorge of Foss Nevin, on the Conway* and *Double Bridge on the Machno* indicate the breadth of sensation of which Fenton was capable. *Foss Nevin* is a strongly Victorian image, romantic and picturesque; with its extraordinary control of light, it is highly successful. But *Double Bridge on the Machno* goes far beyond these qualities. Fenton has closed in on his subject; the lichen-covered banks of the river appear in black and white camouflage, and are reflected in the water below. The branches of trees enter the frame from outside, mere forms with no trunks, and amid all the chiaroscuro and reflection it is difficult to discern what is real and what is reflected. It is an abstraction unrivaled by any photographer of that date, and is in every sense a modern picture. Many more of Fenton's landscapes can be imagined out of the Victorian context, but, interestingly, toward the end of his career in photography he finally turned to Victorian subjects.

A meeting of the Photographic Society in the spring of 1858, chaired by Fenton, when Oscar G. Rejlander showed and explained his notorious picture *The Two Ways of Life*, was the only occasion Fenton broke his silence and commented on the prevailing High Art photography. He declined to discuss Rejlander's print in detail: "I will not refer to the picture before us, which with all respect to its very great merit, I think is too ambitious a beginning . . .," but it was probably this episode that led to his series of Oriental studies, hung at the following year's annual exhibition and praised by *The Photographic Journal*:

Mr. Fenton has come out in great force; and we are pleased to notice that he is turning his attention to a department of the "art" in which he is less known than in his exquisite landscapes—we mean those subjects in art-slang that are generally designated as genre subjects. Of these The Pasha and Bayadere, The Reverie, Turkish Musicians and Dancing Girl, and The Nubian Water Carrier are favorable examples, being admirable illustrations of Eastern scenes of actual life. Their execution is also worthy of Mr. Fenton's well-known fame.[17]

These pictures, like those of the royal children, are not artificial, grand, or posturing in their conception. The models are natural and rather enigmatic; they take up modest, informal poses; and the few carpets and pieces of Eastern upholstery or ornament are the minimum necessary. They are simple, direct, and sensitive

statements, compared to the vulgarity of Rejlander's epic piece. Unfortunately this was where Fenton and his patron Prince Albert parted company, since Prince Albert greatly admired Rejlander's picture, a fitting emblem of the hypocrisy of Victorian domestic morality and religious aspirations.

Fenton followed this group of genre scenes with an exercise in another painterly category, the still life. In 1860 he made about forty still lifes of fruit and flowers, arranged with statuettes, tankards, and jewelry, on rich fabrics and marble. They were almost certainly done in a very short time, since the same fruit is used throughout. When unveiled, they were compared to the contemporary paintings of George Lance, sometimes unfavorably: "Nor can we quite agree with Mr. Fenton in the advantage of employing the photograph on such combinations of fruit and foliage, with jewellery and bric-a-brac, as Mr. Lance has familiarized us with . . . the colour, . . . which is the special glory and charm of fruit and flower not only defies the photographer, but thoroughly defeats him."[18] But this time Fenton was outdoing the Victorians, and they failed to see in the extraordinary detail and texture of the rich, purple prints what Fenton had achieved.

Many of these prints present the fruit over life-size, and in doing so give their reality another dimension. The scale of Fenton's work is important throughout; he had always worked with large plates, and this makes his prints accessible in a way that others of the same period are not. His work was always published on fine art mounts, and these studies are his final acknowledgment

of that status, with no loss of face for photography. The critic who had demanded, in 1857, "Dutch truth allied to Italian poetry," surely had it here. The response to these pictures was mixed, although *The Photographic Journal* thought them "the highest standard to which photography can attain at present in that field," and in 1862, Fenton decided to give up photography. Notice of the sale of his apparatus and negatives was published in October 1862, and nearly 1,000 published and unpublished negatives were sold on 11 and 12 November.

Although the instability of his prints and the commercialization of photography have been given as reasons for Fenton's retirement, it was probably a more complicated decision. The Photographic Society was now well established, as was photography itself. The vogue for large exhibition prints was over, with the advent of the mass-produced tourist prints of the 1860s and 1870s, and Fenton had accomplished just about all there was to accomplish in terms of the breadth of his work and its quality in his ten years. *The Photographic Journal* announced his retirement and ended: "To the exertions of Mr. Fenton the Photographic Society owes its existence, and for many years it has had the benefit of his counsel and advice; it is therefore with unfeigned regret we make the announcement of his resolution, which is, however, mitigated by the hope that, although he retires from the *practical operations of the art*, he will still occasionally attend the meetings of the Society, which owes so much to him, and where his presence is always so welcome and agreeable."[19]

NOTES

1. Carolyn Bloore, "Early Photographic Societies in Britain," unpub. ms. 2. Roger Fenton, "Proposal for the Formation of a Photographic Society," *The Chemist* (March 1852). 3. Roger Fenton, "On the Present Position and Future Prospects of the Art of Photography," abstract published in *A Catalogue of . . . Recent Specimens of Photography* (London: Charles Whittingham, 1852), pp. 3–8. 4. Peter Le Neve Foster, in *Journal of the Photographic Society*, 3 March 1853: 4. 5. Roger Fenton, "Upon the Mode in Which It Is Advisable the Society Should Conduct Its Labours," *Journal of the Photographic Society* 1 (3 March 1853): 8–9. 6. Sir William Newton, "Upon Photography in an Artistic View, and Its Relations to the Arts," *Journal of the Photographic Society* 3 March 1853: 6–7. 7. "Photographic Views from the Crimea," *John Bull*, 22 September 1855. 8. "Exhibition of Photographic Pictures of the Crimea," *The Observer*, 7 October 1855. 9. "History's Telescope," *The Leader*, 2 September 1855. 10.

"Mr. Roger Fenton's Photographs of the Seat of War," *Manchester Guardian*, 25 September 1855. 11. *Literary Gazette*, 22 September 1855. 12. "Photographs from Sebastopol," *The Art-Journal*, 1 October 1855: 285. 13. Leo Tolstoy, *Sevastopol, and Other Military Tales*, trans. Louise and Aylmer Maude (New York: Funk and Wagnall's, 1903), p. 21. 14. Francis Wey, quoted in André Jammes and Eugenia P. Janis, *The Art of the French Calotype* (Princeton: Princeton University Press, 1983), p. 222. 15. *Bulletin de la Société française de photographie*, quoted in *Journal of the Photographic Society*, 21 October 1856: 149. 16. Review of the Photographic Exhibition, *Journal of the Photographic Society*, 21 May 1858: 208–9. 17. Roger Fenton, *Journal of the Photographic Society*, 21 April 1858: 196. 18. "Photographic Society's Sixth Annual Exhibition," *The Photographic Journal* 78 (1 February 1859): 35. 19. "Retirement of Mr. Fenton from Photographic Pursuits," *The Photographic Journal* 126 (15 October 1862): 158.

77 ROGER FENTON, *Double Bridge on the Machno*, 1857, albumen print from wet collodion negative, 40.0 x 33.5 cm, RPS

78 ROGER FENTON, *The Keeper's Rest, Ribbleside*, 1858, albumen print from wet collodion negative, 35.1 x 42.7 cm, VA

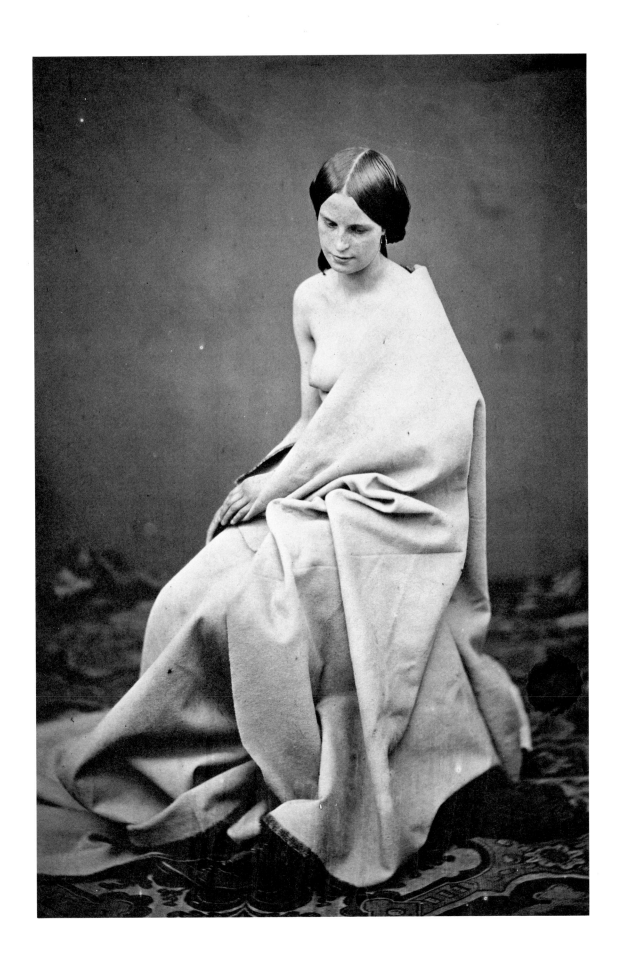

79 ROGER FENTON, *Nude Study*, mid-1850s, salted paper print, 25.6 x 17.4 cm, VA

80 ROGER FENTON, *Fruit and Flowers*, 1860, albumen print from wet collodion negative, 35 x 43 cm, RPS

81 ROGER FENTON, *Litchfield Cathedral: The West Porch*, ca. 1858, albumen print from wet collodion negative, 40.5 x 27.8 cm, VA

4. The Grand Tour

As Britain developed into a great imperial state, its citizens increasingly identified their nation with the creative civilizations of antiquity. Public buildings emulated the styles and proportions of Greece and Rome. London became an imperial city, and the prime minister, William Ewart Gladstone, spent his leisure hours translating the works of Homer. An indication of the reverence felt for the achievements of antiquity is found on the monument raised to the memory of Prince Albert, who died in 1861. The monument is carved with a tableau of the world's poets, which placed Homer as the central and chief figure and stationed Britain's national poet, Shakespeare, in a lesser position. Through such monuments, public buildings, publications, and pictures of many kinds, most levels of society enjoyed the grand tour, especially of the cradle of civilization in Mediterranean lands: "Every day now lessens the distance between the travelled and untravelled man" (Exhibition review by "Theta," *Journal of the Photographic Society*, 21 February 1857: 215).

The grand tour featured prominently in the shows of London. During the first fifty years of the century, a large public appreciated painted panoramas and, later, dioramas, which presented splendid illusions of the monumental and sacred past through their changing light effects. In 1859 *The Athenaeum* saluted a new panorama at "Burford's" in Leicester Square and claimed that, whatever was said in Paris about English insularity, the public amusements of London provided "the very grandest of grand tours" (12 March 1859:

357). When Burford's closed four years later, the whole phenomenon of the painted panorama, so much relished by the generations from Wordsworth to Ruskin, came to an end, the victim of several new developments. First, the Crystal Palace, reopened and expanded at Sydenham in 1854, offered the illusion of other places and periods in a series of reconstructed rooms (the Medieval Court, the Court of Lions from the Alhambra) in three dimensions. Second, the day of the public museum had arrived, notably with the South Kensington Museum, where art treasures presented the substance of the past and huge plaster casts from the sculptures and buildings of Europe indicated scale and detail with new authenticity.

Photography also took over the audience and market for the grand tour. The daguerreotype process had been harnessed to the task of recording the grand tour for domestic consumption as early as 1841, when N. P. Lerebours dispatched operators to Italy, Spain, Greece, Egypt, Nubia, Palestine, and Syria, publishing the results as engravings made directly from the daguerreotype plates in *Excursions Daguerriennes* (1841–43). During the great decade of photography in Mediterranean lands, from 1851 to 1861, British photographers established themselves in Madrid, Rome, and Constantinople—and floated down the Nile, though rarely on luxury cruising boats seen in the view above, taken by Frank Mason Good in the

1860s. They acted both as artists and as entrepreneurs, taking care that their photographic prints should outdo the rival productions of lithographers and aquatint engravers, and marketing their views for the tourist trade and through London print dealers. Charles Clifford, working under the patronage of the royal household in Madrid, photographed the monuments of Spain at the same time that Owen Jones popularized Moorish architecture in London—in publications and three-dimensionally at the Crystal Palace. Robert Macpherson photographed the Campagna and the antiquities of Rome, giving attention to delicate nuances of tonal variation by dodging or masking to distinguish areas of tone. An informed public responded to the topographical photographers of the 1850s and early 1860s: "It has been left to photography to picture Rome in such detail as it is not the province of painting to attempt" (*The Art-Journal*, 1 November 1862: 227). Publishing opportunities and royal command respectively sent Francis Frith and Francis Bedford on their expeditions to the Near East. Frith's 8-foot panorama of Cairo, exhibited in 1859, challenged the painted panorama, while the variety of his book and print production set aside the claims of traditional topography. He pictured Egypt and Palestine on 16 x 20-inch negatives, on 8 x 10-inch, and with a stereoscopic camera. In scale, monumental composition, and depth of tone, but also in microscopic fidelity in stereo form, Frith's photographs ousted other versions of the Egyptian and Palestinian grand tour.

Shortly before his death Prince Albert

arranged for the prince of Wales, "heir of half the world," to undertake a grand tour in company with a scholarly clergyman, Arthur Stanley (later Dean of Westminster). In the Holy Land, the prince's cavalcade rode up from Jericho through the bare mountains of Judea until they reached Bethany. As they traveled to Jerusalem along the way taken by Christ, Stanley rode beside the prince and the rest of the party fell back: "I pointed out each stage of the triumphal entry—the 'fig-trees'—the 'stones,' the first sight of Jerusalem—the acclamations, the palms, the olive branches—the second sight, where 'He beheld the city and wept over it'" (Letter quoted by Hector Bolitho, *Victoria, the Widow and Her Son*, 1934, p.13).

Some of the most meticulous photographs of the period recorded these authentic places of scriptural history for the country rectories and theological seminaries of Victorian Britain, reverberating in their beholders perhaps even more strongly than the views of Roman ruins.

FRANCIS BEDFORD (1816–1894)

Francis Bedford was the son of the prominent architect Francis Octavius Bedford, an influential figure in the Greek Revival of the early nineteenth century. The young Bedford joined the family's architectural practice and was exhibiting architectural designs at the Royal Academy by 1833. His *New Church of Tunstall* was the first of many Bedford architectural drawings to appear at the academy during 1833–49. By the 1850s he was also known for his skill in lithography, especially through publication of Sir Matthew Digby Wyatt's *The Industrial Arts of the Nineteenth Century at the Great Exhibition*, for which Bedford executed 158 colored lithographs.

Bedford had begun to practice photography by 1853, when he exhibited photographs from *Lithographs of Sketches by David Roberts* at the Photographic Society of London's first exhi-

bition. In 1854 Queen Victoria commissioned him to photograph objects in the royal collection, and his work appeared in the Photographic Exchange Club Albums of 1855 and 1856. In 1857 Bedford became a member of the Photographic Society and in the same year received his second royal commission: Prince Albert requested a series of views of Coburg, Bavaria, his birthplace, as a birthday present for the queen. By the late 1850s Bedford's photography business had expanded, and he traveled throughout Great Britain by train or pony trap, photographing with the 10 x 12-inch-plate cameras he preferred. Bedford's exposure time for landscapes was between twenty and thirty seconds. He used the Ross portrait lens for interiors or dark glens, an orthographic lens for architectural views, and a Ross view lens for landscape. As for other photographers of the era, exposure of skies was problematic, and Bedford either painted clouds onto his negatives or overlaid separate sky negatives. Though Bedford is known to have admired the theatricality of Oscar G. Rejlander and Henry Peach Robinson, his own work is more purely documentary.

The 1860s were prolific years for Bedford. In 1861 he was the first photographer to use electric light successfully in printing. In the same year he was elected vice-president of the Photographic Society. In 1862 he was invited to document the tour to be made by the prince of Wales (later Edward VII) to the East, an expedition planned by Prince Albert before his death in December 1861. As a member of the royal entourage, Bedford was allowed to photograph holy sites previously restricted as sacrosanct. Bedford's completed set of 148 prints, published in 1863, offers a unique visual diary of the tour. He received a silver medal for the series at the Exposition Universelle in Paris in 1867. In 1864–68 Bedford also published (through Catherall and Prichard, labeled "C & P" on his negatives) photographic views of north Wales, Tenby, Exeter, Torquay, Warwickshire, and Stratford-upon-Avon, as well as a stereoscopic series, *English Scenery*.

By 1867 Bedford's son William (1846–1893) had assumed much of the operation of the family photography business and his father's committee work at the Photographic Society, though the latter remained a council member until 1886. Many prints of this later period are more likely to be William Bedford's than his father's. Francis Bedford nonetheless outlived his son, and himself died 15 May 1894.

FRANCIS FRITH (1822–1898)

Francis Frith was born into a Devon Quaker family, and attended Quaker schools before his apprenticeship with a cutlery firm in Sheffield, Yorkshire, in 1838. After a succession of commercial ventures Frith became a photographer, and in 1856 embarked on the first of his three professional tours of Egypt. He photographed ancient monuments from Cairo to Abu Simbel, despite difficulties with the wet collodion process in the extreme heat of the desert. On his return in July 1857 Negretti and Zambra published 100 stereoscopic views and Thomas Agnew some larger-format prints (8 x 10 inches and 16 x 20 inches). *The Times* declared that the photographs "carry us far beyond anything that is in the power of the most accomplished artist to transfer to his canvas" (January 1858).

Frith's first trip was such a critical success that Negretti and Zambra commissioned him to travel through Egypt to Syria and Palestine, from November 1857 to May 1858. These 8 x 10-inch negatives were published as *Egypt and Palestine Photographed and Described by Francis Frith*. In the summer of 1859 Frith returned to the East for the third time, traveling 1,500 miles up the Nile from its delta, farther than all previous photographers. As on his earlier expeditions, a wicker carriage served both as his darkroom and sleeping quarters. The finest of the seven publications that resulted from the tours is *Egypt, Sinai, and Palestine* (ca. 1860), with a text by Mr. and Mrs. Reginald Stuart Poole. This was the largest photographically illustrated book yet produced, with 16 x 20-inch plates.

In 1859 Frith opened a printing establishment at Reigate, Surrey, which produced large quantities of albumen prints and illustrated books to satisfy the demand for pictures of the Near East. This publishing firm also employed a large staff of photographers and assembled a huge archive of topographical views of the British Isles and the Continent. The firm also made prints from other photographers' negatives, for example Roger Fenton's after his retirement. After Frith's death in 1898 his children continued the firm, manufacturing an

enormous number of prints and picture post-cards with its familiar "F. Frith and Co." or "Frith Series" blind stamp. Frith and Company remained in the family until 1968 and ceased trading in 1971.

FRANK MASON GOOD (active 1860s–1880s)

Frank Mason Good joined the Photographic Society of London in 1864 and served as a judge of its annual exhibition in 1880. One of the few documents relating to Good from the intervening years is a letter extolling the wet collodion process for "such subjects as wall sculptures which are only lighted for a very short time, and where detail in the deepest shadows and figures [is] required" (*The Photographic Journal,* 15 February 1873: 196). He lived at Hartley Wintney, Winchfield, Hampshire, and photographed the landscape of the nearby Isle of Wight, a popular resort often photographed during the period. J. R. Ware's *The Isle of Wight* (London, 1869) is illustrated with tipped-in photographs by Good and Russell Sedgefield. Good's style is reminiscent of that of Francis Bedford, and like Bedford he photographed in Egypt and the Holy Land. His *Glimpses of the Holy Land* was published in 1880, although the photographs probably date from the 1860s or early 1870s, when Good is known to have made nearly 100 transparent stereoscopic slides of Egypt and the Nile, published by Léon Levy of Paris.

ROBERT MACPHERSON (1811–1872)

Born in Edinburgh, Robert Macpherson studied medicine there in 1831–35 but did not complete his degree. He went to Rome at the beginning of the 1840s and soon immersed himself in the artistic life, earning his living as a landscape painter. In 1849 he married Geraldine Bate, niece of Anna Jameson. In 1851 he took up photography and became immensely successful, surpassing the efforts of his fellow expatriate James Anderson. Rome was popular with the English as a winter resort, and the English Victorian taste for the ruins of the ancient imperial city so favored by Ruskin is reflected in Macpherson's catalogues. The first of his sale catalogues appeared in 1858–59 and 1863.

Beginning in 1856 Macpherson used the collodio-albumen process invented by the French chemist J. M. Taupenot and published in September 1855. This process, the first attempt at a "dry" collodion process, enabled Macpherson to prepare his plates by hand at home and then photograph at any site. The Vatican allowed no portable darkrooms; Macpherson would therefore have been unable to produce his 300-print guide to Vatican sculpture without the new process. Collodio-albumen exposures were extremely long: a landscape in bright sunshine required five minutes, objects near the camera ten to twenty minutes, and photographs in the sculpture galleries from two hours to two days. Macpherson also experimented with other methods of photomechanical reproduction. In 1853 he was granted a patent by the Ministry of Trade, Art, Industry and Agriculture for a bitumen-based method of photolithography.

Macpherson traded in works of art to supplement his income and in 1846 bought Michelangelo's *Entombment of Christ,* which was ultimately sold to the National Gallery, London. Macpherson remained active in British photography through the Photographic Society of Scotland and his exhibitions in London and Edinburgh. The Architectural Photographic Association mounted a well-received exhibition of his photographs in 1862.

JAMES ROBERTSON (active 1850s)

James Robertson is believed to have been a gem engraver and chief engraver to the Imperial Mint in Constantinople, but no documents confirm the description. He is, however, known to have been a photographer by 1854, when he took group portraits of the Coldstream Guards and the Ninety-third Highlanders at Scutari, near Constantinople. Between July and December 1854 his views of Constantinople were published in *The Illustrated London News.* In the same year the English version of *Constantinople* by Théophile Gautier was published with engravings from Robertson's photographs, lent by the Photographic Institution in London.

In 1855 Robertson again showed views of Constantinople at the Photographic Society of London's second annual exhibition and at the Exposition Universelle in Paris, where he also showed photographs of Greece. He was photographing in the Crimea in 1855 and in December held an exhibition in Regent Street on the fall of Sevastopol. In April 1856 he and Roger Fenton held a joint exhibition of their Crimean War work. (Robertson had photographed Fenton himself the previous June in the Crimea.) At the end of the year both Robertson's and Fenton's Crimean negatives and prints were auctioned.

Probably in late 1855 Robertson had married Marie Matilde Beato, believed to be the sister of the photographer Felix Beato. Robertson made a photographic trip with Alexis Benôit Soyer in the summer of 1856, photographing in Smyrna, Malta, Constantinople, and Marseilles. In 1857 Robertson left for India as official photographer to the British army, with Felix (Felice) Beato, photographing en route through Egypt and Palestine. Many photographs from this period are signed "Robertson and Beato" or "Robertson Beato et Cie." Little is known of Robertson's activities after he left India except that he maintained residency in Constantinople until 1881.

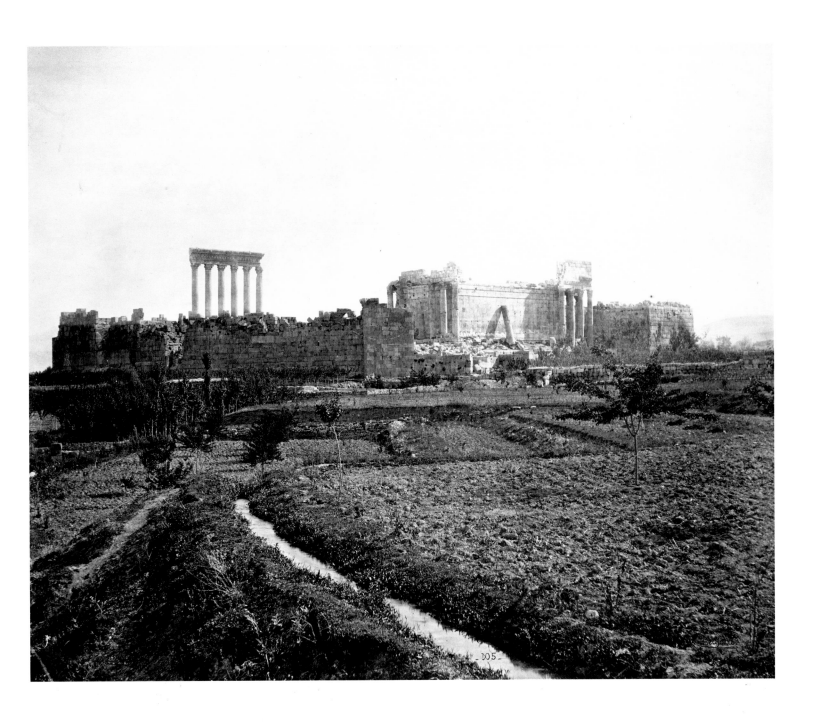

*The traces of those generations long ages since passed from [the earth's] surface,
who, with the inherent feeling of our kind have striven to leave a dim posterity, by their
gigantic but decaying efforts, some relic and memento of their passage:
all have been or will be brought in intense reality to our very hearths.*

William Lake Price, A Manual of Photographic Manipulation, 1858

85 FRANCIS BEDFORD, *Baalbek: General View of the Ruins from the Southwest,* 3 May 1862,
albumen print from wet collodion negative, 23.3 x 28.2 cm, VA

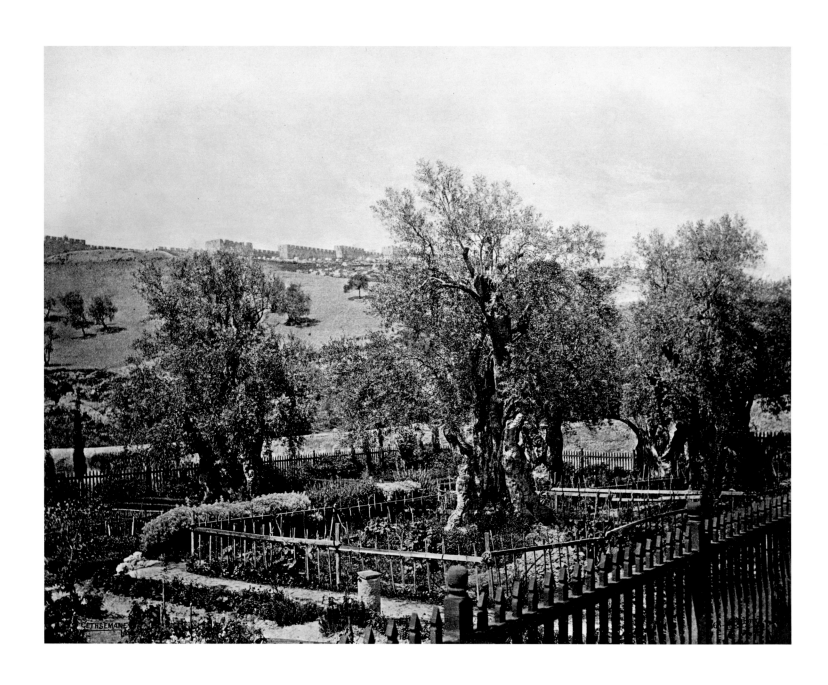

86 FRANCIS BEDFORD, *Jerusalem: View in the Garden of Gethsemane Looking toward the Walls of Jerusalem*, 2 March 1862, albumen print from wet collodion negative, 21.8 x 28.5 cm, VA

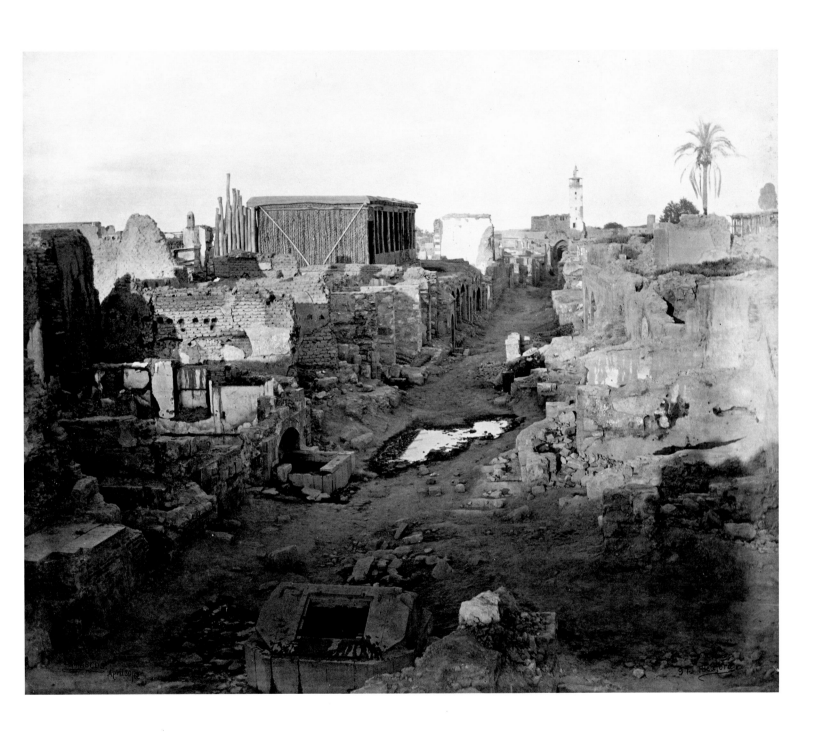

87 FRANCIS BEDFORD, *Damascus: Part of the Straight Street in the Christian Quarter*, 30 April 1862, albumen print from wet collodion negative, 23.9 x 29.0 cm, VA

88 FRANK MASON GOOD, *Esne, Egypt: Temple of Khnum, Capitals of the Portico,* mid-1860s, carbon print, 15.7 x 20.5 cm, VA

89 FRANCIS BEDFORD, *Ghizeh: Excavated Temple at the Foot of the Sphinx,* 4 March 1862,
albumen print from wet collodion negative, 24.3 x 29.2 cm, VA

90 FRANCIS FRITH, *The Pyramids of Dahshoor: from the East*, 1858, albumen print from wet collodion negative, 36.4 x 44.4 cm, VA

91 FRANCIS FRITH, *The Statues of the Plains: Thebes*, 1858, albumen print from wet collodion negative, 37.2 x 47.6 cm, VA

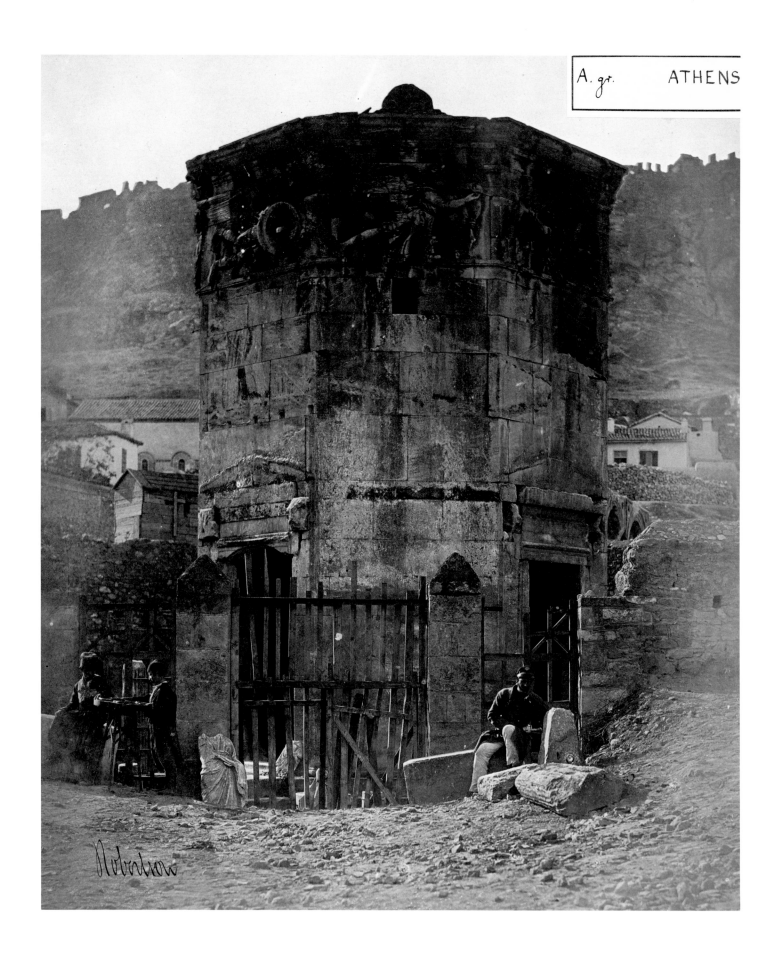

92 JAMES ROBERTSON, *Athens: Temple of Theseus from the South*, 1856–57, albumen print from wet collodion negative, 28.3 x 24.2 cm, VA

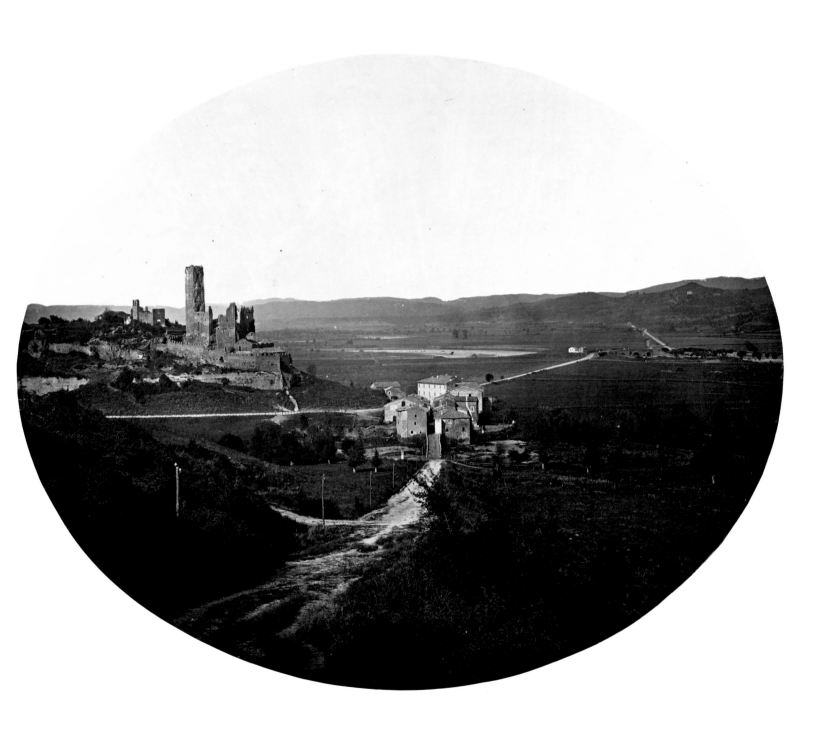

93　ROBERT MACPHERSON, *Valley of the Tiber at Ponte Felice near Borghettaccio, between Civita Castellana and Otricoli*, late 1850s, albumen print from dry collodion negative, 31.7 x 39.5 cm, VA

5. High Art Photography In Search of an Ideal

A new controversial and theatrical photography emerged in the period 1855–60, born of the debates on the relationship between photography and art. As early as 1852 Roger Fenton speculated on photography's appropriateness as a medium for pursuing the lofty goals of High Art. Addressing the Society of Arts on the "difficulty of expressing the ideal by the material," he claimed that "every disposition of mind has its bodily expression," and posed the question "Why should the artist then hesitate to make use of the best material which he can find?" (A *Catalogue of . . . Recent Specimens of Photography,* 1852, p. 6).

In the mid-1850s, aiming to fulfill the higher purposes implicit in ideal beauty—"not merely to amuse, but to instruct, to purify, to ennoble," as photographer Jabez Hughes wrote in 1860 (quoted in Beaumont Newhall, *Essays and Images,* 1980, p. 115)—certain painter-photographers chose the tableau vivant as the "best material" for High Art. Calotypes by David Octavius Hill and Robert Adamson illustrating characters from Sir Walter Scott prefigure these photographic tableaux. Fenton himself produced *A Romance* in four parts, showing stages of courtship leading to betrothal, a work acquired by Prince Albert in 1854. But William Lake Price was the first painter of historical subjects to bring his interests directly into the new medium. He based his *Don Quixote in His Study* on a few details from Cervantes and many more from Scott's novel *The Antiquary.* The antiquarian details of the photograph paralleled activities in architecture, theater, and painting.

Through such channels the accurately verifiable historical past became part of the mid-Victorian world.

Genre painting had already reached a near photographic verisimilitude in the style of Sir David Wilkie and his many followers. Lake Price and Oscar G. Rejlander composed and exhibited photographic genre scenes, perhaps with the idea of entering a lucrative market. Rejlander is principally remembered for his large tableau *The Two Ways of Life,* which he created for the Art Treasures Exhibition held at Manchester in 1857. He gave a very full account of his working methods and the allegorical meaning of the composition. Reviewers had little to say on the subject of the work's edifying message but much to say about the propriety of photography's trespassing on the territory of traditional art. A fair specimen is Robert Hunt's comment in *The Art-Journal* (April 1858: 21):

> The pose of each figure is good and the grouping of the whole as nearly perfect as possible. We do not, however, desire to see many advances in this direction. Works of High Art are not to be executed by a mechanical contrivance. The hand of man, guided by the heaven-born mind, can alone achieve greatness in this direction.

Henry Peach Robinson used Rejlander's experiment as a starting point and continued to develop combination printing down through the following decades of the century. The subject and the relative realism of his *Fading Away* (above) touched a painful nerve in its viewers, but *Bringing Home the May* gave the public a modern idyll inspired by the poetry of Edmund Spenser. Robinson used his knowledge of studio lighting to render with exquisite refinement the May blossoms as well as the complexions of the young girls who act out the scene. The tableaux of Rejlander and Robinson readily separate into their constituent details (indeed, they exhibited the details as independent works). These remain irreducible and serve as monuments to the ambition outlined by Roger Fenton—though perhaps not the monuments he had envisioned.

WILLIAM LAKE PRICE (1810–1896)
William Lake Price was trained in the studio of Augustus Charles Pugin as an architectural and topographical artist, along with the architects A. W. N. Pugin and Benjamin Ferrey and the artists Joseph Nash and E.W. Cooke (the latter of whom he photographed in the 1850s). Lake Price was a member of the Old Watercolour Society and exhibited forty-two paintings there between 1837 and 1852. The earlier of these were primarily antiquarian or topographical, including the interiors of stately homes and historical subjects such as *Scene at Loch Leven with Mary, Queen of Scots Signing Her Abdication.*

Lake Price's photograph *The Scene in the Tower* inspired Lewis Carroll to take up photography in 1856, and it is Carroll's diary which first documents Lake Price's practice in the medium. Lake Price's *Don Quixote in His Study* also reflects the Victorian fashion for antiquarian interiors, and its collection of ob-

jects and armor echoes contemporary paintings of similar subject matter.

In 1858 Lloyd Brothers published Lake Price's *Portraits of Eminent British Artists,* including photographs of J. Frederick Tayler and Edward Matthew Ward. In the same year Price formulated his theories of photography in *A Manual of Photographic Manipulation, Treating of the Practice of the Art and its Various Applications to Nature.* It was the first treatise to deal with the aesthetic as well as technical considerations of photography.

OSCAR G. REJLANDER (1813–1875)

Oscar G. Rejlander, born in Sweden, first became known as a painter and lithographer. He studied in Rome, supporting himself by copying Old Masters and through portraiture. It is not known when Rejlander first came to England, but by 1846 he had settled in Wolverhampton with his wife, Mary. He visited the influential Great Exhibition of 1851 and in 1853, encouraged by William Parke, part owner of the *Wolverhampton Chronicle,* took instruction in photography from Nicholas Henneman at his Regent Street Studio. Rejlander's photography was from the first inclined toward sentimental genre studies and portraiture with a strong theatrical element. Rejlander's painting style was not dissimilar: in 1848 he exhibited a portrait of a young girl titled *Oh yes! Oh yes! Oh yes!* at the Royal Academy. His association in Wolverhampton with John Coleman, the actor-manager of the Theatre Royal, might also have been influential.

When experimenting with the problem of depth-of-field in portraiture Rejlander discovered combination printing. His allegorical study *The Two Ways of Life,* exhibited at the Manchester Art Treasures Exhibition in 1857 and in 1858 at the Photographic Society of London, pioneered this technique as a new photographic aesthetic. Yet, while Rejlander felt that manipulation of the negative drew painting and photography together, his critics did not always agree. Nevertheless the royal family owned a copy of *The Two Ways of Life.*

(In the same year Rejlander met Henry Peach Robinson and introduced him to combination printing.) Rejlander never again attempted work on the scale of *The Two Ways of Life,* concentrating instead on smaller tableaux and genre work, using friends and relatives as his models. Rejlander could also produce work of great spontaneity. *Poor Jo* (1861), based on the character of the homeless crossing sweeper in *Bleak House,* and *Second Edition* (1871), a portrait of a young boy selling newspapers, are precursors of the instantaneous documentary style of the turn of the century.

Rejlander moved to London in 1862 and took a studio in the Malden Road. He concentrated on portrait work and his subjects included Lewis Carroll in 1863 and Gustave Doré in 1869. In 1869 he rented a large studio to cater to the carriage trade of Belgravia and Pimlico. Charles Darwin approached him in 1871 to illustrate *On the Expression of the Emotions in Man and Animals.* Rejlander himself posed for some of the studies, and although by this time he was gravely ill with diabetes, completed the project. He died four years later in great financial difficulty.

HENRY PEACH ROBINSON (1830–1901)

Henry Peach Robinson was born in Ludlow, Shropshire. He left school at the age of thirteen and studied drawing and painting under William Gill. In 1844 he began a five-year apprenticeship to a print publisher. During this period Robinson published articles in the *Journal of the Archaeological Society* and a sketch of Ludlow Castle in *The Illustrated London News* in 1845. In 1851 he visited the Great Exhibition and developed a friendship with Dr. Hugh Diamond, a member of the Photographic Exchange Club. Robinson exhibited his paintings only once, at the Royal Academy in 1852. He had begun to photograph in that year, and in 1857 opened a photography studio in Leamington Spa. With the exhibition in 1858 of his combination photograph *Fading Away,* Robinson's became a household name. He had learned the technique of using several negatives to make a visually coherent print from Oscar G.

Rejlander. The technical virtuosity and uniquely Victorian subject matter of Robinson's scene — a young girl on her deathbed — made *Fading Away* as controversial as Rejlander's *The Two Ways of Life.*

Ill health forced Robinson to move to London in 1864. From 1868 to 1876 he worked in Tunbridge Wells, sharing the Great Hall studio with N. K. Cherrill. He became vicepresident of the Photographic Society of Great Britain in 1887 and in 1892 left the society to form the influential Secessionist group The Linked Ring, from which he had resigned by 1900. Stylistically Robinson's work developed in three distinct ways. In the early 1850s he tended toward architectural and landscape studies; through the late 1850s and 1860s he specialized in narrative genre images and composites; during his period with the Ring he preferred Pictorial landscapes with figures. Yet Robinson's writing played perhaps a greater role in nineteenth-century photography than his photographs. He published eleven volumes on photography and articles in journals on both sides of the Atlantic. His crusade for Pictorialist photography found followers in France, Austria, and the United States, especially Robert Demachy, Heinrich Kuehn, and Clarence H. White. *Pictorial Effect in Photography: Being Hints on Composition and Chiaroscuro for Photographers* (1869) is the most complete statement of Robinson's ideas.

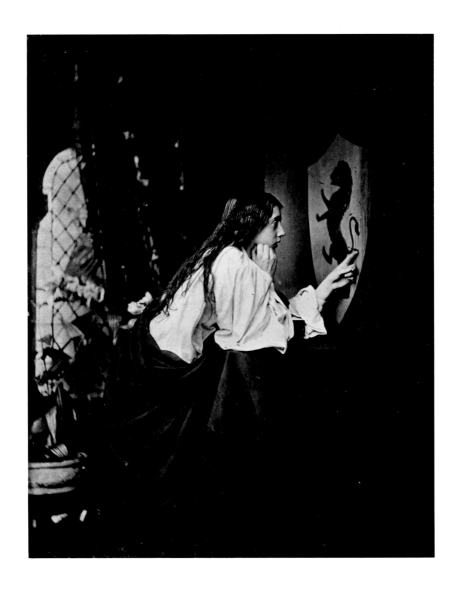

*If [the photographer] be judicious in his arrangements, there is nothing
whatever to prevent his having the satisfaction of seeing his conception perfectly
realized by the camera, with such delicacy of finish as Nature's handling is
alone capable of. . . . The greatest attention will be required that the draperies
take a proper arrangement of folds; that the positions of the bodies,
heads and hands, and more than all, that the expressions
of the countenances are as they should be, for it suffices that a finger
be disagreeably placed to spoil the whole as a perfect work.*

William Lake Price, *A Manual of Photographic Manipulation*, 1858

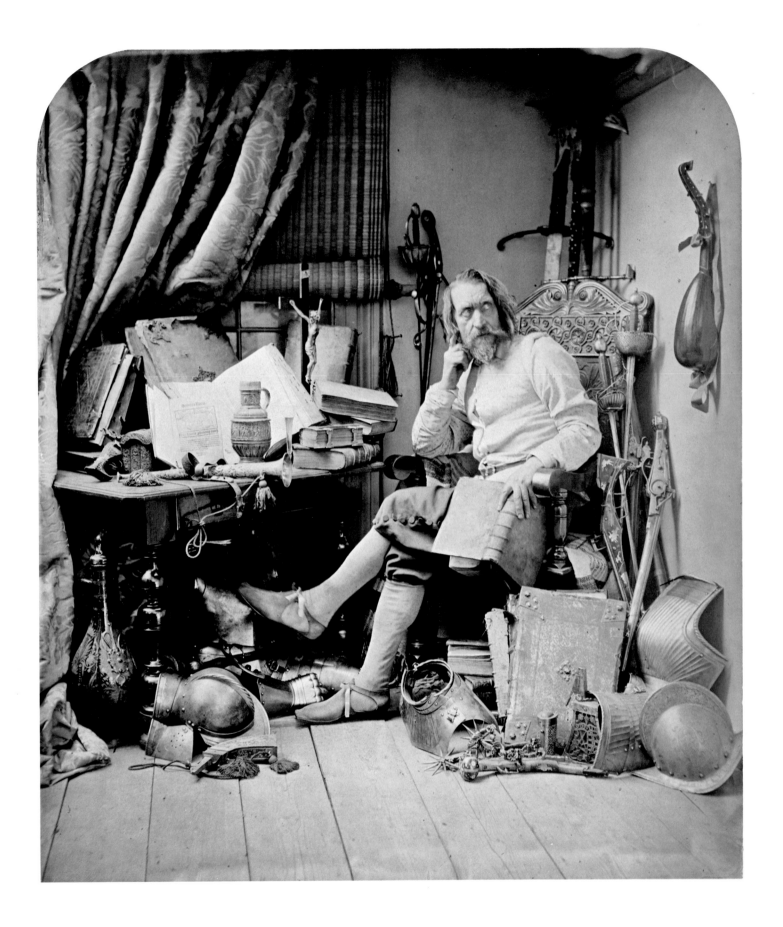

97 WILLIAM LAKE PRICE, *Don Quixote in His Study*, early 1850s, albumen print from wet collodion negative, 32.4 x 28.4 cm, VA

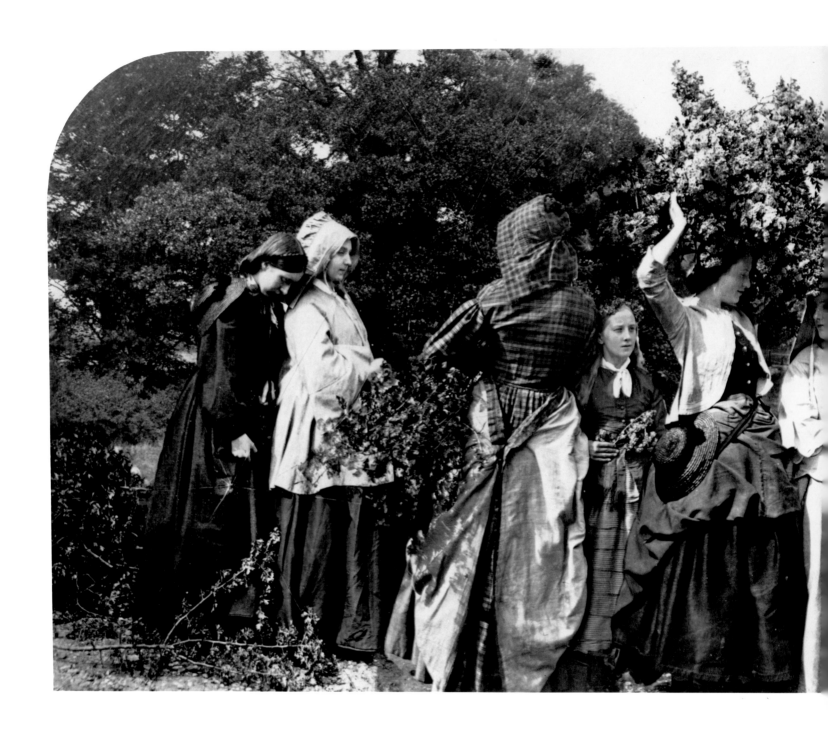

98–99 HENRY PEACH ROBINSON, *Bringing Home the May*, 1862, albumen print from wet collodion negatives, 99.8 x 38.7 cm, RPS

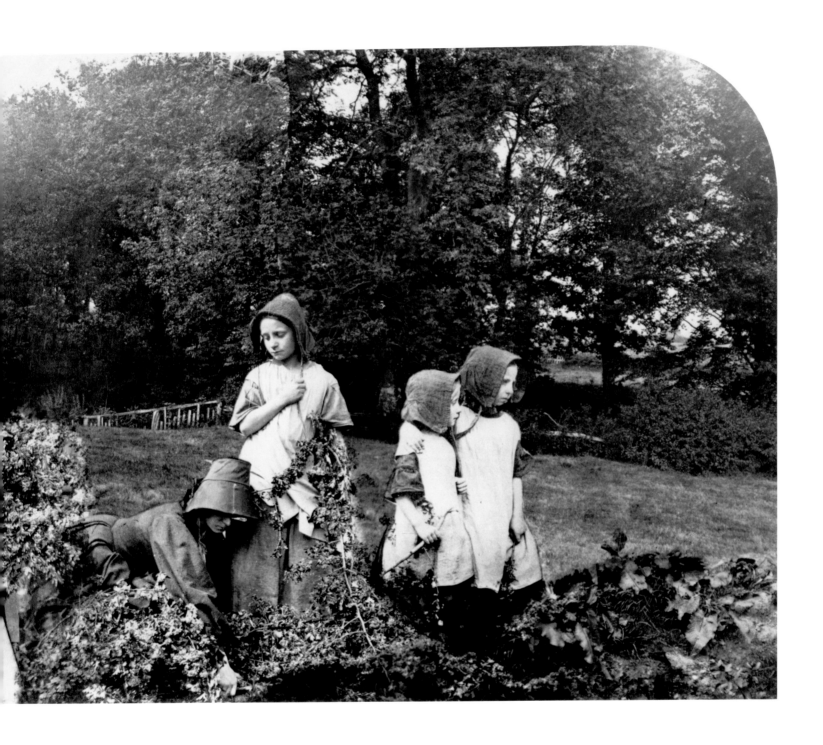

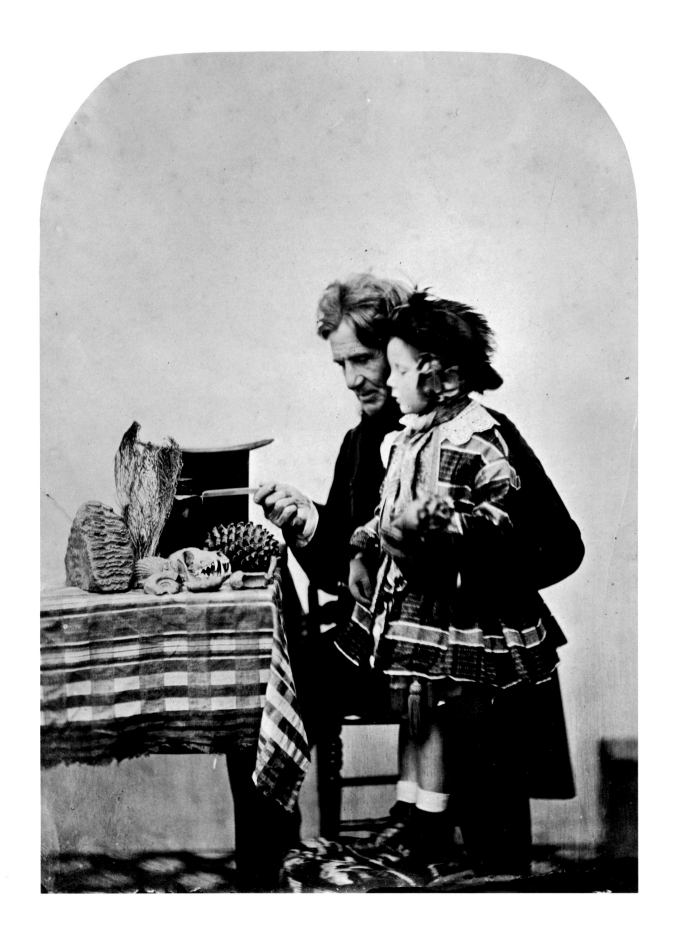

100 OSCAR G. REJLANDER, *A Young Naturalist*, ca. 1860, albumen print from wet collodion negative, 15.0 x 20.0 cm, RPS

101 OSCAR G. REJLANDER, *Drat the East Wind*, ca. 1860, albumen print from wet collodion negative, 15.0 x 18.0 cm, RPS

102–103 OSCAR G. REJLANDER, *The Two Ways of Life*, 1857 (printed 1925), brown-toned carbon print, 40.9 x 76.8 cm, RPS

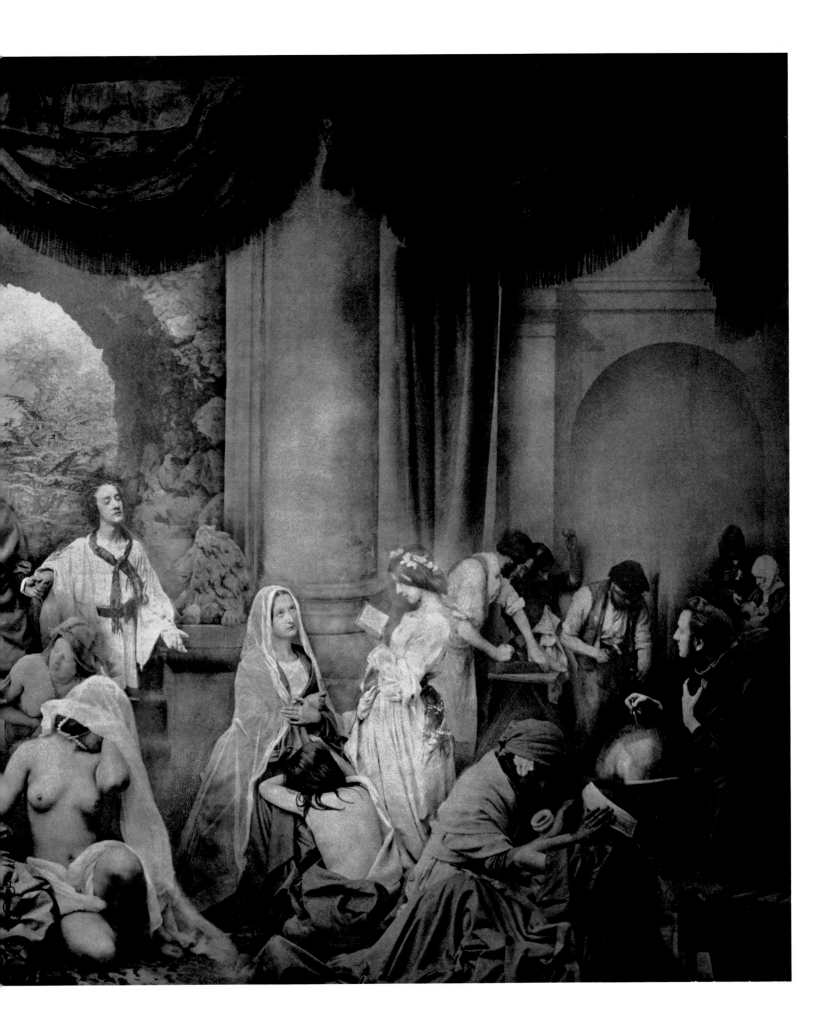

6. Exploring the Empire

When photography was first announced in 1839 Britain and the United States were nearly equal in population—Britain numbering a little over 18,000,000, the United States slightly less. During the century Britain continued to enlarge its overseas empire until, by the time Queen Victoria celebrated her Diamond Jubilee in 1897, the British Empire spanned about 11,000,000 square miles with a population of about 372,000,000: a quarter of the land mass of the earth and a quarter of its population. It was the largest empire in the history of the world.

India, the jewel in the imperial crown, inspired the finest photographs. The first British artist to make major topographical paintings and verbal descriptions of India, William Hodges, visited the subcontinent in the 1780s. His view of India probably expresses much of the experience of the photographers who followed him:

> The clear blue cloudless sky, the polished white buildings, the bright sandy beach, the dark green sea, present a combination totally new to the eye of an Englishman, just arrived from London, who, accustomed to the sight of rolling of clouds floating in a damp atmosphere, cannot but contemplate the difference with delight.　　(William Hodges, Travels in India during the Years 1780, 1781, 1782 and 1783, 1793, p. 2)

By the last thirty years of the eighteenth century, earlier misgivings at home about the expansion of British rule had almost entirely faded, replaced by a new pride in India as a treasured possession. The generous spirit of inquiry characteristic of the Enlightenment produced studies devot-

ed to Sanskrit, and to Indian religious thought and architectural monuments. The scholars of the Enlightenment revealed an India whose roots were profoundly entwined with those of Mediterranean European culture. By the 1820s India had been annexed to the taste for the exotic and Romantic, most notably through Thomas Moore's poem *Lalla Rookh* (1817). Visual representations of the subcontinent mostly followed Romantic prescriptions. As with the lands of the grand tour, there was available by the mid century a wide range of imagery from India, from the lithographs of David Roberts to the splendors of the diorama.

Photographers made their first substantial records of India in the mid-1850s. One of the pioneer photographers, Dr. John Murray, appears in the foreground of his photograph of the Taj Mahal (above). Working with very large, 15 × 18-inch, paper negatives, Murray produced the most subtle, yet monumental photographs of India taken either before or after. These J. Hogarth exhibited and published in London in December 1857. Because the Indian Mutiny had been raging for almost a year, visitors to the exhibition saw these scenes of Agra and neighboring regions as military as well as cultural sites. One added contribution of the photographs was their meticulous rendering of Mogul architecture, which demanded to be scanned with the aid of a magnifying glass. Heretofore

archaeologists had had to carry out their researches with the aid of drawings, and it was still the practice to take plaster casts of carved inscriptions; photographs like Murray's showed that the new medium could replace this cumbersome adjunct of scholarship.

In the mid-1850s the East India Company began to employ photographers to record, with a new accuracy and efficiency in delineation, the immense uncharted antiquity of the subcontinent. This led to the appointment of Captain Linnaeus Tripe in 1855. As with Murray, whose surviving negatives show repeated trial and error attempts to capture picturesque rather than strictly archaeological subjects, Captain Tripe's published views of 1857 and 1858 demonstrate his interest in monuments set in dusty roads, among exotic trees, and at a distance across country.

Samuel Bourne established India as an example of the picturesque in nature taken to a new power. Technically Bourne can be classed with Francis Bedford, but Bourne invented an imperial picturesque, commanding mountaintop vistas of Himalayan extensiveness, architecture of astonishing flamboyance, and an intricate and exotic range of plant and tree species. He also photographed the India occupied by increasing numbers of fellow Britons, who pursued military or civil duties, nurtured garden plots planted with English flowers, attended services in Gothic churches, sometimes resided in cottages fashioned on the rural English model, and maintained the Pax Brittanica. The 800 to 900 negatives Bourne produced on this major expedition covered much of the web—Romantic, topical, and commer-

cial—that connected India to British interests. A small detail shows how closely Bourne's conception of Indian landscape, architecture, and raw materials converged with needs at home. When Bourne and his partner Charles Shepherd sent their 1867 catalogue from their studio in Simla to the South Kensington Museum in London, they received an order for every one of the 1,666 views listed.

SAMUEL BOURNE (1834–1912)

Born in Mucclestononthe Shropshire-Staffordshire border, Samuel Bourne began his working life as a clerk in a bank, but as early as 1853 photographed in the Lake District, north Wales, and the Scottish Highlands. In 1857 he abandoned his career for photography. In 1859 the Nottingham Photographic Society mounted an exhibition of some 2,000 prints, including Bourne's. George Shadbolt, then editor of *The British Journal of Photography*, at first considered Bourne's work artistically inferior but praised his contributions to the 1859 exhibition. Bourne's correspondence with Shadbolt during his journeys to India appeared in *The British Journal of Photography* between 1863 and 1867.

In January 1863 Bourne sailed to India as a professional photographer. He soon made the 1,200-mile journey from Calcutta to Simla, the summer residence of the viceroy of India. Yet the town and surrounding countryside did not correspond to Bourne's notion of the "ideal landscape," and he left on a ten-week expedition into the Himalayas, photographing the River Sutlej in the Kulu and Chini regions.

In 1864 Bourne entered the photography firm of Charles Shepherd and Arthur Robertson, which had just moved from Agra to Simla. The company, which ultimately became Howard, Shepherd, and Bourne, operated until 1870. During this period Shepherd managed the studio and printing enterprise while Bourne photographed in the field, as evidenced by Bourne's nine-month expedition into the Kashmir region in 1864. In 1866 Bourne made his final expedition in India. Accompanied by

Dr. G. R. Playfair, a botanist and geologist from Agra, he traveled for six months to photograph the source of the Ganges.

In 1867 Bourne returned to England to marry Margaret Tolley, then went again to Calcutta to open a branch of Bourne and Shepherd. In 1870 he took up permanent residence in England, and finally withdrew from the firm in 1874 after establishing a cotton-doubling mill. In 1892 he became president of the Nottingham Camera Club and Society of Artists and in 1896 retired from business to devote himself to watercolor painting.

PHILIP H. EGERTON (active 1860s)

All that is known about Philip Egerton's life is that he was deputy commissioner of Kangra during the 1860s. Thirty-five of his photographs, published in his *Journal of a Tour through Spiti* (1864) by Cundall Downes and Company, London, illustrate his desire to encourage and survey trade routes between the Chinese empire and British India. Like Samuel Bourne (whose work has sometimes been confused with Egerton's) he suffered enormous hardships photographing in remote locations. In his *Journal* he reported: "Certainly photography in these remote regions is carried on under difficulties, for my collodion . . . shrivels up and peels off the plate when drying, though carefully sheltered from the sun and wind; and I am constantly losing some of my best pictures in this way." The views Egerton brought back from these journeys reveal a photographer who surmounted these difficulties.

JOHN MURRAY (1809–1898)

John Murray's career in photography began about 1849. He is known for printing large-scale waxed paper negatives on both albumen and salted papers. Like many photographers practicing in India during the 1850s and 1860s, Murray was not a professional. A farmer's son from Blackhouse, Aberdeen, Murray studied medicine and entered the medical service of the army of the British East India Company in 1832. He was medical officer in charge of the medical school at Agra, and between 1867 and 1871 was inspector-general of hospitals in the northwest provinces. Throughout his career he specialized in the treatment of cholera, and his medical skills were a valuable asset to British troops on campaign.

In December 1857 thirty-five views by Murray were exhibited in London by the publisher J. Hogarth, beginning an association that lasted several years. Hogarth published a

pamphlet titled "Photographic Views in Agra and Its Vicinity" in 1858 and a portfolio of twenty-two prints of *Picturesque Views in the Northwestern Provinces of India* in 1859. Murray retired in 1871 but became president of the Epidemiological Society of London. He died at Sheringham, Norfolk, in 1898.

LINNAEUS TRIPE (1822–1902)

In 1839 Linnaeus Tripe was listed as an ensign under the Twelfth Regiment Native Infantry stationed at Bangalore. By 1856 he had risen through the ranks to become a captain. In 1855, when the British East India Company hired Tripe to photograph antiquities, he had already been the photographer to the British mission at the court of Ava in Burma, and as a result of the directive was appointed official photographer to the Madras presidency the following year.

Tripe's early photographs vary in quality. Owing to sickness and bad weather Tripe had only thirty-six days in which to photograph Burma. The skies of these Burmese views, published for the Madras Photographic Society in 1857, were said to have a pronounced granular texture and lack of definition, a fault typical of early negatives since different exposures were required for land and sky. Later Tripe either blacked out the sky on his negative so it printed completely white, daubed artificial clouds on the negative, or settled for a "salt-and-pepper" effect.

In March 1856 Tripe received the commission to photograph in the southern provinces important items of interest to antiquaries, historians, and architects, to document different races, and to initiate other photographic projects. The result was a series of six volumes of photographic views of "Madurai, Tanjore and Trivady, Ryakotta, Seringham, Poodoocottah, and Trichinopoly." In 1858 he returned to these regions and produced a series of stereographic views. Tripe taught the calotype process to employees of the Public Works Department of Madras and the collodion process to pupils of the Madras School of Industrial Arts. His assistant, C. Iyahsawmy, himself became a distinguished photographer, exhibiting at the Madras Photographic Society in 1858–60. The Madras administration headed by Sir Charles Trevelyan abolished Tripe's post in 1860, at which time he seems to have abandoned photography. Tripe retired in 1875 as honorary major-general and returned to England.

Did you ever build a Castle in the Air? Here is one, brought down to earth and fixed for the wonder of ages;
yet so light it seems, so airy, and, when seen from a distance so like a fabric of mist and sunbeams,
with its great dome soaring up, a silvery bubble, about to burst in the sun, that, even after you have touched it,

106–107 JOHN MURRAY, *Panorama of the West Face of the Taj Mahal, Agra*, 1850s, albumen prints from waxed paper negatives, 43.8 x 125.6, cm, VA

and climbed to its summit, you almost doubt its reality. Nothing can better illustrate the feeling for proportion which prevailed in those days—and proportion is Art. . . . Stern, unimaginative persons have been known to burst suddenly into tears, on entering it; and whoever can behold the Taj without feeling a thrill that sends the moisture to his eye, has no sense of beauty in his soul.

Bayard Taylor, *India, China and Japan*, 1855

108 SAMUEL BOURNE, *Vishnu Pud and Other Temples near the Burning Gat*, 1863–66, albumen print from wet collodion negative, 22.3 x 28.0 cm, VA

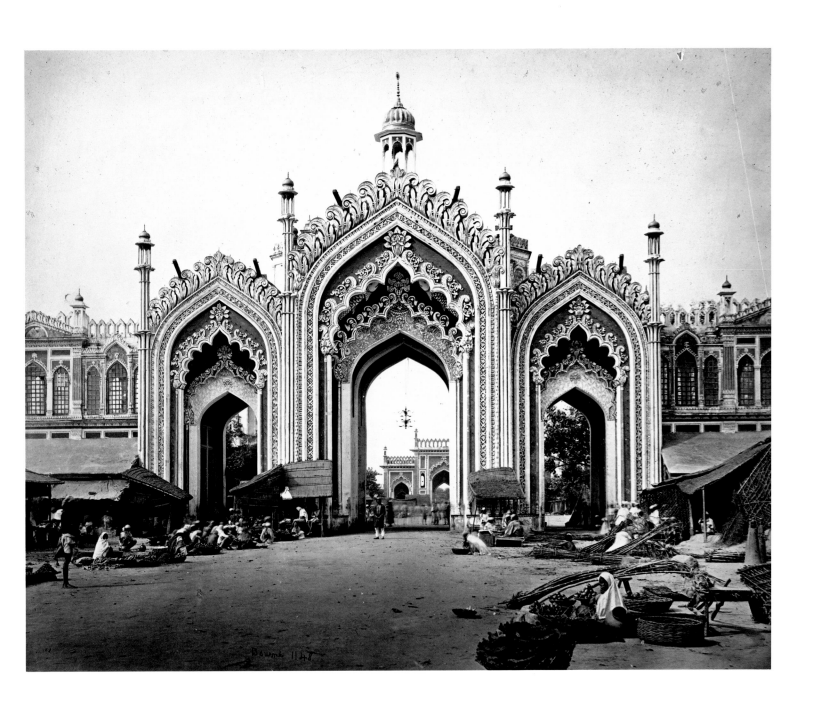

109 SAMUEL BOURNE, *Gateway of the Hooseinabad Bazaar*, 1863–66, albumen print from wet collodion negative, 22.9 x 28.4 cm, VA

110 JOHN MURRAY, *The Octagon at the Northeast Corner of the Taj Mahal, Agra,* 1850s, albumen print from waxed paper negative, 37.1 x 44.8 cm, VA

111 LINNAEUS TRIPE, *Street View, the Dome of the Rock in the Distance*, 1856–57, albumen print from waxed paper negative, 27.0 x 37.3 cm, VA

What a mighty upbearing of mountains! What an endless vista of gigantic ranges and valleys, untold and unknown! Peak rose above peak, summit above summit, range above and beyond range, innumerable and boundless, until the mind refused to follow the eye in its attempt to comprehend the whole in one grand conception.

Samuel Bourne, "Ten Weeks with the Camera in the Himalayas,"
The British Journal of Photography, 15 February 1864

112 SAMUEL BOURNE, *Valley and Snowy Peaks Seen from the Hamta Pass, Spiti Side*, 1863–66, albumen print from wet collodion negative, 23.4 x 29.5 cm, VA

113 PHILIP H. EGERTON, *Dhurmsala Church*, 1864, albumen print from wet collodion negative, 20.9 x 26.8 cm, VA

August 29th [1860] I started off in the morning for Rock creek with Lyall &
Bauermann. . . . We . . . passed over a beautiful tract of country . . . looking very much
like an English park; descending . . . we came to the first ford over the far famed Rock creek.
Here we found a party of miners, who had been working for some time, but at present
were at a standstill waiting for some timber to be sawn out. . . . The glen in which
they were working was very pretty, but the natural beauties were fast fading under
the influence of gold digging & the fine trees falling under the axe.

Charles Wilson, *Diary of the Survey of the 49th Parallel,*
while Secretary of the British Boundary Commission, 1858–62

THE ROYAL ENGINEERS

The Royal Engineers Establishment at Chatham (changed to the School of Military Engineering in 1869) was founded in 1812 by Captain (later, General Sir) Charles William Pasley for instruction of the Corps of Royal Engineers in practical architecture and surveying as well as the more traditional tasks of mining, sapping, and the design of military fieldworks. The expertise acquired by the corps was applied in a wide range of civil projects, including the construction of the South Kensington Museum and the installation of the Exposition Universelle in Paris in 1855. At the Paris exhibition several sappers received training in photography, which upon their return to Southampton was put to practical use in the reduction of military maps and plans. Sir John Burgoyne, inspector general of fortifications, then initiated a systematic training program in photography under the direction of the official photographer of the South Kensington Museum, Charles Thurston Thompson (1816–1868), with graduates to be employed throughout the empire "to send home periodical photographs of all works in progress, and to photograph and transmit to the War Department all drawings of all objects, either valuable in a professional point of view, or interesting as illustrative of history, ethnology, natural history, antiquities, etc." Photographers were sent as members of expeditions to India, China, Greece, the Isthmus of Panama, and, in 1858–62 to survey the United States–Canadian border on the Forty-ninth Parallel.

115 THE ROYAL ENGINEERS, *Cutting on the Forty-ninth Parallel, on the Right Bank of the Mooyie River Looking West,* 1860–61, albumen print from wet collodion negative, 24.5 x 22.5 cm, VA

THE ROYAL ENGINEERS, *Roman Catholic Mission on the Left Bank of the Kootenay River, South of the Boundary Line*, 1860–61, albumen print from wet collodion negative, 22.3 x 25.9 cm, VA (top)

116 THE ROYAL ENGINEERS, *Sinyakwateen Depot Camp, on the Left Bank of the Pend d'Oreille River*, 1860–61, albumen print from wet collodion negative, 22.6 x 26.1 cm, VA (bottom)

THE ROYAL ENGINEERS, *Stone Pyramid on Forty-ninth Parallel, on the Right Bank of the Eastern Intersection of the Kootenay River. Cutting on the Left Bank*, 1860–61, albumen print from wet collodion negative, 22.5 x 26.7 cm, VA (top)

117 THE ROYAL ENGINEERS, *View on Grande Prairie, Newhoialpitiu Valley*, 1860–61, albumen print from wet collodion negative, 19.0 x 24.2 cm, VA (bottom)

7. Aristocratic Amateurs

From the beginning photography was an art pursued by aristocratic amateurs. In the fashionable decade following 1851, the glamorous heyday of the Photographic Society of London, the medium became even more attractive to the well born, well connected, and well off. In 1860, for example, much was made by prominent photographers of the new volunteer movement. Uncertain relations with France and the possibility of war produced the patriotic and fashionable Volunteer Rifle Corps and off went "the Town" to musketry training at Hythe. The weekend soldiery naturally included Captain Horatio Ross, but also John Dillwyn Llewelyn, Benjamin Brecknell Turner, Oscar G. Rejlander, and Roger Fenton, "who has discovered how to be at the same time a Captain amongst Riflemen and a Captain among Photographers—at once a perfect soldier and a consummate artist" (*The Photographic Journal,* 16 July 1860: 270). Fenton preserved the spirit of the volunteers in photographs.

The International Exhibition in South Kensington of 1862 was intended to echo the triumph of 1851, and photographers were appalled to find that the commissioners of the 1862 exhibition intended to place their work not in the long-anticipated fine arts department but with machinery: "Why should photography be placed among Railway plant, locomotive engines and carriages, agricultural machines and implements, and things of this class?" asked *The Photographic Journal* (15 April 1861: 149). Representations were made from the society to the commissioners through Sir Frederick Pollock, the lord chief baron and president of the

society, who argued that "photography, quite as much as engraving, gives room for the exercise of individual genius, so as to stamp a special character on the works of photographers, and give to the result of their labours the *impress of the mind of each artist*" (*The Photographic Journal,* 15 May 1861: 171). Threatened with what was, to them, a demeaning loss of status at the very exhibition they had expected would ratify their medium as fine art, leading photographers challenged the commissioners and lobbied to alter the decision. The issue became controversial precisely because by 1861 photography had become an industry, supplying two mass markets: carte-de-visite portraits ("album portraits," as the society's *Journal* tried against the tide to rename them) and topographical views. By a compromise, photography was provided for as a class on its own, neither fine art nor machinery but "an independent art."

Even so, the photographs were placed high in the dome of the exhibition building and were reached by awkward stairs and shown in conditions that swiftly faded many of them. It was a debacle and, taken with the depression of business and the emphasis on cheapness through mass production, must go a long way toward explaining the departure from the medium of its early masters, such as Roger Fenton and Benjamin Brecknell Turner, and the relative decline from their early achievements of Francis Frith, Francis Bedford, and others.

In the 1862 exhibition, however, a new group called the Amateur Photographic Association exhibited for the first time and received a medal for "general photographic excellence." Founded in 1861, the association specifically excluded professional photographers. The prince of Wales was its patron and the earl of Caithness a leading light, along with the archbishop of York, a number of peers of the realm, and a clutch of fellows of the Royal Society. For over forty years members of the association exhibited together, compiled exchange albums, and eagerly contested prize goblets and other honors.

Notable amateurs of the 1860s pursued subjects and methods at variance with those of professional photography. A schism had been declared, and although commercial use was made of the work of Lewis Carroll (whose portrait of Xie Kitchin appears above) and later that of Julia Margaret Cameron, their status as amateurs remained unchanged. The new divide may have prompted such intensely productive amateurs as Clementina, Lady Hawarden, to an exaggerated but technically brilliant freedom in the use of light as the graphic hallmark of "*the impress of the mind of [the] artist.*"

It is sometimes thought that the amateurs were remote from the artistic and technical currents of the time, but this was rarely true. Lady Hawarden, for example, was admired for her technical excellence. Her acquaintances included the surgeon and etcher Sir Francis Seymour Haden, a frequent visitor to the family house at Dundrum. Haden made at least one etching based on a photograph by Lady Hawarden, worked with the same woodland

subjects, and as brother-in-law of James Abbott McNeill Whistler was associated with major contemporary art. The professional portrait photographer Jabez Hughes published a "Tribute to Amateurs" in 1863 and generously argued that

> Though the extensive diffusion and numerous applications of the art depend upon the professional, yet it must be always borne in mind that the original discoveries—marked improvements—are made by the amateur. . . . It is scarcely to be wondered at that the impulses forward should emanate rather from the amateur than the professional. The former pursues the art for pleasure, the later for profit. The one can try all manner of experiments, and whether he succeeds or fails, he secures his object—agreeable occupation. The professional has all his energies directed to make things pay. He has too much at stake to speculate. (The British Journal of Photography, 1 December 1863: 466)

JULIA MARGARET CAMERON (1815–1879)

Julia Margaret Cameron was the third daughter of James Pattle, a civil servant stationed in Bengal. In 1834 she married Charles Hay Cameron, a philosopher, a Benthamite jurist, and, as a member of the Council of Calcutta, a leading figure of expatriate society in India. The Camerons moved to England in 1848 and lived briefly in Tunbridge Wells, where Mrs. Cameron began a lifelong friendship with Sir Henry Taylor (author of Philip van Artevalde) and his wife. Through her sister Sara Prinsep, who held a weekly salon, Cameron met some of the great artistic and literary figures of the day, among them George Frederic Watts, Sir John Herschel, William Makepeace Thackeray, and Alfred, Lord Tennyson.

Cameron took up photography late in 1863, after her daughter Julia and son-in-law had presented her with a camera. Throughout her career her work, distinguished more for its mood than for its mastery of technique, met with mixed critical reaction. A critic writing in Photographic Notes (9[1864]: 171), for example, judged it to be "admirably expressive and vigorous, but dreadfully opposed to photographic conventionalities and properties." She was compared unfavorably with David Wilkie Wynfield, who had taught her the rudiments of photography. At the Exposition Universelle in Paris of 1867 she received her greatest accolade—place of honor next to the photographs of Henry Peach Robinson and Oscar G. Rejlander. She hired the P. and D. Colnaghi gallery in 1866 and the German Gallery in 1868, but these exhibitions were not successful. Most often decried by the critics as a technical failure, the out-of-focus quality of Cameron's work was intentional. In Annals to My Glass House (1874) she confessed, "When focussing and coming to something which, to my eye, was very beautiful, I stopped there instead of screwing on the lens to the more definite focus which all other photographers insist upon." Her exposure times, from three to seven minutes, also caused blurring, since some of her subjects inevitably moved.

Initially Cameron experimented with allegorical and religious subjects, but by 1866 she had begun the expressive portraiture for which she is best known. In the early 1870s she turned to illustrations of poetic works, most notably Tennyson's Idylls of the King (1874 and 1875), which was her last large-scale photographic project. Late in 1875, because of her husband's ill health, the Camerons left for Ceylon, where Cameron executed her last few works. She died in Ceylon in 1879.

LEWIS CARROLL (1832–1898)

Lewis Carroll's fascination with children inspired his extraordinary contributions both to writing and to portrait photography. He is known primarily as the author of the children's classics Alice's Adventures in Wonderland (1865), Through the Looking Glass and What Alice Found There

(1871), and The Hunting of the Snark (1876). The first two books were written for Alice Liddell, daughter of Carroll's friend Dean Liddell; Alice was also the subject of one of Carroll's first successful photographs, taken in 1856.

Carroll was born Charles Lutwidge Dodgson, the eldest son of the Reverend Charles Dodgson. He was educated at Rugby and Christ Church, Oxford, where he lived from 1851 until his death in 1898. In 1852 he became a student of Christ Church and four years later began to lecture in mathematics. In 1861 he was ordained a deacon. In 1855 Carroll's uncle Skeffington Lutwidge, an amateur photographer, had introduced him to the calotype process, but it was not until Carroll had seen the annual exhibition at the Photographic Society of London in January 1856 that he acknowledged the potential of the medium: William Lake Price's picture The Scene in the Tower proved an inspiration. On his return to Oxford, Carroll and Reginald Southey, another student at Christ Church, together bought wet-collodion apparatus. Carroll was essentially self-taught, and for locations used his rooms in college, the Deanery, or sometimes hired a studio. By 1857 photography had assumed a major role in his life. His diaries document his encounters with Oxford academics, clergy, and their children, and his attempts—usually successful—to have them sit for him. Carroll did travel farther afield for subjects—in September 1857 he photographed the Tennyson family in the Lake District.

Carroll did not belong to photography clubs and societies but did have links with families active in the field. His cousin Charles Pollock was a son of Sir Frederick Pollock. And Carroll exhibited his work: the 1858 catalogue of the Photographic Society lists four portrait studies by C. L. Dodgson. By the end of the 1850s Carroll had written on photography in his Hiawatha's Photographing, The Legend of "Scotland," and A Photographer's Day Out. He also published, in 1860–61, a private circulation catalogue listing for sale 159 photographs of clergy. Most of Carroll's portraits are straightforward but some genre pieces do appear. He was familiar with the narrative work of Oscar G. Rejlander, who photographed Carroll in March 1863. Carroll's own celebrity portraits included artists and poets such as the Rossettis, Alphonse Legros, Arthur Hughes, and Alexander Munro.

CLEMENTINA, LADY HAWARDEN
(1822–1865)

Lady Hawarden was born at Cumbernauld House, near Glasgow. Her father was Charles Elphinstone-Fleming, member of Parliament for Stirlingshire and governor of Greenwich Hospital. She married Cornwallis Maude, fourth viscount Hawarden and Baron de Montalt of Hawarden, in 1845.

Lady Hawarden used her four children as her principal models; other models included her husband and staff at the family's house Dundrum, Cashel, County Tipperary. Most of the studies were taken at the house in Prince's Gate, South Kensington (now demolished). Lady Hawarden exhibited photographic studies at the Photographic Society's exhibitions in 1863, when she was awarded a medal as the best amateur exhibitor, and 1864, when she showed "studies from life" and photographic studies, which won her the medal for the best composition from a single negative. Her work was generally well received by her contemporaries: commenting on the exhibition of 1864 Lewis Carroll said, "I did *not* admire Mrs. Cameron's large heads, taken out of focus. The best of the life ones were Lady Hawarden's" (quoted in Helmut Gernsheim, *Lewis Carroll, Photographer*, 1949, p. 55).

Oscar G. Rejlander wrote Lady Hawarden's obituary in *The British Journal of Photography* (27 January 1865: 38):

The Lady Hawarden is gone to the source of all light. She was an earnest believer in the progress of photography, and that it could be used as an art and abused like a daub. She worked honestly, in a good comprehensible style. She aimed at elegant and if possible, idealised truth. There was nothing of mysticism nor Flemish Pre-Raphaellistic conceit about her work. So also was her manner and conversation — fair, straightforward, nay manly, with a feminine grace. She is a loss to photography, for she would have progressed. She is a loss to many many friends.

Over 600 photographs by Lady Hawarden are in the Victoria and Albert collection.

HENRY ARTHUR HERBERT (1840–1901)

Major Henry Arthur Herbert of the London Irish Rifles, member of Parliament for County Kerry, Ireland, 1866–80, may have been the amateur photographer whose work is collected in the album assembled by the Herbert family of Muckross, County Kerry. Muckross House, an Elizabethan revival manor built in 1843, is the likely setting, and Herbert's sister Blanche Herbert, who is known to have compiled similar photograph albums, may be the sitter in one of these graceful interiors.

THE ROSSETTI ALBUM

Dante Gabriel Rossetti (1828–1882) is well known as a painter and poet. He was a pupil of Ford Madox Brown and later shared a studio with William Holman Hunt, with whom he and John Everett Millais founded the Pre-Raphaelite Brotherhood in 1848–49. In 1860 he married Elizabeth Siddal, the model who had been an inspiration for many of his early paintings. Rossetti knew Edward Burne-Jones and William Morris from the 1857–58 period he had spent working on the Oxford Union frescoes, and soon after was introduced to Jane Burden, who became Morris's wife. Upon the death of Siddal in 1862 Rossetti developed a close friendship with Jane Morris, whose beauty played a part in many of his later paintings, including *The Daydream* (1880).

Rossetti is not known to have had an interest in photography, but on 5 July 1865 he sent a letter to Jane Morris that read, "My dear Janey, the photographer is coming at eleven on Wednesday. So I'll expect you as early as you can manage. Love to all at the Hole-Evers. Yours, D. G. Rossetti." The result of the photographic session was a series of portraits of Jane Morris. Although the camera was operated by an anonymous photographer, the prints are "in essence original compositions by Rossetti, and the proportion of figure to space is an expressive part of his intention," according to George Bottomley, who was commissioned in the 1930s to compile the photographs into an album and to make modern prints from the original negatives.

DAVID WILKIE WYNFIELD (1837–1887)

David Wilkie Wynfield was born in India, where his father, James Stainback Wynfield, was captain of the Forty-seventh Bengal Native Infantry. Wynfield's mother, Sophie Mary Burroughes, was the niece and adopted daughter of the Scottish artist Sir David Wilkie and appeared in many of his paintings. Captain Wynfield retired from the army, returned to England, and died in 1842.

Wynfield had first planned to become a priest but in 1856 entered the studio of J. M. Leigh. He became known as a painter of genre subjects drawn from English history: paintings entitled *Death of Cromwell; Ministers in an Adjoining Room, Whitehall, Friday 3 September 1658* (in the Victoria and Albert Museum) and *The Last Days of Elizabeth, When the Queen Groweth Sad, Mopish, and Melancholy*, which was exhibited at the Royal Academy in 1865, are typical of his work. Wynfield was also the founder of the St. John's Wood Clique. This was a group of young artists who, like the Pre-Raphaelite Brotherhood before them, embraced the vision of a past world.

Wynfield became a proficient photographer, and in 1864 Julia Margaret Cameron came to him as a pupil, later insisting that "to his beautiful photography I owe all my attempts and indeed consequently all my successes." Wynfield himself made a series of portraits of Royal Academicians in Tudor and Renaissance costume chosen to express the sitters' personalities. These photographs share the atmospheric, impressionistic quality that became the hallmark of Cameron's work. They were exhibited at the Photographic Society of London in the early 1860s and some were published by the Messrs. Herring of Regent Street under the title *The Studio*. In 1867 Yeames and his wife (Wynfield's sister, whom Yeames married in 1865), the Camerons, and Wynfield and his mother rented Hever Castle; Wynfield, in his passion for Tudor England, had hoped to photograph the ghost of Anne Boleyn while on holiday. With his death in 1887 the clique disbanded and photography lost—as Cameron described her mentor to Sir John Herschel—"its Great Amateur."

121 PHOTOGRAPHER UNKNOWN, *Portrait of Jane Morris* (from the Rossetti album), 1865,
albumen print from wet collodion negative, 19.9 x 14.8 cm, VA

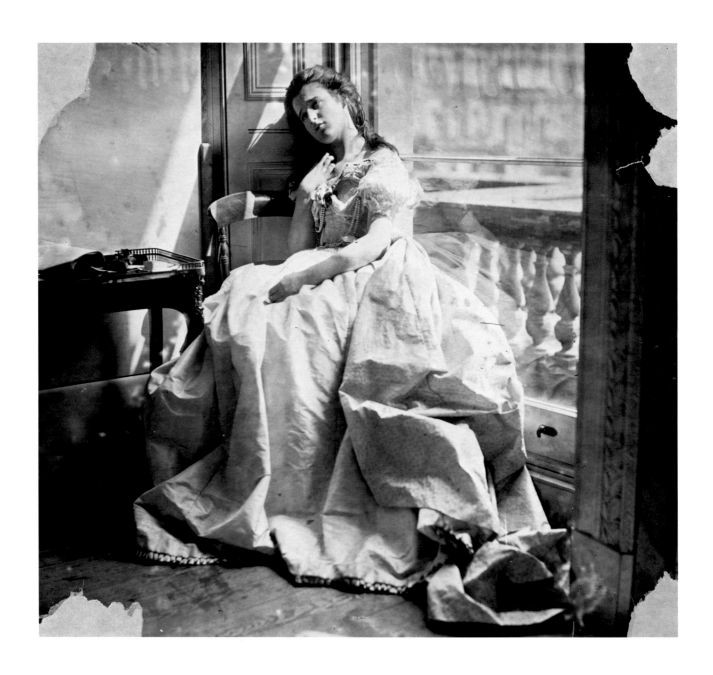

All at once breaks a small light in the far West, and a new world slowly widens to our sight—new sky, new earth, new flowers, a very heaven compared with the old earth. The new land is Photography, Art's youngest and fairest child; no rival of the old family, no struggler for worn-out birthrights, but heir to a new heaven and a new earth, found by itself, and to be left to its own children. For photography there are new secrets to conquer, new difficulties to overcome, new Madonnas to invent, new ideals to imagine. There will be perhaps photograph Raphaels, photograph Titians, founders of new empires, and not subverters of the old.

Essay by "Theta," *Journal of the Photographic Society*, 21 February 1857

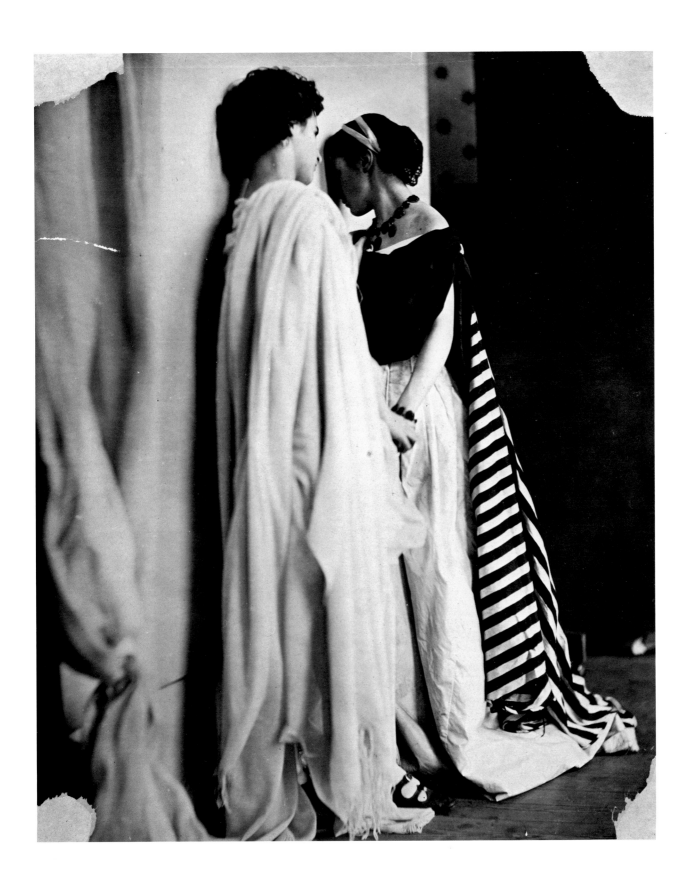

123 CLEMENTINA, LADY HAWARDEN, *Photographic Study*, early 1860s, albumen print from wet collodion negative, 23.6 x 19.2 cm, VA

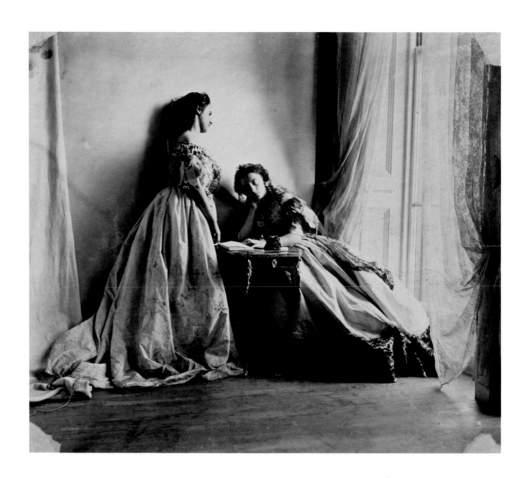

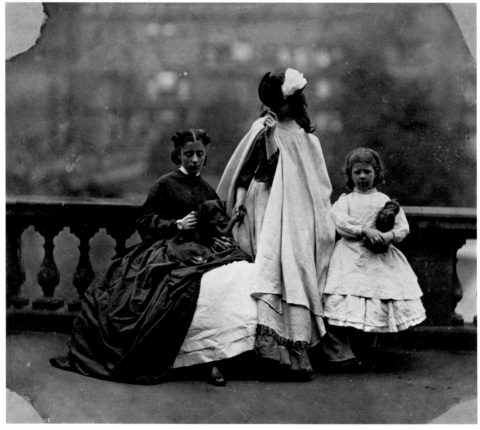

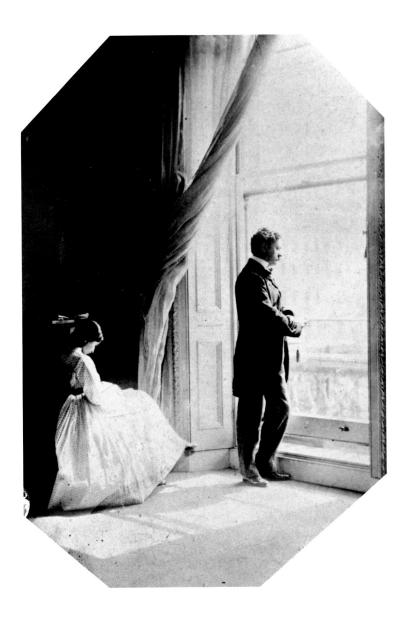

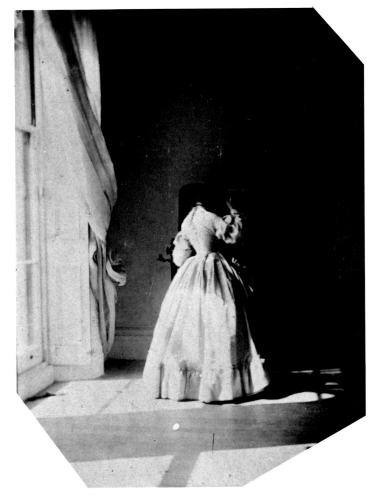

CLEMENTINA, LADY HAWARDEN, *Photographic Study*, early 1860s, albumen print from wet collodion negative, 11.4 x 7.7 cm, VA (top)

125 CLEMENTINA, LADY HAWARDEN, *Photographic Study*, early 1860s, albumen print from wet collodion negative, 11.9 x 9.2 cm, VA (bottom)

126 LEWIS CARROLL, *Portrait of a Clergyman*, 1860s, albumen print from wet collodion negative, 18.8 x 14.0 cm, VA

127 LEWIS CARROLL, *Portrait of Thomas Woolmer*, 1860s, albumen print from wet collodion negative, 16.0 x 12.5 cm, VA

128 Attributed to HENRY ARTHUR HERBERT, *Interior,* ca. 1865, albumen print from wet collodion negative, diam. 23.7 cm, VA

129 Attributed to HENRY ARTHUR HERBERT, *Corridor, Muckross House*, ca. 1865, albumen print from wet collodion negative, diam. 21 cm, VA

130 DAVID WILKIE WYNFIELD, *Portrait of John Everett Millais in Fancy Dress*, early 1860s, albumen print from wet collodion negative, 21.3 x 16.3 cm, VA

131 DAVID WILKIE WYNFIELD, *Portrait of William Holman Hunt*, early 1860s,
 albumen print from wet collodion negative, 21.1 x 16.2 cm, VA

Julia Margaret Cameron
Christian Pictorialist

Mike Weaver

My mortal but yet divine! Art of photography
Julia Margaret Cameron

Artists of the Victorian period had high standards for high art: fine art was morally neutral, capable of inspiring good or evil thoughts in equal measure, but high art expressed a lofty and religious ideal, a grand moral purpose. For Julia Margaret Cameron, it was the firmness of her Christian beliefs that allowed her to place photography in those exalted realms.

As a photographer she was not alone in her convictions; the religious foundation of Victorian taste was very deep, frequently attached to an appreciation of artists of the past thought to have captured that moral purpose. A small David Octavius Hill and Robert Adamson album at the National Library of Scotland, for example, contains a reproduction of Raphael's Sistine Madonna; Hill was to continue his interest in Raphael after Adamson's death. Sigmund Freud, who viewed the same Raphael Madonna in Dresden in 1883, just four years after Julia Margaret Cameron's death, made an observation that aptly captures the Victorian view: "One would think her sixteen years, she looks into the world with such innocence and liveliness that the idea obtruded itself against my will that she was a charming and appealing nursemaid from our own world rather than from heaven."[1] This was the aspect of the divine that appealed to Cameron; she photographed maids from her own world, yet presented the images as if from heaven.

Prince Albert, who acquainted himself with Raphael through photographic reproductions and engravings, was instrumental in the great Raphael revival of the nineteenth century. Another important figure in the Victorian fervor for the Italian High Renaissance was the writer Anna Jameson, who brought before the public the fruits of the latest German art historical research on the subject. For six years she worked on her great opus, in its first edition called *The Poetry of Sacred and Legendary Art* (1848). She went on to produce further works in the series, *Legends of the Monastic Orders* (1850), *Legends of the Madonna* (1852), and *The History of Our Lord* (1864), substantially completed for her by Lady Eastlake (née Elizabeth Rigby) after Jameson's death in 1860. Early editions of *Sacred and Legendary Art* had woodcuts after line drawings of Italian art by Jameson herself, but in the

1850s these were replaced by those of her niece Gerardine Macpherson, wife of the photographer of Rome, Robert Macpherson.

Anna Jameson disavowed any drift toward Romanism in paying such attention to Catholic iconography: "I hope it will be clearly understood that I have taken throughout the aesthetic and not the religious view of those productions of Art which in as far as they are informed with a true and earnest feeling, and steeped in that beauty which emanates from genius inspired by faith, may cease to be Religion, but cannot cease to be Poetry; and as poetry only have I considered them."[2] Aubrey de Vere, an intimate friend of Cameron's, was a poet and a Catholic convert. He accompanied Sir Henry Taylor, Cameron's closest friend, on his Italian journey of 1844 and wrote about his passionate interest in Perugino, Pinturrichio, and Fra Angelico. Taylor may have come back from these travels with the *Madonna and Child with the Young Saint John* by Francia, now in the Ashmolean Museum, Oxford. What de Vere appreciated in early Italian painting was a fully developed Christian symbolism, firmly founded on the idea of the Incarnation, "mortal but yet *divine!*" Cameron undoubtedly believed with them—and with Freud—that in Raphael's painting the Word had been made flesh in a nursemaid. She went on to believe that this incarnation extended to poets and natural philosophers.

If Cameron was no less Protestant and no more Catholic than the iconographers Anna Jameson and Lady Eastlake, she was no less interested in religious art. She engaged Sir John Herschel on theological questions, writing to him about the Cambridge history professor J. R. Seeley's *Ecce Homo: A Survey of the Life and Work of Jesus Christ* (1866), and getting a sternly conservative reply.[3] She sent him a series of photographs that she described as "a theological work of some Interest." Herschel responded that he preferred her "other manner."[4] Like Jameson, Cameron thought that Christian iconography should merge with poetry in the way that classical allusions merged in Tennyson's poetry. Classical, Christian, and Arthurian elements must sit together at the same Round Table. She posed Sir John Herschel in the velvet cap of a Nazarene, but he thought of it merely as the cap of a paterfamilias. She wrapped Tennyson in a blanket, and he called the image "The Dirty Monk," knowing that the monastic was less favored than the chivalric, that the image of the bo-

hemian *barbu* was unheroic for a poet. That same day, 3 June 1869, she photographed him again, this time as a contemporary man of letters, with collar and tie. It was nearer to the John Mayall portrait he preferred, but much finer.[5]

Cameron had friends of many shades of Anglican opinion. Tennyson may have had religious doubts, but his religious confidante Agnes Weld gave Julia's husband, Charles Cameron, a Book of Common Prayer that found its way into Tennyson's wife's library.[6] Sir Henry Taylor had doubts too, but his close friend de Vere was the friend of Cardinal Newman and Cardinal Manning. Coventry Patmore, who reviewed Cameron's exhibition of 1866, became a famous Catholic convert in 1864. Cameron's name appears on the cover of a copy of his *Odes* (1868), poems of parental and marital life in a heightened style. But Patmore complained of Cameron's photographs that figures from life could not be composed in the manner of the masters without avoiding "the effect of the 'realistic' air which most of her groups persist in maintaining for themselves, after all has been done to bring them into the pure region of ideality."[7] He would have preferred a Romantic idealism to the near sacrilegious realism or literalism always potential in photography.

Sir Charles Eastlake, Elizabeth's husband, had written in *Contributions to the Literature of the Fine Arts* (1848) that the subjects of the Old Testament were universally considered, in early Christian art, to be types or models for the New Testament: "The selection, or at least the treatment, of subjects for the Gospels, may have been regulated in some instances also by their assumed correspondence with certain prophecies; indeed, the circumstances alluded to in the predictions of the Old Testament are not unfrequently blended in pictures with the facts of the New."[8] In Victorian typological allegory one event or person may be seen in terms of another while retaining the identity of the first. So, if history may be said to span from the Creation to the Judgment Day, all the lives and events between are capable of typological interpretation. John the Baptist is the forerunner of Christ; Rachel, who opens the well so the sheep may drink, prefigures the angel who rolls away the stone of the Sepulcher. This retro- and prospective way of thinking was practiced by the Pre-Raphaelites in their narratives of life under the druids, but Cameron was not concerned with realist narrative. Her biblical references are so idealized and unspecific as to be entirely overlooked. Yet her series "of some theological interest" constitutes an oeuvre that is epic in quality.

Cameron's *Return after Three Days* is sometimes called *The Return from the Temple*.[9] In the social sense, it is a Victorian problem picture (where is the father?), but it is also a problem picture in a metaphysical sense: Where is the Father? Under the *Return from the Temple* title, the absentee is Joseph; under *The Return after Three Days*, the Resurrection, the Father is not absent at all because God the Son is God the Father incarnate. The biblical quotation appended in Cameron's hand on one print, "Wist ye not your Father and I sought thee sorrowing?,"[10] extends the meaning to the Crucifixion as well as to the Finding among

the Doctors. The flowers symbolize the Day Spring and the Sepulcher. That the child is neither twelve nor thirty-three is immaterial; the shadow of the cross fell upon Christ at his birth. So Cameron did not treat the theme as Holman Hunt did, showing an adult figure with the shadow upon the wall. She pictured a sleeping child under the watchful eye of his mother in the manner of Guido Reni, or clutching a wooden toy cross, or in a composite picture with three women, which also serves as an

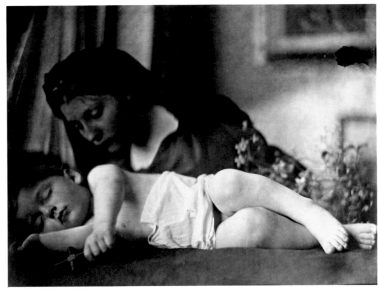

Julia Margaret Cameron, *The Shadow of the Cross*, August 1865, VA

Adoration and the Three Marys at the Sepulcher. The three girls in *The Return after Three Days* are types for the three adoring and sorrowing Marys. The roses and lilies they offer symbolize a Passion of perfect purity in death as well as birth. In a picture like *The Red and White Roses*[11] puberty controlled by the Christian spirit may be the theme, but the pictorial elements are related to *The Return* because of the contextual serialism of Cameron's work. It does not require the kind of detailed interpretation that the critic John Ruskin applied to Tintoretto's *Annunciation*, but it does require wide comparison with other Cameron images.

In Charles Allston Collins's painting *Convent Thoughts*, the passionflower is offered for symbolic interpretation in terms of the open missal; in Cameron's *Maud*, the actual lines by Tennyson that it illustrates,

There has fallen a splendid tear
From the passion-flower at the gate.

are extratextual; that is to say, the picture refers as much to Cameron's other work as it does to Tennyson's poem. The figure who momentarily expresses Maud otherwise typifies the angel at the Sepulcher, the Guinevere of the *Idylls of the King*, and the Ophelia of *Hamlet*. So Cameron—who loved flowers—does not use the passionflower in a medieval sense to represent the Passion of Christ (leaves, spear; tendrils, whips; and so on). Instead, it is a humanist symbol of a love, now fierce, now penitent.

Cameron's difficulty in reconciling the sacred to the profane

133

derived both from the anxieties peculiar to her day and her own passionate nature. Tennyson, Patmore, and Cameron sought to sublimate desire and to make desire sublime. They were as possessed by Cupid as they were devoted to Psyche. This is why Cameron's angels and cupids are interchangeable. Some of her

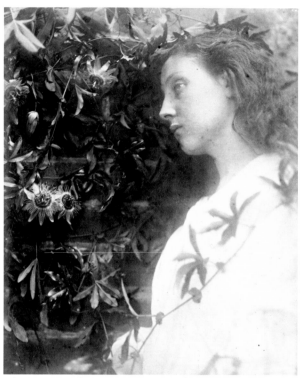

Julia Margaret Cameron, *From "Maud,"* ca. 1867–70, VA

versions of Cupid evoke classical sensuality or the Entombment of Christ, but they never suffer the prurience that dominates Lewis Carroll's sickly children. For Cameron, sensuousness and holy sadness could be compatible.

Anna Jameson believed that classical subjects were suitable for contemporary art: "In the mythology of the Pagans the worship was to *beauty, immortality,* and *power,* and in the Christian mythology—if I may call it so—of the Middle Ages, the worship was to *purity, self-denial,* and *charity.*"[12] In her "Notes on Art" she asked herself how Greek legend could be used by contemporary artists in the way poets like Goethe and Keats had used the classial tradition in *Iphigenia* and *Hyperion.*[13] She allowed that occasions could arise when "an abstract quality or thought is far more impressively and intelligently conveyed by an *impersonation* than by a *personification,*" meaning that Jonathan and David (or Pylades and Orestes) might impersonate friendship, for instance. Angels should have a "bodily type," under which they could be represented. David as king-hero, prophet-poet, should not be represented as a young Apollo or an Orpheus. Contrasting phases of the destiny of women could be represented by Rebecca and Rachel. Characters from Shakespeare and Spenser could be used. She especially recommended Miranda and Cordelia. In her *Characteristics of Women* (1858) she wrote that "if Cordelia reminded us of anything on earth, it is one of the Ma-

donnas in the old Italian pictures."[14] But she insisted that these Shakespearean characters "must either have the look of real individual portraiture, or become mere idealizations of certain qualities; and Shakespeare's creations are neither one nor the other." Likewise, Cameron's *The Mountain Nymph, Sweet Liberty* is both an individual portrait and an illustration from John Milton's *L'Allegro,* an idealization of vital womanhood.[15]

In impersonating one role, however, some of Cameron's actors are found to be entitled to another. Furthermore, any part played at a given moment is modified by a succeeding role. Sir Henry Taylor played King Ahasuerus, Prospero, and King David. The basic type, which is David, affects the perception of Taylor as Taylor as well as Taylor as Ahasuerus. Similarly, Tennyson partakes of Arthur, and Charles Cameron, the Benthamite, is curiously related to Merlin, the rationalist, whom he plays in *Idylls of the King.* There are also cross relations among the types. King Ahasuerus and King Lear are played by Taylor and Charles Cameron, respectively, and the two kings have much in common: they both have women less than compliant to their wills. Accordingly the personae of Taylor and Cameron are affected by the sharing of the type. Young Freddy Gould impersonated Astyanax, a classical type of Christ, and Cupid. In many pictures the heroic, sacrificial, and erotic are successfully combined.

Even more complicated, when a type is created by more than one actor a subtle metamorphosis of the characteristics of the type takes place before our eyes. The basic type that Cyllene Wilson impersonates as *Ophelia, The Angel at the Sepulchre,* and in *The Dream* is Mary Magdalene. But the Magdalene figure is modified by the uncanny resemblance of the actor to Mary Hillier, who plays the Madonna.[16] The image itself embodies the reality of the metamorphosis from sinner into saint. The mark of divine love is that what one dreams becomes a reality, in the twinkling of an eye. In one *Study of a Woman's Head,*[17] it is difficult to judge whether the model is Hillier or Wilson, yet we are sure she belongs among the Magdalenes rather than with the Madonnas; with the Wilson persona rather than the Hillier persona. Here the Magdalene is patron saint: the head drapery forms a dark nimbus; this woman knows sin and sorrow but is beyond penitence and despair. In another version, *The Angel at the Tomb,* Cameron has the light striking the model's hair in an echo of the quotation she appended to the print—"God's glory smote her on the face"—which is followed by a footnote: "A coruscation of spiritual & unearthly light is playing over the head in mystic lightning flash of glory."[18] The lightning flash gives the angel not so much a spiritual presence as a bodily vitality, a look of human reality, unexpected in any order of angels. As Jameson wrote,

Of all the personages who figure in history, in poetry, in art
Mary Magdalene is at once the most unreal and the most real:—
the most unreal, *if we attempt to fix her identity, which has*
been the subject of dispute for ages; the most real, *if we consider*
her as having been, for ages, recognised and accepted in every

Christian heart as the impersonation of the penitent sinner absolved through faith and love.[19]

The doctrine of religious reserve controls Cameron's approach at a moral level, where the sensuous and the spiritual are reconciled. No alabaster boxes of ointment intrude upon this portrait idealization.

Cameron perceived life as a metaphysical whole. When Florence Fisher was not Florence Fisher she could be John the Baptist as a child—no different, despite her sex, from Freddy Gould,

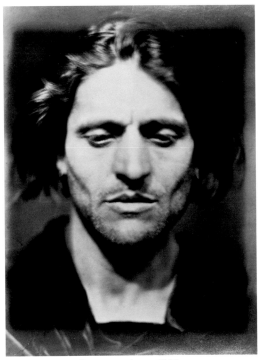

Julia Margaret Cameron, *Iago*, 1867, VA

another impersonator of the Christ-type. When Mary Spartali was not Mnemosyne, mother of the muses, she could be Hypatia, the neo-Platonist philosopher denounced as a Circe and murdered by the church at Alexandria. The Sir John Herschel album contains an image entitled *Iago*.[20] The bristled beard and sunken cheeks over fine Mediterranean bones present an ambiguous front. Is it Satanic, or is it Christian? This Iago of Mrs. Cameron, is he not a man of infinite sorrows? She could have called him Judas, the contratype of Christ, but that might have given too much away. She was treading the verge of profanity. Yet if George Eliot used Jews and Italians as interchangeable racial types, and Italian models in London, like this one, could be used for both classical and biblical subjects, could we not have here a preposterous and beautiful attempt to depict Christ?

Shakespeare and Tennyson are the poets who contribute to Cameron's typological approach to history. They offer a third Testament. In King Arthur, Tennyson provided a British Messiah. King-hero of a united people of Britons, Saxons, and Normans, he was used by successive English kings to imbue them with divinity and offset the power of the Roman church. As sons of empire the Cameron family subscribed to that Anglo-

Saxonism, no matter how liberally they served the empire. Natives were natives, servants were servants, but this did not mean that the Holy Family could not be recognized in every one of them. Thomas Carlyle, whom Mrs. Cameron photographed, and Thomas Macaulay, with whom Charles Cameron served in India, were propagandists of a racial and social doctrine which supported the Anglo-Saxonism of the age. Julia Margaret Cameron made at least one image of the early British heroine Boadicea. In her eyes Tennyson was King Arthur, *redivivus*; a second manifestation of ideal British manhood.

Cameron, like Tennyson, cast her work in an idyllic mode, while appearing to fulfill the conventional categories of genre, illustration, and portraiture. One poem by Tennyson, which Cameron illustrated, is entitled *The Gardener's Daughter; or, The Pictures*. Such pictures are allusive, discontinuous, heightened in feeling, and achieve their meaning by juxtaposition. They are emblematic and circumstantial at the same time. But all of her work is illustrative in the sense that it consists of pictured moments of emotional intensity relating to a spiritual and ideal world.

The various ideals of the Victorian age were intricately intertwined. In 1862 Hill and Alexander Macglashon published a photograph of *The Sculptor of 'Sir Galahad, the Good Knight,'* with an engraving of Raphael's *Parnassus* in the background. The picture is "inscribed" to the religious and Arthurian Scottish painter, Sir Joseph Noel Paton. The woman has a Christian, Raphaelite air, the background is a classical Raphaelite subject, and the title and the inscription evoke the world of Arthurian chivalry. This kind of Christian pictorialism, in which myths blend together as poetry, contributed not only to new directions in fine art photography but formed the basis of Cameron's religious sensibility. Her genius was as deeply embedded in her age as her work was expressive of it.

NOTES

1. I owe this reference to Simon Haviland, from E. H. Gombrich, "Freud's Aesthetics," *Encounter*, January 1966: 31. **2.** Anna Jameson, *Sacred and Legendary Art*, 9th ed. (London, 1883), vol. I, p. vii. **3.** See Colin Ford, *The Cameron Collection* (London, 1975), p. 142. **4.** Ibid., p. 104–42. **5.** Helmut Gernsheim, *Julia Margaret Cameron* (Millerton, N.Y.: Aperture, 1975), p. 93. **6.** My knowledge of the titles of the books that Cameron gave to Tennyson is gleaned from *Tennyson in Lincoln*, Nancie Campbell, comp. (Lincoln: Tennyson Society, 1971), vol. I. **7.** [Coventry Patmore], "Mrs. Cameron's Photographs," *Macmillan's Magazine* 13 (1866): 231. **8.** Sir Charles Eastlake, *Contributions to the Literature of the Fine Arts* (London, 1848), p. 18. **9.** Ford, *The Cameron Collection*, pl. 130. **10.** This print is at George Eastman House, Rochester, New York. **11.** Ford, *The Cameron Collection*, pl. 56. **12.** Anna Jameson, *A Commonplace Book* (London, 1854), p. 164. **13.** Ibid., pp. 330–71. **14.** Anna Jameson, *Characteristics of Women* (London, 1858), vol. II, p. 117. **15.** Gernsheim, *Julia Margaret Cameron*, p. 157. **16.** Ibid., p. 151. **17.** Ibid., p. 163. **18.** Inscription on the print at George Eastman House. **19.** Jameson, *Sacred and Legendary Art*, vol. I, p. 343. **20.** Ford, *The Cameron Collection*, pl. 69.

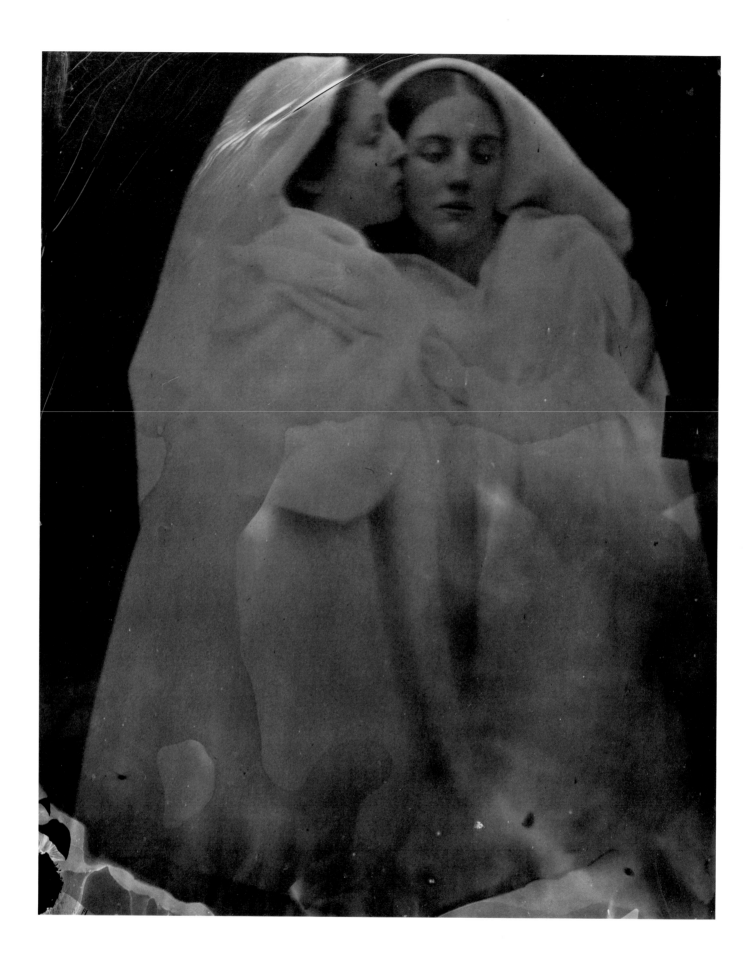

136 JULIA MARGARET CAMERON, *Ioland and Floss [Mary Hillier and unidentified woman]*, 1864–65, albumen print from wet collodion negative, 25.4 x 20.7 cm, VA

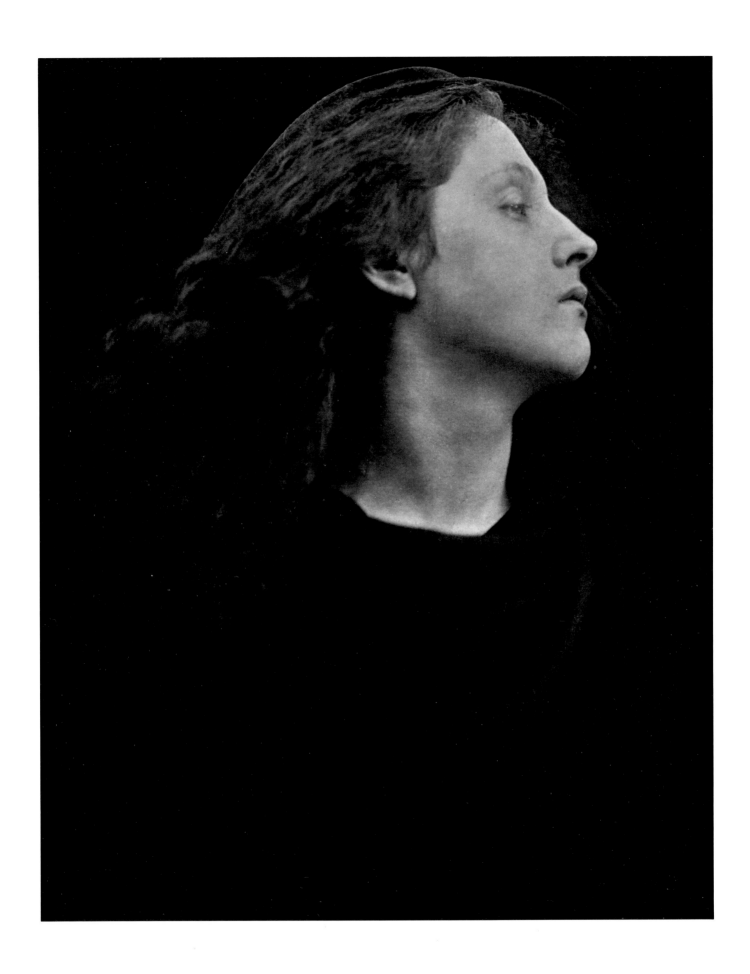

137 JULIA MARGARET CAMERON, *Portrait of Mary Hillier*, 1865–75, carbon print, 35.0 x 26.7 cm, VA

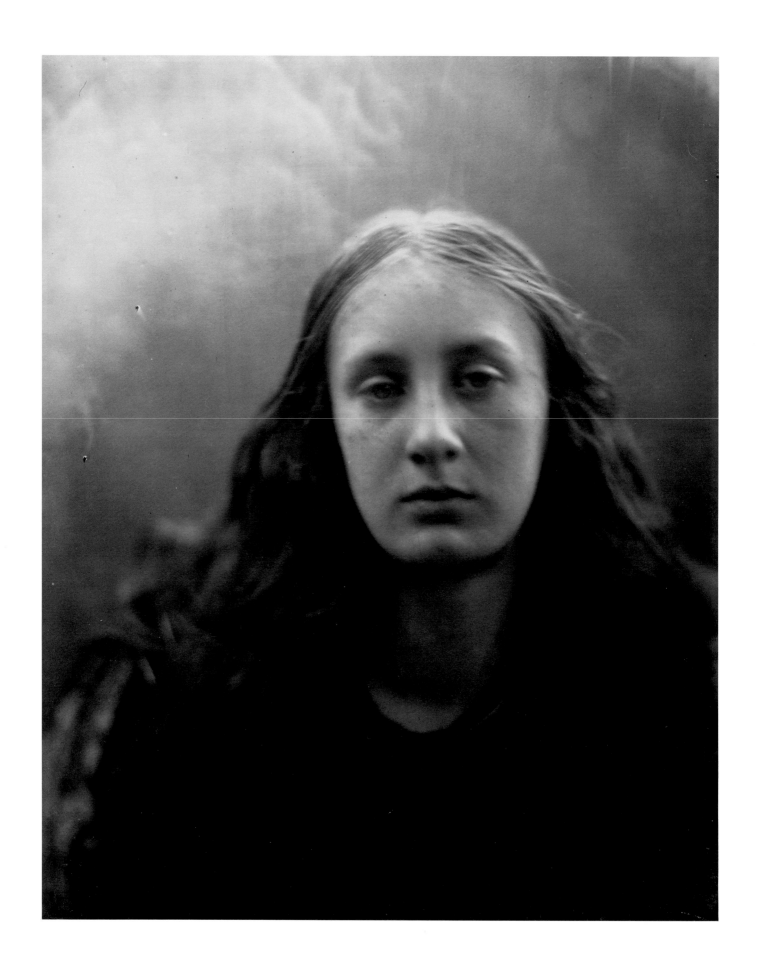

138 JULIA MARGARET CAMERON, *Christabel [Portrait of May Prinsep]*, ca. 1867, albumen print from wet collodion negative, 33.7 x 27.7 cm, VA

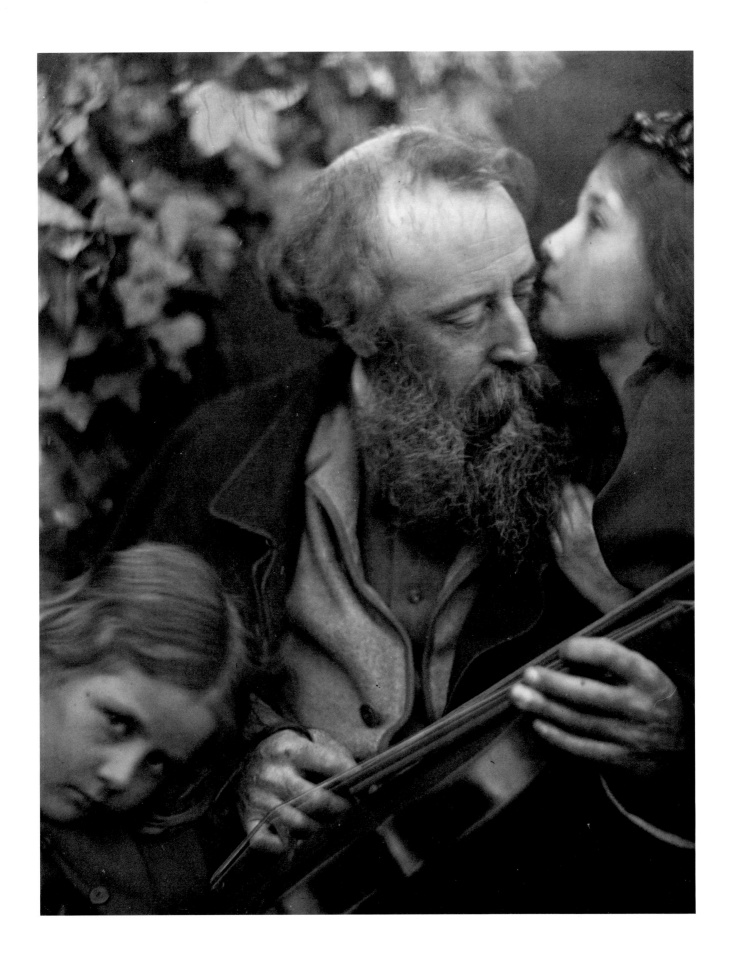

139 JULIA MARGARET CAMERON, *Whisper of the Muse [George F. Watts]*, 1864–65, albumen print from wet collodion negative, 25.2 x 19.7 cm, VA

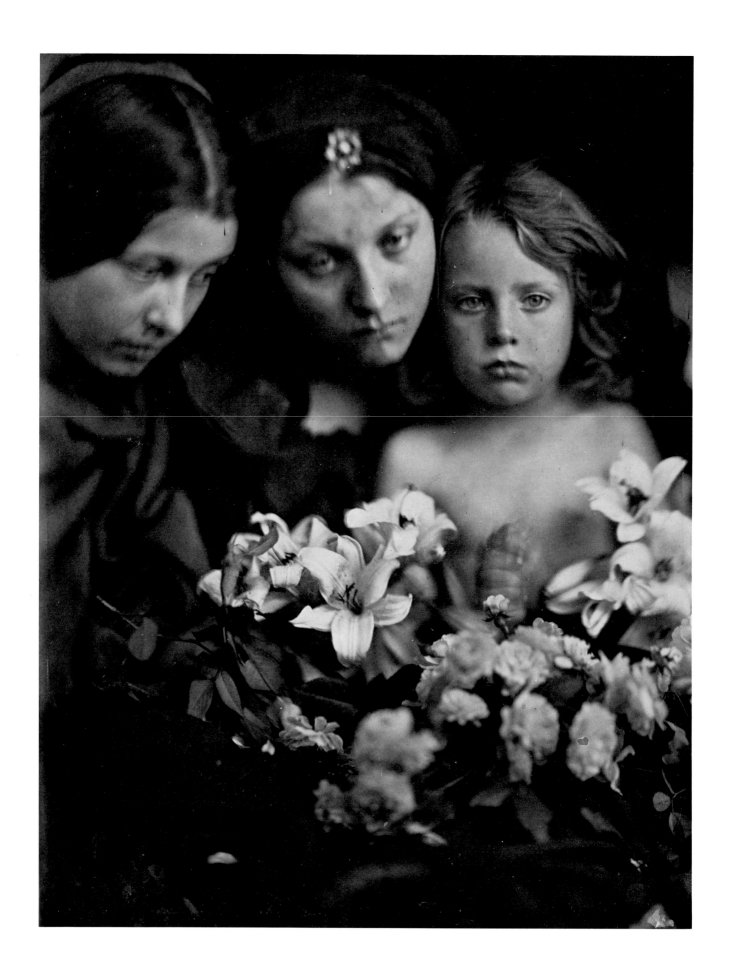

140 JULIA MARGARET CAMERON, *The Return after Three Days*, ca. 1865, albumen print from wet collodion negative, 27.9 x 21.7 cm, VA

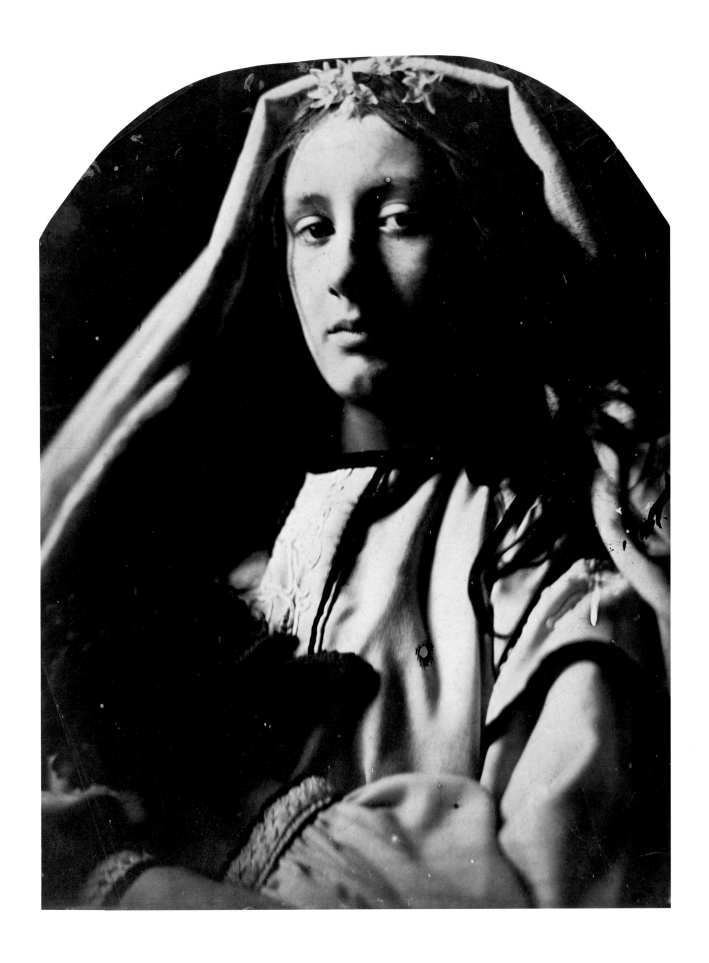

141 JULIA MARGARET CAMERON, *Woman in Costume [possibly Julia Jackson]*, 1865–75, albumen print from wet collodion negative 27.6 x 22.0 cm, VA

8. Street Life

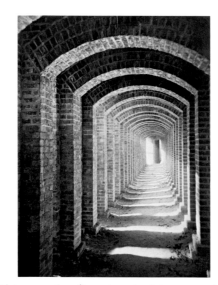

Victorian photography and Victorian actuality converge at many points, but the city was a most notable exception until the last decade of the century. Roger Fenton's few known photographs of London are renditions of the Houses of Parliament under construction and a (lost) view of St. James's Park under fog, while others of his generation photographed nothing of the city except the Crystal Palace. "Instantaneous" photographs from the end of the 1850s and the early 1860s record the movement of pedestrians and carriages in the streets of cities, but these are small-scale stereographs. The real subject was too fast-moving—certainly for large cameras—too dense, and, probably, too unquestionably the province of the black-and-white draftsmen for wood engraving, such as Gustave Doré, whose production appeared in the popular illustrated magazines. The lightning sketch of graphic art came under serious threat from photography only at the end of the century, with the arrival of the aptly named "snapshot." Monumental construction, like the building of the Albert Memorial (1861–63), was recorded; Cundall and Fleming's photograph of the basement of the memorial is above. Apart from graphic art, the observation and description of cities lay in the hands of social commentators and novelists, with occasional references made by painters and poets. There are also three principal photographic studies, by Thomas Annan in Glasgow, John Thomson in London, and the Society for Photographing Relics of Old London.

By the 1850s the balance of Britain's population had shifted from rural to urban.

This was the first time in history such a shift had occurred. Glasgow was second only to London in the growth of its population; it increased five times between 1801 and 1861, but with little change in the structure of the inner city except, inevitably, for the creation of slums. Nathaniel Hawthorne, observing these slums in 1856, reported that "the poorer classes of Glasgow excel even those in Liverpool in the bad eminence of filth, uncombed and unwashed children, drunkenness, disorderly deportment, evil smell, and all that makes city poverty disgusting" (*Our Old Home and English Notebooks,* quoted in Anita Mozley, *Thomas Annan,* 1977, p. vi). In the typical pattern, the older central housing stock filtered down to the urban poor and became multioccupied. The Glasgow City Improvements Act (1866) has been described as the first massive municipal intervention designed to sweep away the most insanitary and delapidated and archaic central areas and to rebuild on new models. The need for the act required no photographic evidence, but the proposed wholesale alteration to the city fabric moved the Trustees of the Act to commission the leading commercial photographer in Glasgow, Thomas Annan, to record the closes and wynds in 1868. The nature of the task obliged Annan to make not only the first document

of slum dwellings but also a photography different in kind from any that had been seen before. Although his series includes photographs taken in relatively spacious "closes" and in the thoroughfares they adjoined, the main subject was the constricted "wynd," or passageway. These were recorded, as they had to be, dead-on, producing results that appear forensic in their viewpoint and exactness. The movement of figures and washing indicates the long exposures required by the dim and claustrophobic illumination of the wynds.

In London John Thomson challenged the dominance of graphic artists in the portrayal of urban types in his serially published *Street Life in London.* Each photograph appeared with a full text including eye- and earwitness commentary on the individuals photographed, and data assembled on the model of Henry Mayhew's *London Labour and the London Poor* (1851–62), as well as an infusion of Dickensian characterization. When the publication was announced in 1877, a writer in *The Athenaeum* questioned whether the streets of London could supply sufficient types to sustain the series. The remark suggests Thomson's uncommon acuity in recognizing the large variety of London's street workers as a photographic subject. Possibly his unique recognition of contemporary city life as subject derives from his documentary work in the streets of Peking and other Chinese cities in the immediately preceding years. He recorded London types not only as a traveler among social groups but as a trained observer.

Crucial to Thomson's way of seeing was his ability to arrange or direct his subjects.

Many of the plates resemble set pieces from the works of Charles Dickens. Thomson included an early account of street photographers, written by his co-author Adolphe Smith. Smith pointed out that the success of street or park portrait photographers depended "more on manners than on the skill of the photographer." Those who failed were without the "impudence to accost all who pass by, they have no tact or diplomacy, they are unable to modify the style of their language to suit the individual they may happen to meet. . . ." Among Thomson's instruments were the social skills that made the photographs possible.

The Society for Photographing Relics of Old London, founded in 1875 in response to the threatened demolition of a sixteenth-century coaching inn, the Oxford Arms, near St. Paul's Cathedral, commissioned Henry Dixon and Alfred and John Bool to record the inn (demolished 1878) and its yard (demolished 1903), and many other ancient buildings. Through such ventures photography fulfilled a role equivalent to that of printing as an art preservative of all the arts.

THOMAS ANNAN (1829–1887)

Thomas Annan opened his first photography studio in 1855, specializing in landscapes and art reproductions. In 1866, using a pigment printing process, he published his photograph of David Octavius Hill's painting of the Disruption. In the same year the Glasgow City Improvement Trust hired Annan to document slum areas before their demolition. The result was a series of thirty-one albumen prints bound and presented to the Glasgow Town Council in 1868. In 1878–79 the trust published an edition of 100 volumes of forty carbon prints. (The 1900 edition, Old Closes and Streets, a Series of Photogravures 1868–1899, published after Annan's

death, included in addition eleven photogravures of work from the 1890s.) The Old Country Houses of the Old Glasgow Gentry (1870) examined another stratum of local life. Annan was also an accomplished portrait photographer, as evidenced by the 1871 Memorials of the Old College Glasgow, which featured straightforward portraits of Glasgow academics, reflecting the simple style of his friend Hill. The firm of T. and R. Annan remains in business today in Glasgow.

ALFRED AND JOHN BOOL (active 1870s)
HENRY DIXON (1820–1893)

Employed by the Society for Photographing Relics of Old London, Alfred and John Bool first photographed the Oxford Arms Inn near St. Paul's Cathedral, and the carbon prints made from their negatives by Henry Dixon were distributed to subscribers. Though Dixon had been apprenticed as a copperplate printer, he had become a professional photographer by 1864, and in 1879 Henry Dixon and Son themselves began to photograph as well as print the series of architectural views distributed annually to members of the society. In his eagerness to photograph unobtrusively on the crowded streets of London, Dixon often would remove a wheel from his work van, have an assistant begin its repair, and photograph discreetly from beneath the tarpaulin. Dixon and Son was in business until World War II.

JOHN THOMSON (1837–1921)

John Thomson's early life is not documented. He is reputed to have studied chemistry at Edinburgh University and is known to have experimented with microphotography in the late 1850s. From 1862 to 1872 he traveled throughout the Far East and maintained a commercial photography studio, first in Singapore and then in Hong Kong. His books of photography include The Antiquities of Cambodia (1867), illustrated with tipped-in albumen prints; Illustrations of China and Its People (1873–74), a four-volume work of 200

autotypes, some showing street traders who prefigure subjects in his famous London work of the later 1870s; and The Straits of Malacca, Indo-China and China: or Ten Years' Travels, Adventures and Residence Abroad (1875), illustrated with engravings from his photographs.

Thomson's most famous project was initiated after his return to London. Street Life in London was first issued in twelve monthly installments in 1877–78, then in book format, and was finally abridged as Street Incidents in 1881. Thomson's thirty-seven Woodburytypes are regarded as a classic of social documentary. Thomson also collaborated in writing the text with Adolphe Smith. In 1879 Thomson returned to travel photography with the publication of his Through Cyprus with a Camera, an account of a three-month visit to the newly designated British protectorate, seen in sixty autotype and Woodburytype reproductions. This was Thomson's last travel project, though in 1898 Through China with a Camera reproduced many of his wet collodion photographs of the 1870s.

Thomson was translator and editor of George Tissandier's History and Handbook of Photography (1876). His lengthy footnotes reveal not only an understanding of the chemistry and optic principles of photography but the innovative character of his own approach to the medium. The second edition included an appendix by William Henry Fox Talbot (completed by his son after his death) and two additional chapters by Thomson, including "Pioneers of Photography in Britain." By the 1880s Thomson was established as a fashionable Mayfair portrait photographer under royal patronage. He continued, however, to crusade for the acceptance of photographs primarily as scientific tools and "permanent works of reference . . . the absolute lights and shadows of all things seen and that are of value in expanding our knowledge of the world in which we live."

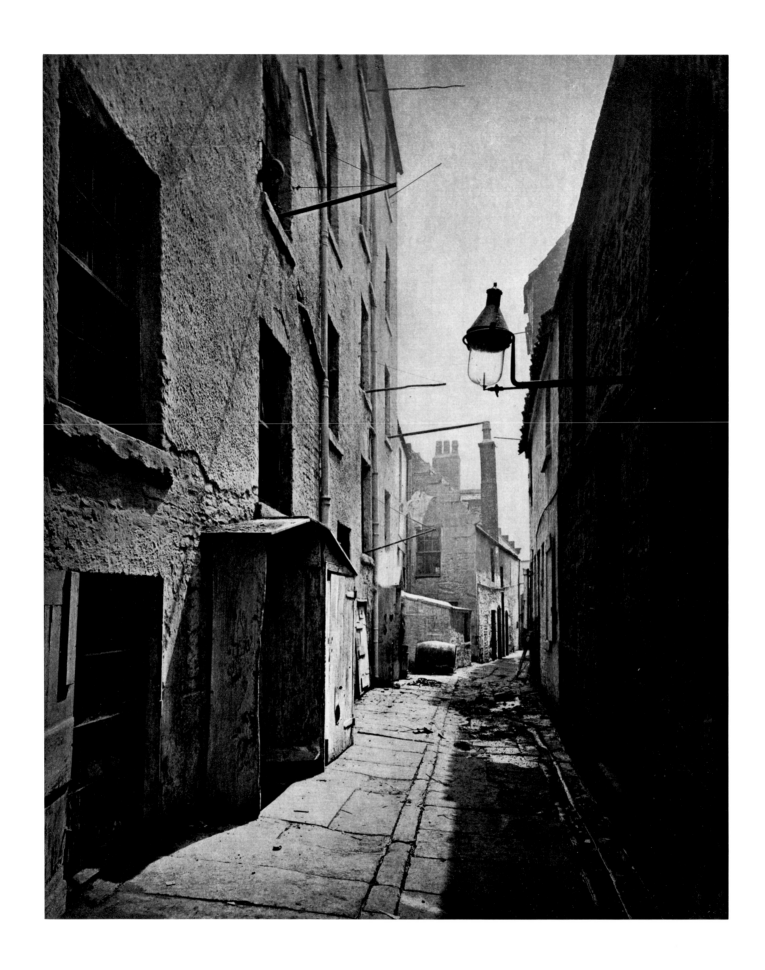

144 THOMAS ANNAN, *Close No. 157, Bridgegate,* 1868, photogravure, 22.8 x 18.2 cm, VA

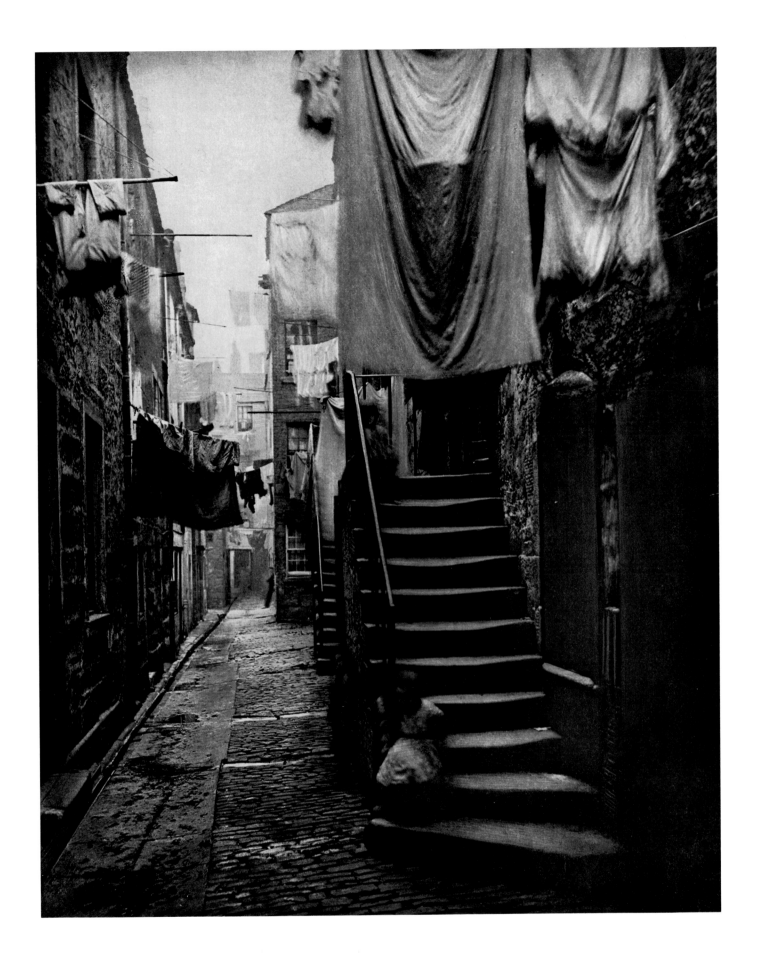

145 THOMAS ANNAN, *Close No. 193, High Street,* 1868, photogravure, 22.2 x 18.1 cm, VA

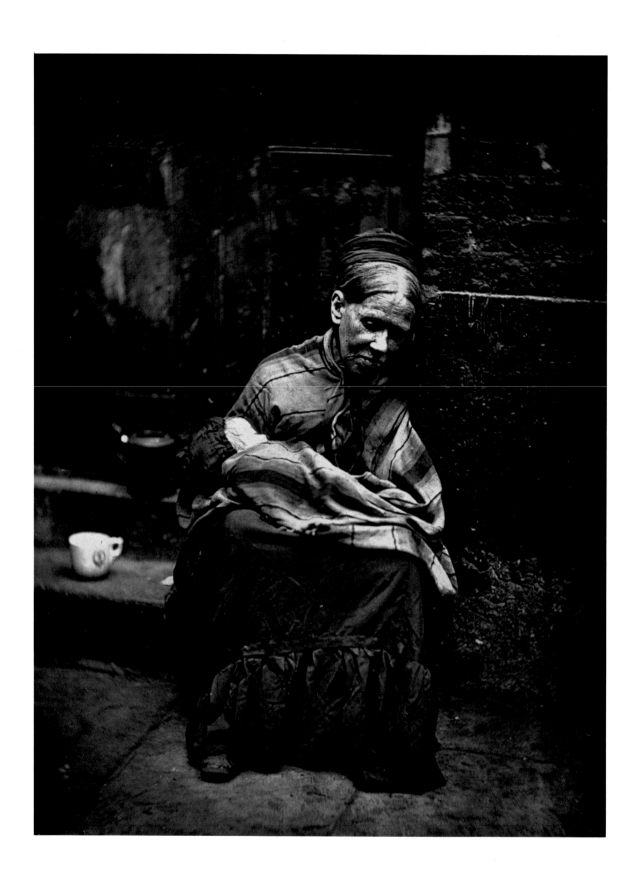

146 JOHN THOMSON, "*The Crawlers*," 1877–78, Woodburytype, 11.6 x 8.8 cm, VA

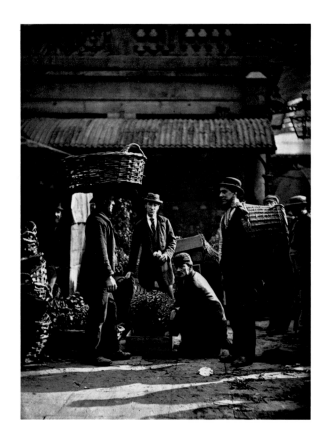

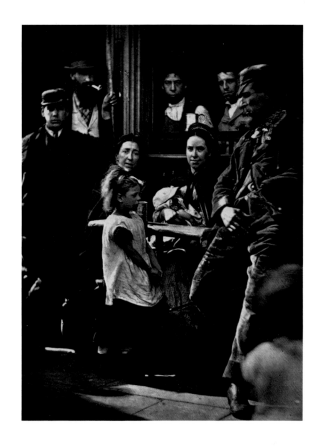

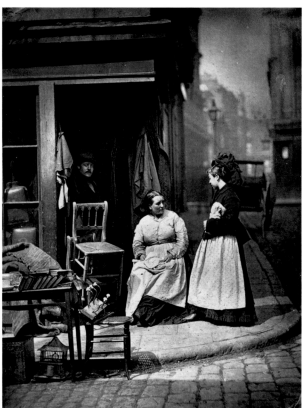

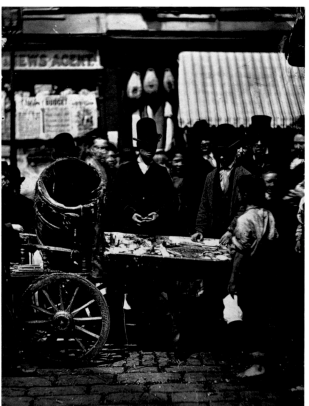

JOHN THOMSON, *Covent Garden Laborers*, 1877–78, Woodburytype, 11.4 x 8.6 cm, VA (top left)

JOHN THOMSON, *"Hookey Alf," of Whitechapel*, 1877–78, Woodburytype, 11.2 x 8.6 cm, VA (top right)

JOHN THOMSON, *Old Furniture*, 1877–78, Woodburytype, 11.5 x 9.0 cm, VA (bottom left)

147 JOHN THOMSON, *Cheap Fish of St. Giles's*, 1877–78, Woodburytype, 11.2 x 9.0 cm, VA (bottom right)

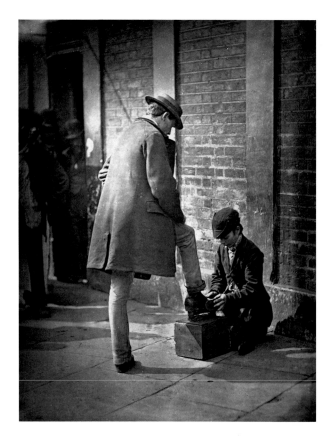

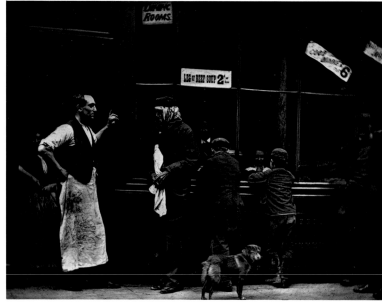

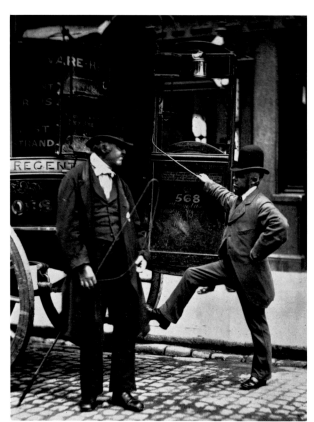

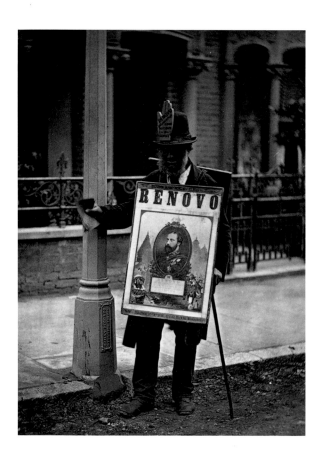

JOHN THOMSON, *The Independent Shoe-black*, 1877–78, Woodburytype, 11.2 x 8.7 cm, VA (top left)

JOHN THOMSON, *A Convict's Home*, 1877–78, Woodburytype, 8.9 x 11.6 cm, VA (top right)

JOHN THOMSON, *Cast-iron Billy*, 1877–78, Woodburytype, 11.6 x 9 cm, VA (bottom left)

148 JOHN THOMSON, *The London Boardmen*, 1877–78, Woodburytype, 11.7 x 8.5 cm, VA (bottom right)

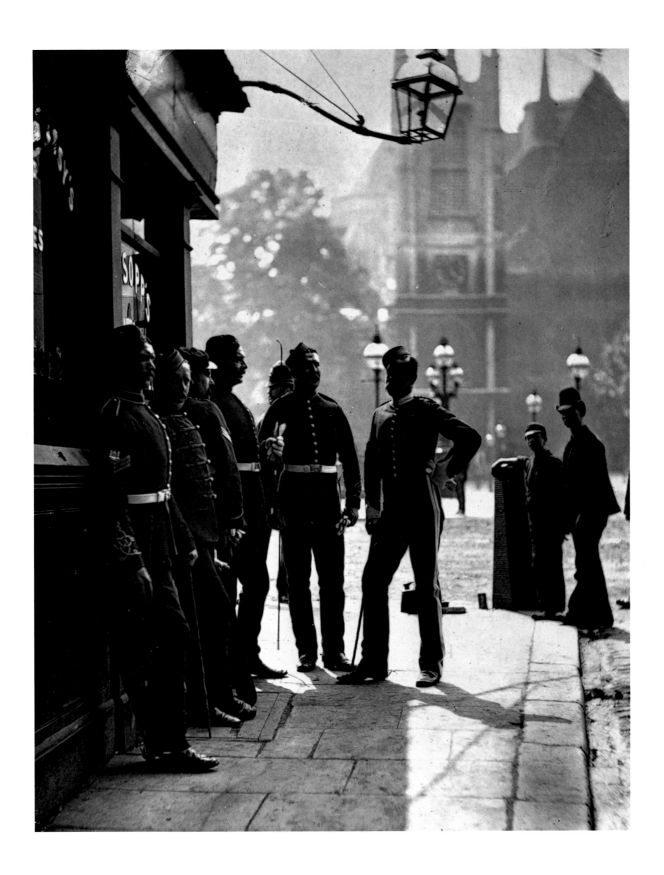

149 JOHN THOMSON, *Recruiting Sergeants at Westminster*, 1877–78, Woodburytype, 10.9 x 8.6 cm, VA

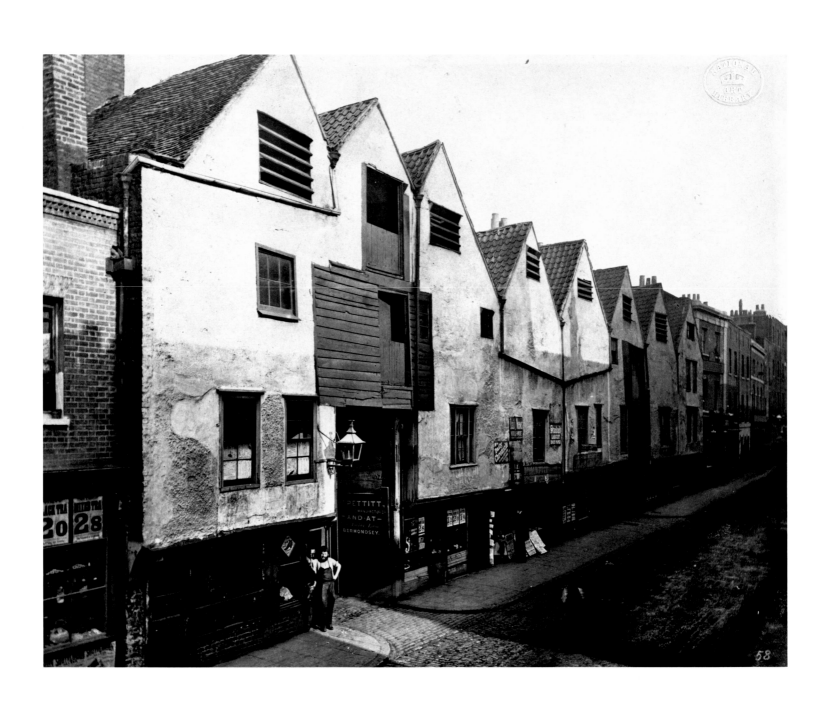

150 HENRY DIXON AND ALFRED AND JOHN BOOL, *Old Houses in Bermondsey Street, Southwark, London*, 1875, carbon print, 17.9 x 22.6 cm, VA

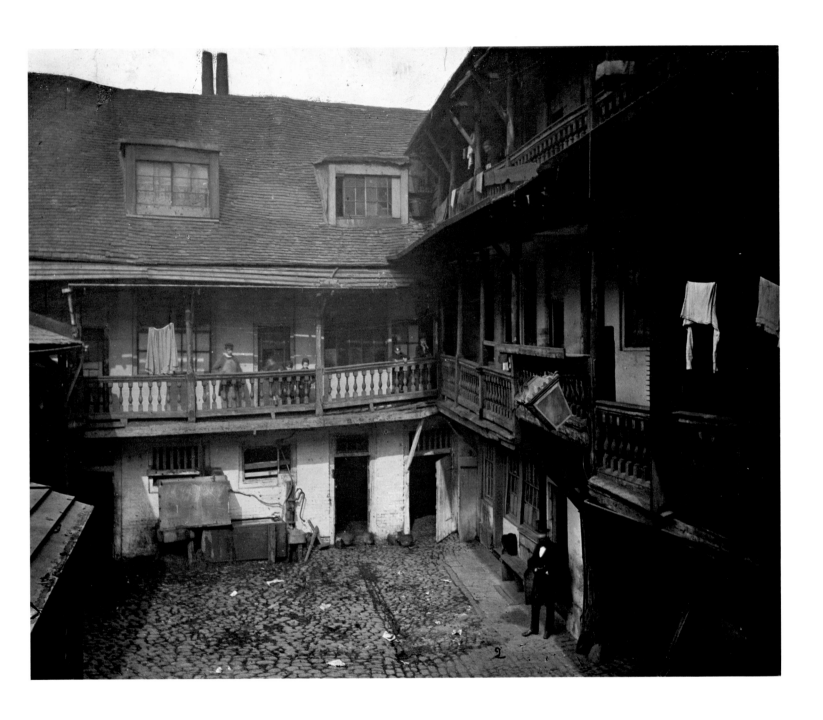

151 HENRY DIXON AND ALFRED AND JOHN BOOL, *The Oxford Arms, Warwick Lane, London*, 1875, carbon print, 19.4 x 23.8 cm, VA

9. The Art of Photography Fulfilling the Vision

A new generation of photographers, using the term "art photography" to identify their aims and to distinguish themselves from the currents of scientific and commercial photography, adopted the profound fastidiousness of the Aesthetic Movement and entered into close rapport with the art of printmaking as practiced in etching. In the 1880s they established the highest standards of quality in their books and portfolios of prints, in exhibition design, and in the presentation of mounted photographs. In 1880 graphic artists formed the Society of Painter-Etchers, which received a royal charter three years later. Art photography followed a similar path by forming an exhibiting association called The Linked Ring (1893), separate from the diffuse annual shows of the Photographic Society.

Four technical factors influenced the new photography of this period. First, the introduction of gelatino-bromide dry plates in 1879 provided a clean, light, compact, and rapid new process that soon replaced the relatively awkward, slow, and complex procedures of wet collodion, which had required a portable darkroom. The great reduction in exposure times resulted in new possibilities for the genre of figures and landscapes—which acquired a more natural and spontaneous appearance. Second, the photogravure process, also available beginning in 1879, supplied a subtle, multiple, and permanent form of reproduction. Third, the invention of platinum paper by William Willis in the same year greatly raised the level of photographic printing quality. The era of platinum (about 1880–1914) is distin-

guished by photography of minute subtlety of tonal range combined with broad and handsome realism. Fourth, the development of simple, mass-produced cameras for a large new market of amateurs, for whom photography was a fad akin to the cycling craze, altered the meaning of the word *amateur*. It lost its connotations of disinterested pursuit of a medium for the love of it and attracted the pejorative implication of a merely casual interest.

The stern words on amateurs uttered by Peter Henry Emerson signify the intense seriousness with which he and his colleagues regarded their medium. While some photographers sought to distance their work from the amateurs by adopting highly graphic techniques, James Craig Annan (son of Thomas Annan), Frederick H. Evans, and Emerson persevered with the production of, in Emerson's words, "sun pictures, produced, however, in so far as it is possible, in accordance with the true principles of art, and so far as I have been able to exert control, free from fake, dodge, and all the mischievous arts of the charlatan and 'photographic artist' " *The Photographic Journal*, 31 May 1900: 265). The ambitions of the art photographers are best displayed in a detailed program Emerson formulated for the future direction of the affairs of the Photographic Society. Beginning with the society's exhibition, he questioned the value of appointing as judges "old-fashioned and second-rate painters such as we had" and

suggested instead "good black and white men" (graphic artists), such as William Strang, Sir Frank Short, Phil May, and Joseph Pennell. Emerson's preference for graphic artists was typically shrewd, but he collaborated closely with the painter Thomas Goodall, and on at least one occasion they worked from the same motif (see Goodall's *The Bow-Net*, above).

In 1890 Emerson had outlined how the society could and should develop into a modern and comprehensive institute. After obtaining a royal charter, a building would be acquired, "by begging—nothing more or less." The building would be furnished with a first-rate library, well-fitted laboratories for chemistry and process work, a gallery for exhibitions, a print room for storing and studying prints, lecture rooms, darkrooms—some set aside for instruction—enlarging and copying rooms, and "a light refreshment bar, but no dinners, no billiards, nothing of any kind that will invite people to loaf and lounge about the place." Finally, he enjoined that each department of the institute should be in the hands of experts. In this way, "a *real* profession will be started" (*The Photographic Journal*, 21 March 1890: 118–19).

As part of his generous efforts on behalf of art photography Emerson presented valuable technical books, his own volumes of photographs, and portfolios of photogravures to the society and to other institutions, including the Victoria and Albert Museum. His vision of the institutional necessities of photography is the most comprehensive expressed in the epoch of art photography.

JAMES CRAIG ANNAN (1864–1946)

For a full biography, see "James Craig Annan: Brave Days in Glasgow" by William Buchanan, page 170.

PETER HENRY EMERSON (1856–1936)

Peter Henry Emerson was born in Cuba. His father was a wealthy American, his mother English. In 1869, after his father's death, the family moved to England. Emerson was a studious child, interested from an early age in science and natural history. In 1874 he entered King's College, London, to study medicine, and from 1879 continued his studies at Clare College, Cambridge.

At this time Emerson began to study art history, though as a scientist he was disturbed by its basis in "taste." Consequently he became interested in Naturalism and Impressionism, and the principle of "truth to nature." In 1882 he bought his first camera and began studying photography. He made constant experiments under a variety of conditions, and investigated all the techniques and equipment available. Much of his work was presented in the form of books and portfolios as well as exhibition prints. He schooled several photogravure printing companies to provide the absolutely unretouched results he required. In 1884 Emerson moved to Southwold in Suffolk. The East Anglia landscape and its people were to provide his characteristic subject matter throughout his career.

In 1885 Emerson passed his final medical examinations and celebrated with a holiday on the Norfolk Broads. He met Thomas F. Goodall, a landscape painter and Naturalist whose ideas were to influence his own. In the same year he helped found the Camera Club of London, for amateurs only, and in 1886 was elected to the council of the Photographic Society of Great Britain to represent amateurs. In 1886 he read a controversial paper to members of the Camera Club (*The Amateur Photographer*, 19 March 1886: 138–39): "Art has at last found a scientific basis and can be rationally discussed, and the modern school is the school which has adopted this rational

view, and I think I am right in saying that I was the first to base the claims of photography as a Fine Art on these grounds, and I venture to predict that the day will come when photographs will be admitted to hang on the walls of the Royal Academy." Emerson decided to write a book explaining his ideas, as an answer to his critics and a guide to his followers. *Naturalistic Photography for Students of the Art* appeared in 1889 and provoked vitriolic argument in photography circles.

Emerson supported his opinions with articles, letters, lectures, and more photographs, but in 1890 two circumstances combined to alter his views. New scientific discoveries proved to him certain limitations in the technical possibilities of photography, and a "great painter" (probably James Abbott McNeill Whistler) convinced him that photography was not art. In a black-edged pamphlet, *The Death of Naturalistic Photography*, he explained: "The limitations of photography are so great that, though the results may and sometimes do give a certain aesthetic pleasure, the medium must always rank the lowest of all the arts. . . . No differential analysis can be made, no subduing of parts, no emphasis—save by dodging, and that is not pure photography. Impure photography is merely a confession of limitations" (1890, p. 3).

Emerson's involvement in photography gradually declined. He won the Photographic Society's highest honor, the silver "Progress" medal, the first ever to be awarded for artistic achievement, and in 1924 began a "true history" of photography that was never published; the manuscript is now lost.

FREDERICK H. EVANS (1853–1943)

Frederick H. Evans ran a bookshop in Queen Street, Cheapside, and numbered George Bernard Shaw and the young Aubrey Beardsley among his clients. In 1886 he and George Smith of the Sciopticon Company (which produced lantern slides) experimented with microphotography, in pictures of shells and sea creatures. As a result Evans won a Photographic Society medal and came to depend for inspiration upon Smith's concept of a

pure photography grounded in impeccable technique. Evans's "at home" portraits shown at the 1891 Photographic Society exhibition were completely unretouched, confirming his commitment to the unmanipulated image.

In 1898 Evans retired from the bookshop on a small annuity and took up photography professionally. He was soon preoccupied by the documentation of architecture. Transcending the topographical, he instead focused upon the depiction of light and shade within a complex space. During the 1890s Evans traveled to the cathedral towns of England, pausing several weeks, for instance at Ely, simply to study the light. His rule was to place the camera as far from his subject as possible, select the lens that would fill his viewing screen, and expose for minutes on end, preferably with the lens stopped down to f.32 to achieve a clear depth of field. He aspired to the effects achieved by J. Bosboom (1817–1891) in his paintings of nineteenth-century architecture — without, however, imitating painting itself. Neither did Evans accept imitation of his own style as flattery, insisting instead that each photographer must find his own mode of expression.

In 1894 Evans held his first one-man exhibition at the Photographic Society and was elected to The Linked Ring. Evans was honorary secretary of the Ring from 1902 to 1905 and supervised the annual Link salon. He revolutionized the installation of photographic exhibitions by arranging pictures by theme in an organized space rather than randomly as had been the rule. In 1903 Evans became the first English photographer to be reproduced in *Camera Work* magazine, to which he contributed reviews and articles from 1904 to 1907. Alfred Stieglitz showed Evans's work at the "291" Gallery in New York, with work by James Craig Annan and Hill and Adamson.

Commissions for *Country Life* magazine led Evans to enlarge the range of his architectural photography, and in 1906 he photographed French châteaux and villages. His work remained centered on the static and permanent; the encroaching "snapshot" was beyond his comprehension. As Evans grew more frail he eventually limited himself to photographing his own art collection, and by 1912 other interests had begun to supersede photography. In that year he published *William Blake's Illustrations to Thornton's Pastoral of Virgil*. By 1914 Evans had retired completely from photography, although as Alvin Langdon Coburn noted, he "will always be remembered as a champion of the purity" of the medium. In 1928 Evans was made an honorary fellow of the Royal Photographic Society.

Peter Henry Emerson
Art and Solitude

Ian Jeffrey

Peter Henry Emerson, born at La Palma in Cuba on 13 May 1856, spent a well-publicized decade in British photography after which he withdrew into private life. In 1885 he was a founding member of the Camera Club. In 1895 David Nutt published the last and probably the greatest of all Emerson's books, *Marsh Leaves.* During that period his pictures, as platinotypes and photogravures, came out in two portfolios and six books. In most cases he was writer as well as illustrator. In addition he was the author of *English Idylls* (1889), *East Coast Yarns* (1891), *Signor Lippo. Burnt-Cork Artiste. His Life and Adventures, Founded on Blower's Private Papers* (1893), *Tales from Welsh Wales: Founded on Fact and Current Tradition* (1894), and *Birds, Beasts and Fishes of the Norfolk Broadland* (1895). In 1889 he published his controversial *Naturalistic Photography for Students of the Art.* During these years he was also an active lecturer and polemical essayist. There can have been few busier people in Britain in the last decade of the nineteenth century, and few with a wider range of interests. And his talent matched his industry; he was equally a specialist in Norfolk dialect and the London argot of "flash coves," which he could set down in the manner born—his blow-by-blow accounts of horse-racing scandals, of "doping" and "pulling" in *Signor Lippo* are as vivid as the reports of Charles Dickens and Robert Smith Surtees. Yet he was scarcely considered as a writer, and much of his quite exceptional photography has been taken for granted.

Emerson is now known mainly as an early advocate of soft-focus photography, which he promoted because, he argued, it was true to the nature of perception: attending to the scene in front of us we concentrate on one thing at a time. He criticized the older sharp-focus style of photography as "realistic," as no better than "an impersonal mathematical 'plotting' by the lens of objects before it."[1] Additionally such a style denied the way in which things in nature showed themselves to be interwoven and interdependent: "Nothing in nature has a hard outline, but everything is seen against something else, and its outlines fade gently into that something else, often so subtilely that you cannot quite distinguish where one ends and the other begins."[2] Soft-focus photography permitted this fading of one thing into another.

But it was not simply a question of greater truth to nature. To stress viewpoint and the instant of perception was to stress individual vision, and in the 1880s such vision mattered greatly. The critic Walter Pater, in an essay entitled "Style," remarked in 1888: "Literary art, that is, like all art which is in any way imitative or reproductive of fact—form, or colour, or incident—is the representation of such fact as connected with soul, of a specific personality, in its preferences, its volition and power."[3] Artists of merit were expected to have volition and power in plenty. At the same time they were not expected to be rampantly subjective, for the great virtue of their strength was that it made them especially susceptible to the preexistent order, a harmony in nature. Emerson, theorizing, wrote on nature and of works of art "singing in harmony,"[4] and Walter Pater valued unity before everything: "All depends upon the original unity, the vital wholeness and identity, of the initiatory apprehension or view."[5]

This Symbolist ethos was scarcely relaxing, for how could an artist be sure of having grasped anything so elemental and magnificent as "vital wholeness." Working under such premises artists could hardly be other than uncertain of their adequacy—as uncertain as any believer under the unmediated terms of Protestantism. Emerson asserted himself in these testing conditions. In *Naturalistic Photography* he emerged as ostentatiously confident of his own judgment and in a long chapter on *Impressionism in Pictorial and Glyptic Art* wrote what amounts to a critical history of world art in which the false is sharply distinguished from the true. No one is spared: "Turner is not the man to study, and if you cannot 'understand him' well and good. Many artists cannot and do not wish to, and many French painters of great ability jeer at his very name."[6] Emerson held few opinions mildly, as though vehemence were a sign both to himself and to others that he was especially gifted with insight.

He wanted to be right and to be seen to be right. No reader of the Impressionism chapter in *Naturalistic Photography* can fail to take note of both the certainty of his judgments and his grasp of history. He was evidently both well informed and rich in intuitions, a cultured artist who was also a seer. He could also be a pedant, with his insistence on correct usage: "This cannot be too strongly insisted upon, as some cultured writers have been guilty of the wrong use of the word 'photographic,' and therefore of writing bad English."[7] This is a typical aside by the braggart Emerson, at his most overweening in *Naturalistic Photography.*

His devotion to the objective truth was strict. When the chemists Hurter and Driffield demonstrated through their researches that tonal values and their relations could not be altered at will in photographic development, Emerson took this to mean that photography was purely and irrevocably a mechanical process. Thus in 1891 he published a famous renunciation of his earlier writings on behalf of soft-focus naturalism. He phrased it thus in 1893: "I believe there is no true realism nor naturalism in the arts proper but only in *photography*: for TRUE realism and naturalism are *impersonal*—the results of a mechanical process which photography logically is, because under the same *physical* conditions the same *results* will always follow . . ., which is *not* the case with art, which is *personal*; indeed, the personal element in real art is paramount and all-pervading."[8]

From 1891 onward he adamantly maintained that photography was not a fit medium for art, yet his great photographic achievements are his last illustrated books, *On English Lagoons* (1893) and *Marsh Leaves* (1895). Perhaps the renunciation of 1891 gave him a respite in which to attune himself to those harmonies in nature he had come to insist were beyond the scope of photography. To add contradiction to contradiction, the late pictures, tender, almost abstract images printed as gravures, take their gentle places in tales of violence and loneliness.

The truth about Emerson is that the contradictions of his era were intensified in him. As a public man he was committed, at the outset, to historicist beliefs in the inevitability of progress. In an article of 1885, for example, he prophesied that "in a few years the art of photography will drive all competitors from the field, painting alone excepted; and should photography in colours ever be perfected, let painting look to herself for she will tremble in the balance. . . ."[9] Ignorance impeded progress but could be overcome by ridicule and by instruction, and when not lashing out at idiots in office Emerson fashioned prose worthy of a government inspector. At the same time he was an artist, and as such open to the promptings of the mysterious harmonics of nature. When nature moved him to ecstasy, his social concerns counted for very little.

The public Emerson, respectful of logic and tradition, and confident of progress, was overthrown by the artist Emerson— overthrown and routed. Art revealed a force in himself that could not be denied. It was less a case of sympathy between nature and a sensitive artist than the flowering of the kind of love that a mystic might feel for God. The reforming public artist who began the journey ended by presenting himself as a solitary who chose to associate with outcasts and savage nature.

From the beginning he described himself as enraptured by nature, moved by the beauty of the earth to a state of ecstasy. He remembered, in 1886, his experience of a Norfolk sunrise:

Little by little the burning red changes to a glowing orange, and lights up the delicate greys of the mist and the tender greens of the rush. This peacefulness, sacred to Zoroaster, is disturbed only by the splash of the silver-bellied roach. Now day deepens,

the mists disappear, the trees are pencilled against the sky, down the dike comes a punt laden with reapers; they startle the birds, life begins, and the spell is broken.[10]

The ecstatic watcher is alone; indeed, for Emerson, experiences of this sort depended on solitude. In this case a boatload of reapers causes the interruption; in 1893 a similar ecstasy ended when "a

Peter Henry Emerson, *The Lone Lagoon*, 1893, VA

slamming of doors and the sound of gruff voices broke the spell."[11] Society, so defined in these brief parables, is intrusive and heedless of beauty.

He was charmed, charmed almost to death, but he was also baffled by his inability to find a form for his feelings. After an especially tender vision remembered in *On English Lagoons* (1893) he concluded: "Why is mortal permitted to gaze upon such perfect beauty, why is he allowed to lift the veil, for after such magic visions the greater part of life must be prosy indeed, and yet we poor worshippers try to preserve such scenes in paint or fetter them in verse, living with the shadow of the thing that was."[12] Experience of beauty often raised feelings of inadequacy; Emerson deflected these misgivings and doubts in generalizations that blamed his personal failures on the incapacity of art as a whole: "The sense of spaciousness and breadth was unpaintable, indescribable, wonderful."[13]

Emerson emerges in his books as a modern Ulysses. Like Homer's original wanderer he craved experience of the earth at its most beautiful, and was spellbound and endangered to the point of annihilation. After such experience the commonplace world was too belittled to permit a ready return to normal life, and it is easy to imagine Emerson after his fenland wanderings of the early 1890s living on as little more than a shadow diminished by the intensity of his encounters with the "unpaintable, indescribable, wonderful" skyscapes of Norfolk.

Homer acknowledged a danger in beauty and had Circe advise Ulysses to guard against the Sirens "crying beauty to bewitch men coasting by."[14] The Victorians too reflected on paradise. Lord Tennyson's Lady of Shalott, "half sick of shadows," died of unmediated contact with "the blue unclouded weather" of

Camelot. Kipling's Edwardian children, charmed by Puck in 1906 back into a magical old England, received certain leaves to eat so that they might slip back into normal life unimpaired. In the most famous of all meetings with nature's divinities, Rat and Mole found themselves in the presence of Pan, the piper at the gates of dawn in *The Wind in the Willows* of 1908. After their audience a caressing breeze brought forgetfulness: "Lest the awful remembrance should remain and grow, and overshadow mirth and pleasure. . . ."[15]

Others fudged their encounters with the numinous in nature. Arthur Symons, for example, a poet, critic, and essayist and a contemporary of Emerson's, described elemental experiences in an essay of 1900, "In a Northern Bay." Having evoked "the caress of the sand upon one's feet as one walks slowly at night under a great vault of darkness," he ended with the sort of question that might have crossed the mind of T. S. Eliot's equivocating

Peter Henry Emerson, *The Clay-Mill (Norfolk)*, 1888, VA

Prufrock in 1917: "Or do we, after all, feel them [flawless sensations] more keenly, since more consciously, for the moment, because they are not our inner life, but a release from our inner life?"[16] Emerson was no casual, stand-offish visionary: the mermaids, tormentingly, sang for him as they would never do for Prufrock and he, enraptured, had to reply within the narrow limits of his discredited art.

Emerson's friend the painter Thomas F. Goodall was his co-author in *Life and Landscape on the Norfolk Broads* (London: Sampson Low, Marston, Searle, and Rivington, 1886), the first of Emerson's illustrated books. A series of short essays, the book was illustrated by forty platinotypes, all save one from photographs by Emerson. The authors wrote, alternately, on the flora and fauna, landscape and social life of the region. In some cases essays are addressed very directly to their adjoining pictures, but sometimes the discussion is more general, and the images do no more than set a scene. In his preface Emerson outlined their intentions:

"The text, far from being illustrated by the plates, is illustrative of and somewhat supplementary to them; sometimes explanatory, and containing interesting incidental information or folk-lore intended to bring the scene or phase of life treated of more vividly before the reader, and depicting in words surroundings which cannot be expressed by pictorial art."

There were precedents for such combinations of photographs and brief essays—even in the 1850s Francis Frith had accompanied his Egyptian pictures with texts of two or three paragraphs—but Emerson attended to his task with a higher degree of scrutiny than ever before, sometimes in the role of anthropologist, pointing out and naming. In the first of his thirty-nine illustrations, *Coming Home from the Marshes*, which features four stolid walkers, he noted that their short scythes were called "meaks" and their long marsh boots "waders." He gave detailed accounts of eel catching; of the cutting, towing, and ricking of reeds; and of the cutting and carrying of gladdon, or bulrushes. This was Emerson as practical observer. But the practical man sometimes ran wild and indulged in extravagant asides rich in historical and etymological detail. Discussing fenland uses of "schoof-stuff" (rushes), he veered away thus: "The iris, the lily of France, is said to have been the national flower in that country since, at the battle of Tolbiac, the victorious soldiers of Clovis decorated themselves with its blossoms—suitable emblems for the Franks who came from a marshy home."[17] He wrote similarly of water lilies, pointing out their distinguished place in Greek and German culture. Writing of this type was in a tradition best exemplified by Izaak Walton and Sir Thomas Browne, both of whom were well known among literary Britons in the 1880s. Walton, in *The Compleat Angler*, originally published in 1653, instructed and described in the broadest terms. As well as noting that angling was invented by Seth, one of the sons of Adam, he quoted from the Bible, from Plutarch, Pliny, Montaigne, and John Donne. Browne, in the *Garden of Cyrus* of 1658, ranged as widely and he too was a naturalist—and additionally a Norwich man. Emerson mentioned him once only, in the frontispiece to *Birds, Beasts and Fishes of the Norfolk Broadlands*, but such discursive, encyclopedic writing certainly influenced his own approach.

Emerson was also a dreamer for whom the photograph was often no more than a stimulus to his imagining. The third illustration in *Life and Landscape* is of *A Broadman's Cottage*, which looks little better than a hovel in winter. It is interpreted, however, as a site in paradise, close to the "bee-loud glade" described by W. B. Yeats in "The Lake Isle of Innisfree" and published in *The Rose* in 1893. "Here is the Broadman's Cottage, perched on a low hill overlooking the Broad. From his door, over which is trained a creeper, down to the sedgy border of the mere, extends his patch of garden, in which rise banks green with celery and rows of blossoming potatoes, straggly peas and scarlet runners; whilst here and there are scattered patches of pot-leeks destined to season the coot stews. Near the cottage door stand some straw bee-hives, around which the bees hum in the summer sun."[18]

Just as the landscape of the fens is glamorized, so its people are heroized, lifted from the obscurity of their backwaters by the power of Emerson's imagination. Describing the most withdrawn of the four walkers in *Coming Home from the Marshes,* he expounded: "The octogenarian who is down the bank lacing his boot, for he has been badly fed, has drunk spirits enough to float a wherry, and chewed bad tobacco enough to load it."[19] The

Peter Henry Emerson, *A Dame's School,* 1887, VA

crouched cape, hat, and legging in the ditch are the details from which the writer dreams up a giant of endurance and depravity—the first of many who will emerge from the reeds and gladdon.

The writing in *Life and Landscape* is eclectic and impulsive, the work of a widely read man of letters, a scientist, and a dreamer. The photographs, which vary as well, are the work of an artist impressed by both Jean-François Millet and James Abbott McNeill Whistler. Two kinds of photographs appear in *Life and Landscape:* in one, ponderous laborers linger over their work, and in the other, soothing arrangements of earth and water lie under tranquil skies. Neither individually nor as a set are they unusual. Emerson was quite simply practicing his photography as contemporary painters and etchers practiced their arts. His peasant types descended from Millet, through such French naturalist painters as Pascal Dagnan-Bouveret, Jules Bastien-Lepage, Léon Lhermitte, and Jules Breton. His landscapes are flat and open like the work of the popular Hague painters—Jozef Israëls, for example, active from the 1850s onward. They are nevertheless sparing and almost abstract in composition, reminiscent of the etchings and paintings of Whistler, whom he greatly admired—both as an artist and as a firebrand.

The range of his work of 1886 also corresponds to that of a Whistler or an Israëls. Whistler, in his set of Thames etchings

of 1871, included detailed surveys of the waterfront, fleeting impressions of the river, and a documentary portrait of a lime burner standing in a roadway. Portraits, solitary workers, and tranquil landscapes recur in Israëls's etchings, as in his paintings. Alphonse Legros, an influential French etcher who had moved to London in the mid-1860s, worked across just such a range: *The Plough, A Canal Morning, The Mill with Two Grinding Stones* are typical of his titles. In other words, a prejudice against specialization existed in the 1880s. Naturalist artists were expected to be able to represent the figure both as personality and as type, and also to depict its habitat. In this respect *Life and Landscape* is completely consistent with the documentary art of that time.

The difference was that Emerson, despite having contrived a kind of photography that acknowledged individual viewpoint and the moment of perception, tried hard to transcend naturalistic instantaneity. Through writing he introduced the narrative element, clarifying obscurities and placing the moment in history. He also described an activity such as reed cutting in several stages, as in the series *A Reed Cutter at Work, Towing the Reed, Ricking the Reed,* and *During the Reed Harvest.*

But complementary commentaries and analytical picture sets were makeshifts and too diffuse to conjure up the "vital wholeness" recommended by Pater. Nonetheless, and despite his documentary intent, Emerson did achieve that sort of wholeness in *Gathering Water-lilies,* the ninth image in the book. An oarsman watches as a young woman reaches out to pluck a blossom from the water. What makes the image exceptional is Emerson's control of tone: the white of the lily is caught by the sun and set off against an area of deepest shadow. The whites and grays are intensified at the narrative center of the scene, which serves as an emblem of the abstract tonal elements. In an etching of 1858, *Reading by Lamplight,* Whistler had similarly consolidated his tones around the rim of a lamp shining in darkness. The lamp shines and the lily holds the light of the place in images that are metaphors for etching and photography, both monochrome processes dependent on the isolation and manipulation of light. Light and dark gather as intensely and emblematically in the spurting lights and storm clouds of Sir Frank Short's mezzotints. Short, like Emerson, was impressed by Whistler, an inescapable influence for any artist working in monochrome then. Yet Emerson, always starting afresh, achieved nothing more in this mode.

A year later Emerson published *Pictures from Life in Field and Fen* (London: G. Bell and Sons, 1887), a set of twenty photogravures. Evidently he intended his effort to be a work of art, for he headed his didactic introduction with a long quotation from Robert Browning that ends: "Because it is the glory and the good of Art,/That Art remains the one way possible/Of speaking truth, to mouths like mine, at least." He went on to deplore the way in which photography was practiced "by illiterate and ignorant tradesmen."

Pictures from Life looks like a miscellany of genre pieces, indifferent views, and documentary images that failed to find a

place in the earlier book. In fact it shows Emerson, as often, working in two minds. On the one hand he was a conventional artist, and on the other he was an experimentalist.

The influence of Bastien-Lepage and of Millet is evident. Representative country figures try to act characteristically. A fisherman at home polishes his telescope and chews on the stem of a dainty clay pipe, a country urchin fishes idly on a riverbank, a poacher examines a gorse bush, and an old man observed by a girl grafts a fruiting stem onto an apple stock. At a school conducted in the fisherman's cobbled yard, the dame teaches lettering to a boy in a floppy hat, two girls sit to the side reading, and a young boy stands by astonished. Clearly Emerson was not at home with tableaux in which the various parts would not add up. In *A Spring Idyl*, for instance, the grafter's girl, puzzlingly, peels potatoes under the branches of an apple tree. The poacher's dog by the gorse bush fails to act its part and looks about quite as idly as any of Courbet's doggish witnesses at the events of life in Ornans, where this realist tradition of art began in the 1840s.

Interspersed among the large figure pieces are a number of plain, scene-setting views under such titles as *On Southwold Marshes*, *An Autumn Pastoral*, and *In the Barley Sele*. These indicate a world over there, going on in its own way and making no special arrangements for Emerson or for anyone else of importance. He emphasized this quality in two photographs which show the oddly random way in which sheep graze. They find their own spaces and pay little attention to anything beyond the task in hand. Such evident indifference would interest Emerson increasingly.

Perhaps he was aware of the contradictory impulse in his art. The first picture in the set, variously called *The Pond in Winter* and *A Winter's Morning*, features a cloaked figure stooped and tentative on the edge of a frozen pond. At least the pond is frozen over the greater part of its surface, but seemingly open under the shelter of a wind-trimmed tree. The stooped figure has every reason for prudence, and her two watchers have good cause to be attentive when the next move might bring a breaking of that brittle winter calm. Again Emerson interpolates a metaphoric element into a plain country scene, although this time the tenor of his metaphor is understressed: he hints at risk. He is beginning to subvert the traditions in which he works. He too might be uneasy in the dame's school.

In *Idyls of the Norfolk Broads* (London: The Autotype Company, 1887), each of twelve photogravures is accompanied by a short commentary that presents Emerson at his most literary. In 1886 his literary models had been Izaak Walton and Sir Thomas Browne; in the *Idyls*, his example was Theocritus, from whom he borrowed both his title and the idea of a series of short and inconclusive rural evocations. In later writing he referred admiringly to Theocritus, the Sicilian poet-shepherd, whose *Idyls* had been translated into English from the Greek by Andrew Lang and published by Macmillan and Company in pocketbook form in 1880.

In style Emerson diverged from his model. Whereas Theocritus

was deft and discursive, Emerson was measured and seemly: "To the lover of pastoral life and landscape, East Norfolk is an earthly paradise. At all seasons of the year it is beautiful." In this earthly paradise of "shady nooks" Emerson employs a sonorous prose rich in adjectives and ornate subordinate clauses: "The doves bill and

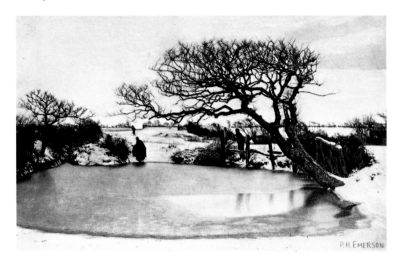

Peter Henry Emerson, *A Winter's Morning*, 1888, VA

coo in the high elms all day, and at noontide the brilliant kingfisher, glowing with azure and scarlet, darts forth and by the quick beatings of his jewelled wings hangs poised in the air, a living diadem. . . ."[20]

The images, in contrast, verge on the taciturn. They are his least successful photographs, for they show virtually nothing of any documentary interest. The landscape is remote and inscrutable, even down to season and time of day. In a typical image in the set, entitled *Noontide on the Marshes*, five grazing cows, two dozing horses, and a faraway house stand by a still ditch under a featureless sky. In *On the Skirt of the Village* two small children face a hedgerow where they have "spied a fieldmouse which has quickly disappeared." In almost every case Emerson fantasizes an animated secret life beyond placid surfaces: guard dogs in isolated farm houses, savage pike in still waters, mice in the hedges, and a whirring of gears in a silhouetted mill. Wanting to write a book in the style of Theocritus he had been forced to rethink his earlier adherence to the idea of the autonomous picture that completed the story or form and thus impeded the work of imagination. In front of the gray gravures of the *Idyls* everything remains to be imagined.

While engaged in the creation of his first three books, Emerson was also at work on a comprehensive report on folk life in Norfolk and Suffolk. After several years' labor *Pictures of East Anglian Life* (London: Sampson Low, Marston, Searle and Rivington) was published in 1888. It has the look of a scientific survey, almost of a government report, with its statistics and documentary details. Most of its thirty-two full-page photogravures relate directly to their topics, as do fifteen smaller photographs incorporated in the text. Emerson took his example from George Christopher Davies, the author of *Norfolk Broads and Rivers, or the Water-*

ways, Lagoons, and Decoys of East Anglia (1883). Davies, a prolific writer whose guidebooks to East Anglia went into many editions, illustrated his *Norfolk Broads* with photogravures based on his own photographs.

In *Pictures of East Anglian Life* Emerson maintained the pattern of imagery established in his first two publications. Representative country figures demonstrate their skills in instructive close-ups: furze cutters, eel pickers, brickmakers, osier peelers, plowmen, poachers, and basket makers. Then, in such generalized views as *Where Winds the Dike,* he sketches in the setting. As in *Idyls* he also invoked what cannot be seen: two ordinary children standing on a pathway are stopped in their tracks by the jewel-like magnificence of a toad, successor to the mouse of the *Idyls.*

In much of the text he writes with the detachment of an official inspector, sometimes condescendingly: "It is true that the Suffolk peasant is inferior to the Norfolk peasant."[21] Or he adopts a literary stance, likening his characters to figures from Emile Zola's *Germinal,* for example. His literary prose is nicely balanced, made mellifluous by repetitions of phrasing and judicious qualifications: "What is more affectingly beautiful than the sight of the simple trust and unselfish love to be met with in many a peasant home, where the struggle for life is of the fiercest, and the life when won is of the rudest! To our mind the picture of Catherine in Zola's *Germinal* is the most harrowing yet the most admirable picture of this self-sacrificing devotion to the family."[22]

But such balance was not always evident. The writer was often swept away by his enthusiasms and by his hatreds. Reminders of modernity brought him easily to the boil: "Will not the modern hotel, with electric bells, elevators, hot-air pipes, dynamo machines, telephones, ammoniaphones, electric fighting and shooting gear à la Jules Verne, water tricycles, and the devil knows what, spring up?"[23] The once judicious observer took the offensive in a storm of words, tokens of a reserve of power. Conventional forms were clearly inadequate if he was to make an adequate response "in these days of chromo-civilisation and greedy barbarism."

His enthusiasms took other forms. He was, for example, fascinated by skill and the private languages developed by skilled workers. He wrote at length on fencing techniques and on ways of hedge cutting; he is a font of information on fishing, smelting, shrimping, and eel picking. The practice of "swiping for" or reclaiming anchors is fully described with data on "swipe-locks," "bousing tackle," and "salvagees."

His overall emphasis was eccentric. In the first section of the book, on the "inferior" Suffolk peasantry, he began by discussing character and intelligence, moved to religion, superstition, witchcraft, and ghost stories before touching on politics, habits, and customs. The relations of farmer to landlord came in only as a tenth subsection, and his comments on the plates include an inordinate thirteen pages on poaching and the game laws.

This was Emerson's last attempt to write within the cultural conventions of his age and the last time he addressed a public of well-spoken Englishmen in their own terms. In *Pictures of East*

Anglian Life he assumed a readership both culturally informed and willing to be interested. In the future he would abandon all assumption. His writing in the 1890s is an amalgam of fragments, memories of his own responses, and the hearsay reports of others delivered in their own particular terms. His photography took a comparable turn; he had worked with the example of painting in mind but would look increasingly toward the transient, slight effects of contemporary graphic art. The year 1888 also saw the

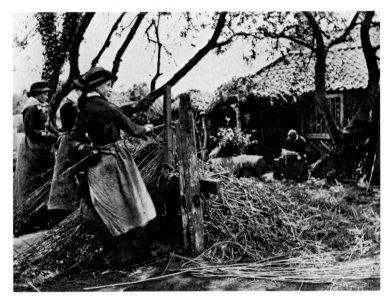

Peter Henry Emerson, *Osier-Peeling,* 1888, VA

publication of a special edition of *The Compleat Angler* (London: Sampson Low, Marston, Searle and Rivington) with twenty-seven photographs by Emerson, mainly of the River Lea, one of Walton's favorite stretches of water to the north and east of London, illustrating the first volume.[24] (Photographs of the rivers Dove, Wye, and Derwent by George Bankart illustrated the second volume.) Although steadily overlooked by historians and anthologists, these pictures, taken in the spring of 1887 when he was finishing work on *Pictures of East Anglian Life,* constitute one of Emerson's most outstanding achievements. None of his precursors, illustrators such as Thomas Creswick, had remained true to Walton's original text; they had drawn characteristic rural bits—cottages, bridges, and clumps of trees. Emerson maintained that tradition, but in the pollarded willows of the misty Lea and Ash he found a subject that sang more readily in harmony than anything had before. As still waters in flat countryside, the Lea and its tributaries were difficult to represent as anything other than shapeless millponds mirroring the sky. Emerson was forced to indicate space and the fluctuating shoreline through ranks of willows and poplars, an organic order often set against the regular slats and spars of white painted bridges. He hints metaphorically at this work of gauging, in a photograph of bowls players at Old Rye House.

Before these days on the quiet Lea, Emerson photographed as though he could get at his subjects directly, showing these harvesters as they might appear at rest on a summer's day, or he

made images as impersonal vehicles for his embellished prose. He had wanted to communicate powerfully and immediately. On the Lea he discovered another kind of art, an elusive calligraphy through which the underlying reality of a place might be read in the rhythm of a line of trees. Paradoxically and characteristically it was through this quite humble illustrative task that he began to move toward the making of that resonant, near abstract art that the Symbolists later admired and longed to achieve.

The summer of 1887 Emerson spent at Great Yarmouth on the houseboat *Electra* with his friend Goodall. The journal he

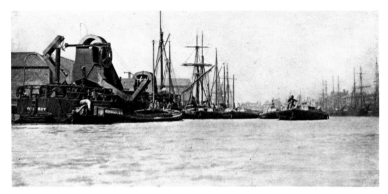

Peter Henry Emerson, *Toil and Grime*, 1890, VA

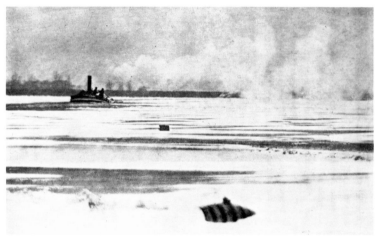

Peter Henry Emerson, *The Fetters of Winter*, 1895, VA

kept that summer became the basis for *Wild Life on a Tidal Water* (London: Sampson Low, Marston, Searle and Rivington, 1890), illustrated with twenty-nine photoetchings.

From the earliest books his commentaries had embraced a multitude of subjects. Now he took the logical step and began to publish his thoughts as they came. He observed wildlife, reminisced, and met the locals face to face. Something of the sententious man of letters survived, but not much. From his new vantage point close to nature he set himself in opposition to most major authors: "They all smell, more or less, of the lamp or the hospital."[25] Art criticism in the *Athenaeum*—"Golly what a paper!"—made him roar with laughter.

But *Wild Life* is chiefly remarkable for its eccentric characters. Some make brief appearances, like this sailor in a pub: "Then I oncet had Wenus, the queen o'love, tattooed on my chest, an'

a light from my pipe got betwixt me an' my shirt, an' burnt the best part of her off. . . ."[26] Pintail, a fowler, crops up most notably in the sixth chapter, called "A Drowning Accident": "Well, sir, them warmin don't know much 'bout small-boat sailing—sarve 'em right if they com up here and get drownded. Besides we poor men mun get a living, and they'd only hev given me a half-a-crown if I had saved the lot on 'em, d—n 'em! I know 'em well; and I shall get tree half-crowns for this (pointing to the pigmy curlew)."[27] Pintail, stupendously, had concentrated on his profitable hunting of a rare bird rather than turn aside to save a boatload of tourists. Pintail made a deep impression on Emerson, who had already used his story in "Fatal Water," a tale published in a collection of 1889, *English Idyls*. Their constant companion is Joey, cook and assistant, who turns out to be an incompetent, a liar, and an embezzler—who charms the author nonetheless.

Wild Life, in respect to its text at least, is a pastoral in the classic sense. Such rude, even savage, fen-men as Joey, Pintail, and the hunters Darkel and the Harnsee constitute a powerful Dionysian element, against which Emerson and Goodall are ranged as civilized foils, defenders of order and plain dealing. The two strains meld in the author himself, for, although his behavior is exemplary, he is also at home in the speech of these sly outsiders—Bottom meets Theseus in a midsummer's fenland dream.[28]

At first sight there seems to be little connection between text and pictures. His model seems to have been those Whistler lithographs of the late 1880s in which foreground details are omitted. Or he might have looked at pictures by the outstanding British marine painter W. L. Wylie, who had made his reputation in 1883 at the Royal Academy with *Toil, Glitter, Grime and Wealth on a Flowing Tide,* a picture of barges, tugboats, and moored ships. Plate XI in *Wild Life,* called *Toil and Grime,*[29] features a gross iron apparatus dredging to one side of a harbor elegantly marked out by fine masts and spars. Wylie's painting gives a close-up view; Emerson leaves a wide stretch of water between his viewpoint and the activity of the port, which results in the stilling of that activity. In general his is a very tranquil view of Great Yarmouth, with no more than residual signs of activity: children play on the dockside and a few inscriptions dimly come into view, such as the letters of "THE BRITISH GAS LIGHT COMPANY," remotely legible on a tower alongside the North River. Prosaic details have all but vanished, leaving an impression of the larger social and industrial world in the most tranquil of contexts. As in the text, Emerson negotiated two largely antithetical terms, but with such an excess of moderation that *Wild Life* remains one of his least-known books.

In the autumn of 1890 Emerson began a cruise through the Norfolk Broads in a converted sailing barge, *Maid of the Mist.* He kept a journal of the year-long cruise, and this was published as *On English Lagoons* (London: David Nutt, 1893). The fifteen copperplate engravings interspersed through the text were printed by Emerson himself, always critical of the way in which his pictures had been reproduced by commercial printers.

This was the first of Emerson's books to be published by David Nutt. Between 1890 and 1912 the business was carried on "At the Sign of the Phoenix" in Long Acre by Alfred Trübner Nutt, who was also a folklorist and Celtic scholar. Nutt published six books by Emerson including *Tales from Welsh Wales* and *Welsh Fairy Tales,* both of 1894. Nutt was an early member of the Folklore Society and a founder of the *Folklore Journal* under its original title, *Folk-lore.*[30] Emerson's skill as a writer in dialect must have commended him to Nutt at a time when dialect stories were much published in such popular literary periodicals as *Longman's Magazine.*

Emerson's companion on the *Maid of the Mist* was Jim, a local man quite opposite in character to the scurrilous Joey of the *Electra.* Decent though he was, Jim made far less of a mark than Joey, who suited Emerson's pastoral purposes in *Wild Life. On English Lagoons,* with its many loving evocations of the author alone with landscape, is far more lyrical than pastoral in tone. Jim kept to his own cabin, and those fen-men who did crop up were more reserved than Pintail and Joey.

From the contrasting types met during his houseboat days Emerson constructed an entertainment that reads like a fable. *On English Lagoons* is altogether more of a journal, faithful to impressions. Indeed Emerson was at pains to stress just how little he had intervened, and how little he cared to imagine his way into the lives of others: "Much of the false pity and sentiment in life is due to second-rate art, for your mediocre craftsman always describes humanity from his own standpoint, as he imagines he would feel were he in the position of the pitied; but the sufferers seldom realise misery as does the sentimental writer."[31] Figures crop up and are gone, and the writer simply registers their momentary presence.

"The silent, pure, radiant beauty of the world" assuaged the author again and again. But calm was often interrupted by, for example, the wild cries of birds: the "chicken-like squeals" of water rails, the "wild shouting" of grebes, and the drumming of snipe.[32] He appreciated such disruptive experience: "The rude gusts of wind brought vigour in their train, and one's life felt full. Man has no need to travel far after he has found what delighteth his soul. Some experiences fill his being and exclude all thought: thought so pernicious to happiness."[33] The thought he referred to was analytical and managerial, and those who thought it distanced themselves from nature as he had done in *Pictures of East Anglian Life.*

Specific places are noted in the journal and much very particular information is given on such matters as the virtues of plovers' eggs and the correct way to make a starling pie. But it is less the instantaneous present with which he is concerned than with timeless moments, benign and inspirational. His photographs match the text, both featuring a suspended timeless present into which the trafficking world barely intrudes. In *Wild Life* Emerson presented and refined the port, representative of business. In *On English Lagoons* he offered a more luminous world of misty gray landscapes, punctuated by items that are merely tokens of that various elsewhere he had tried to generalize in 1890.

All the busy world beyond is now summed up in the image of a tolling bell in two of the finest pictures of his career, taken at Buckenham Ferry during this journey: "Day and night the ferry-bell was jangling and the winch clanking as the actors of country life passed before us in an endless panorama."[34] In a sweeping view of Buckenham Ferry (facing page 39) the bell hangs in a frame towards one side, and opposite a windmill stands dimly in the mist; a heavy barge makes a dark shadow on the water. In *At the Ferry—A Misty Morning* (facing page 73) a slatted spring cart laden with milk churns labors under the trees toward the river and the bell, again partly obscured in mist. The bell rings for the panorama of country life, a precise synecdoche drawn from the world of traffic. Other Symbolists, who had modern life as their subject, would work with similar significant details: Alfred Stieglitz, in photography, and the Futurists, in painting, both alluded to the city as system in images of trams and trains.

In both ferry bell images, with their significant details set against backgrounds of mist, Emerson gracefully comprehended the practical and the transcendental. And nowhere else in his oeuvre did he make such a various appeal to the senses: the cart and its tin cans with the bell jangle in the stillness of the mist; the black shadow of the barge personifies bulk; and the far sails of the mill describe the air. In general Emerson gave priority to one sense or the other, but hearing, seeing, and feeling simultaneously at the ferry he approaches much more nearly than elsewhere the sensuous variety of his admired Theocritus.

"Dedicated to my friend and publisher Alfred Nutt," *Marsh Leaves* (London: David Nutt, 1895) contains sixteen of Emerson's finest photoetchings. Its sixty prose pieces—local anecdotes, tales told to the author, or recollections—are once more in the manner of the *Idyls* of Theocritus. Few of these prose pieces are rounded out to anything like a conclusion or moral, although Emerson sums up moodily at times: "All things must sleep, and all things must die, and these are the two secrets of life." Once an image is established Emerson falls silent.

The great invention of this last photographic book is Old Wrote, an ancient fen-man and, according to Emerson, almost a deity. Whatever his source, Old Wrote is mostly metaphor, through whom the artist describes himself. Though aged and deaf he remains strong and (dear to Emerson's heart) judicious: "While at his work he did not deign even to answer the young men, but when he saw a good workman he would always stop and speak to him."[35] Old Wrote damns his feeble times: " 'Dar Bor! a shiver in the hand; mean you don't wrote,' for this hardy but deaf old Hercules despised the young men of the day, saying they were more like 'mawthers' with their prayer meetings, smooth tongues, and lazy ways."[36] A character has been established and left standing, just as another singular fen-man is introduced for the sake of a phrase and a gesture: " 'When she's dirty I takes her works out and biles 'em in the saucepan for an hour; then I stands 'em on the hob to dry, and arter that I grease with paraffin, and she

do go right beautiful. Look at her.' And the clock struck all she could in vindication of the cleaner."[37]

A phrase, a gesture, a moment, an image—fragments: nothing in *Marsh Leaves* is developed, nothing resolved. The author provides only sharp reminders of a here-and-now in which the flow of "prosy" time is disrupted by intensely apprehended moments. Emerson the narrator emerges as a giant embodying the earth and its forces: "I could feel before I arose that a south-westerly wind was blowing. My skin was no longer dry and smooth like the reed-stalks, but swollen out and modelled; the light and shade played in and out of the little hollows and hillocks on my arm, and all the fluids of my body seemed to flow wildly and healthily through my body, just as the sap was rising in the young plants on the marshland."[38] The longtime observer of nature had at last become fused with his subject.

In *Marsh Leaves* Emerson edges in the direction that Ezra Pound was to take twenty years later. Like Pound, Emerson was possessed by a lifelong preoccupation with history, at first in order to admonish and to change. By 1895 history and the society in which it was embodied had become alien forces against which he protested his existence—his solitary, sentient, exuberant, craving, and fearful being. He protested in his asides on the inadequacy of "thought" and then more powerfully in his invocations of the fen-men as they existed in aphorisms and anecdotes, each one associated with a grand or disgraceful gesture. Emerson recognized the meaning of their vivid phrases, which so stand out from his own flowing standard English. Pound quoted in the same way and introduced history into the *Cantos* as quotation, as voices gesturing against that continuum of history into which individual identity is so easily submerged. Abruptly introduced, Pound's

quotations and Emerson's part-told tales stand out, denying analysis.[39] Old Wrote has nothing of practical value to impart. He is simply an isolated image of ruin.

Detail, subdued in the photographs of 1893, was all but suppressed in 1895, although there is one equivalent to the earlier ferry bell images in *The Fetters of Winter*, where a distant tugboat and an iced-in buoy represent traffic and normalcy in a stratified ice-scape. Otherwise the dominant tone is bleak, most obvious in *The Lone Lagoon*, a vignetted remoteness on the verge of nothing. Time and again Emerson reached the edge of abstraction in images that are more calligraphic than descriptive. In *Marsh Weeds* and *The Snow Garden* pale backgrounds hold the dark marks of desiccated stems and leaves as a stave holds musical notations. The matter of these last photoetchings is interval, with documentary elements hardly admitted. They constitute the art of a visionary preoccupied by absolutes.

The basis of this art was harmonic, in the sense that its elements in themselves were of no importance in comparison to their interrelationships. The French Impressionist Georges Seurat had evolved an art of this sort, and very much along the lines followed by Emerson; he too had been confronted by history and society, as embodied in Parisian people and places, and he too had adjusted and muted the details of that society in the interests of a harmony equally and simultaneously present.

Emerson may never have heard of Seurat nor of Piet Mondrian, whose art was to follow the same direction in the late 1890s. Had he been more tolerant and less impatient with his times he might have taken heart and added to the exceptional ten years he spent in photography. On the other hand a temperate Emerson may have remained in obscurity all his days.

NOTES

1. *Naturalistic Photography*, 3rd ed. (London: Dawbarn and Ward, 1899), p. 32. **2.** Ibid., p. 73. **3.** Walter Pater, *Appreciation with an Essay on Style* (London: Macmillan and Co., 1910), p. 10. **4.** *Naturalistic Photography*, 3rd ed., p. 183. **5.** Walter Pater, *Appreciation*, p. 22. **6.** *Naturalistic Photography*, 3rd ed., p. 93. **7.** Ibid., p. 31. **8.** Ibid., p. 175. **9.** Nancy Newhall, *P. H. Emerson* (Millerton, N.Y.: Aperture, 1975), p. 37. **10.** *Life and Landscape*, pp. 33–35. **11.** *On English Lagoons*, p. 20. **12.** Ibid., p. 22. **13.** Ibid. **14.** Robert Fitzgerald, trans., *The Odyssey* (London: William Heinemann, 1961), p. 198. **15.** Kenneth Grahame, *The Wind in the Willows*, chap. VII. **16.** Arthur Symons, *Cities and Sea Coasts and Islands* (London: W. Collins, n.d.), pp. 243–45. **17.** *Life and Landscape*, pp. 27–29, 53–54. **18.** Ibid., p. 13. **19.** Ibid., p. 9. **20.** *Idyls of the Norfolk Broads*, p. 7. **21.** *Pictures of East Anglian Life*, p. 1. **22.** Ibid., p. 134. **23.** Ibid., p. 81. **24.** *The Compleat Angler* (1653) was in vogue in the 1880s with deluxe, facsimile, and popular editions published almost every year. **25.** *Wild Life on a Tidal Water*, p. 47. **26.** Ibid., p. 67. **27.** Ibid., p. 36. **28.** For a discussion of pastoral see Richard Cody, *The Landscapes of the Mind* (Oxford: Clarendon Press, 1969), pp. 153–76. **29.** Exhibit No. 1493 in the Royal Academy, 1883, and illustrated in *Academy Notes 9* (1883): 79. **30.** *Dictionary of National Biography*, 2nd supp., Nutt, A. T., vol. III, pp. 30–31. **31.** *On English Lagoons*, p. 112. **32.** Ibid., pp. 49, 181, 187. **33.** Ibid., p. 188. **34.** Ibid., p. 39. **35.** *Marsh Leaves*, p. 51. **36.** Ibid., p. 3. **37.** Ibid., p. 7. **38.** Ibid., pp. 75–76. **39.** Regarding Pound and history see Richard Pevear, "Notes on the Cantos of Ezra Pound," *Hudson Review* 25 (1973): 51–70.

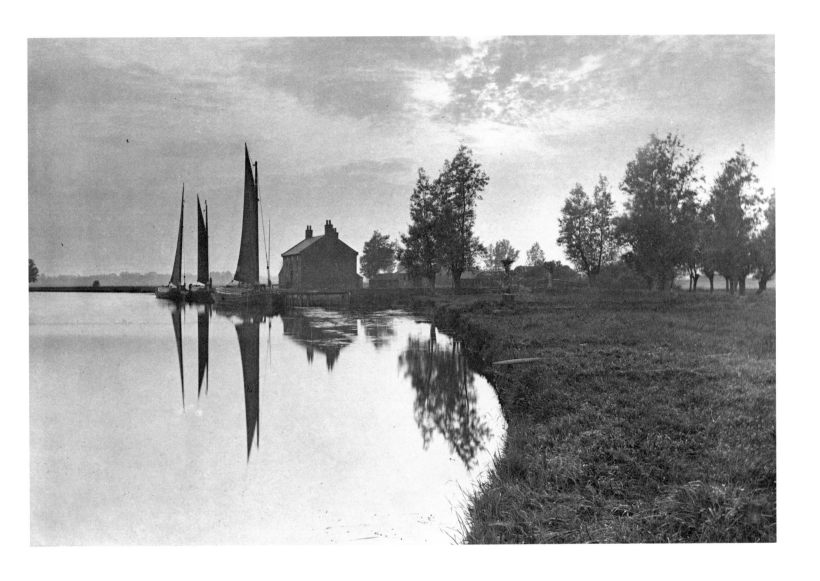

*Nature is full of pictures, and they are to be found in what appears to the uninitiated
the most unlikely places. Let the honest student then choose some district with which he
is in sympathy, and let him go there quietly and spend a few months, or even weeks if he
cannot spare months, and let him day and night study the effects of nature, and try to produce
one picture of his own, which shall show an honest attempt to probe the mysteries of
nature and art, one picture which shall show the author has something to say and
knows how to say it, as perhaps no other living person could say it; that is something
to have accomplished. Remember, that your photograph is a rough index
of your mind; it is a sort of rough confession on paper.*

Peter Henry Emerson, *Naturalistic Photography for Students of the Art*, 1889

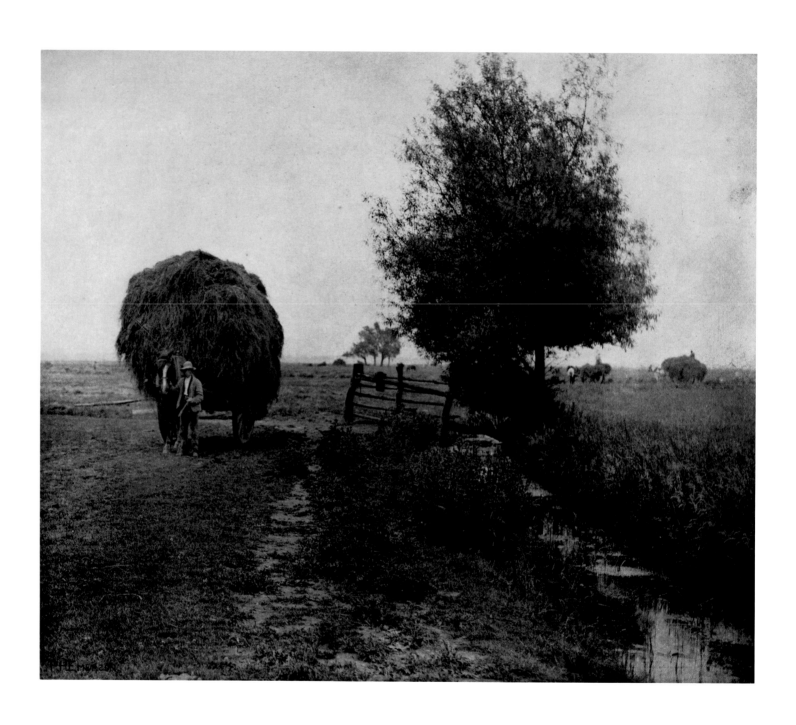

164 PETER HENRY EMERSON, *In the Haysel, Norfolk*, 1888, photogravure 28.1 x 33.4 cm, PMA

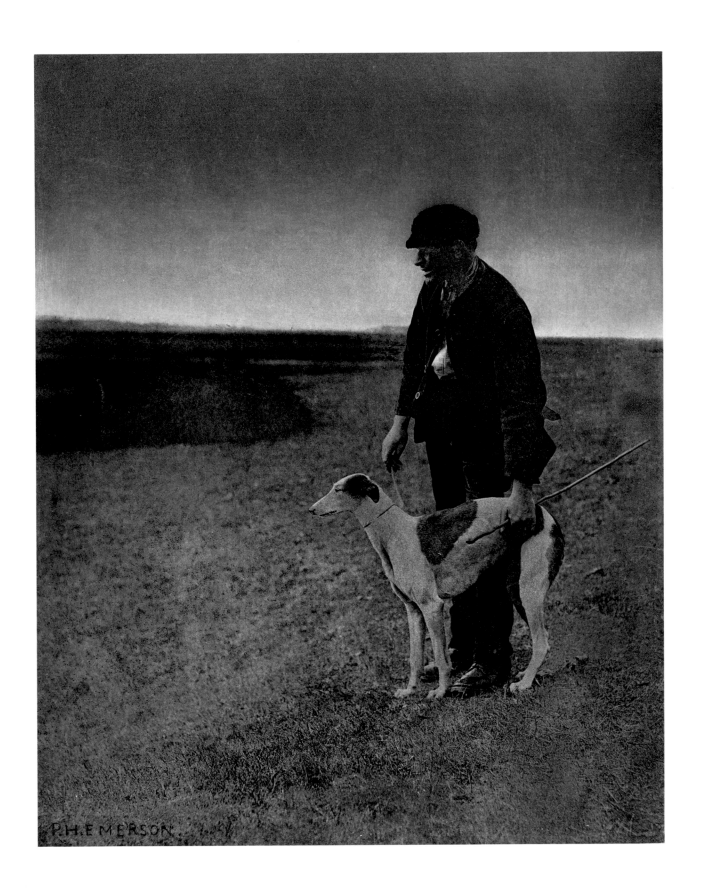

165 PETER HENRY EMERSON, *The Poacher—A Hare in View, Suffolk*, 1888, photogravure, 28.5 x 23.6 cm, VA

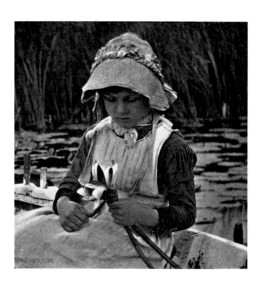

PETER HENRY EMERSON, *Flowers of the Mere,* 1887, photogravure, 7.1 x 7.2 cm, VA (top)
166 PETER HENRY EMERSON, *Water-lilies,* 1886, platinum print, 12.4 x 28.3 cm, PMA (bottom)

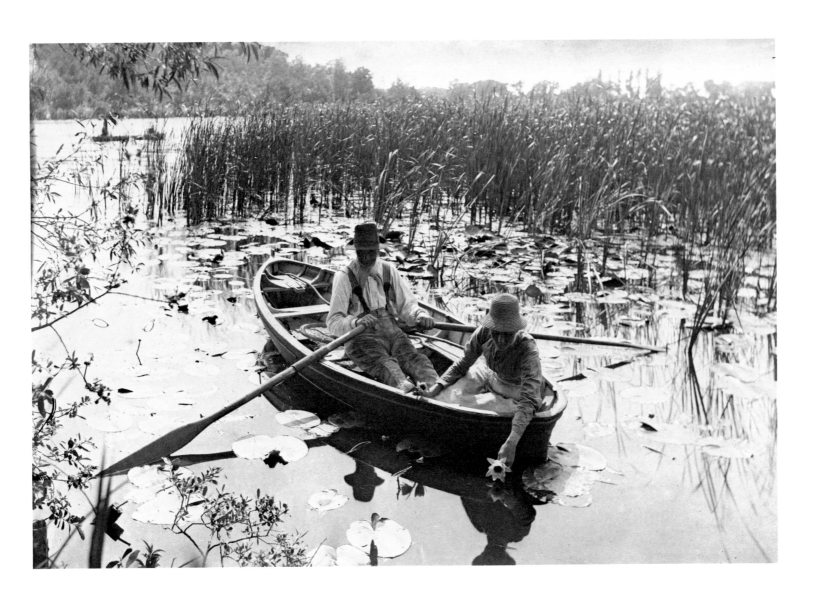

167 PETER HENRY EMERSON, *Gathering Water-lilies*, 1886, platinum print, 19.9 x 29.2 cm, PMA

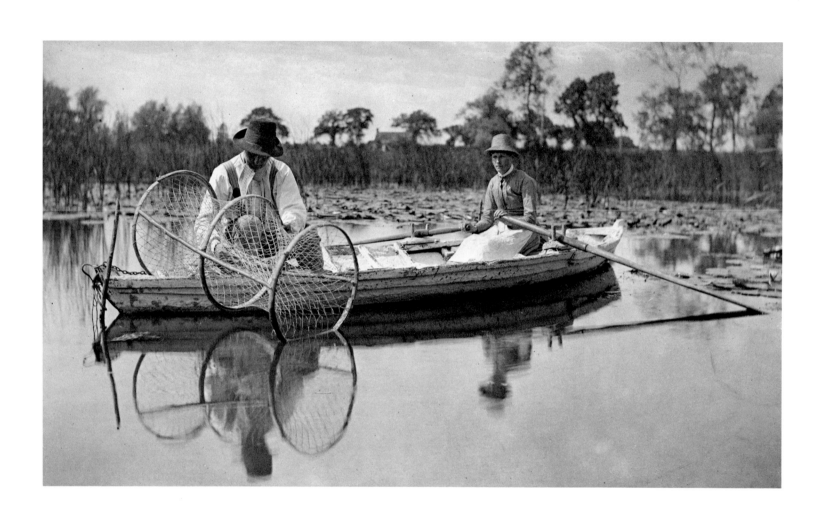

168 PETER HENRY EMERSON, *Setting the Bow-Net*, 1886, platinum print, 16.5 x 28.5 cm, PMA

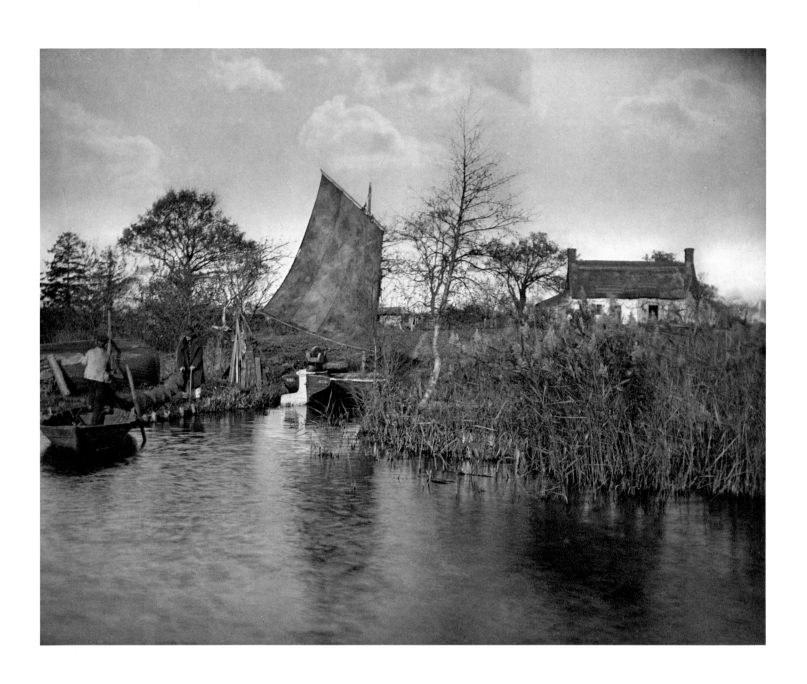

169 PETER HENRY EMERSON, *A Broadman's Cottage*, 1886, platinum print, 22.8 x 28.9 cm, PMA

James Craig Annan
Brave Days in Glasgow

William Buchanan

In achieving his reputation as a photographer, James Craig Annan had several advantages: he grew up and worked in Glasgow's exciting artistic *stramash* (to use a Scottish word for turmoil), and he was the son of the photographer Thomas Annan. Thomas Annan founded the firm, later T. and R. Annan,[1] in 1855. James Craig, the second son of Thomas, was born on 8 March 1864 at Hamilton (to the southwest of Glasgow) in the family home called—and here is another of his advantages—Talbot Cottage. Thomas was remembered at the time of his death in 1887 for his skill in the reproduction of works of art. He is remembered today for his dignified portraits and the powerful series of photographs of *The Old Closes and Streets of Glasgow*, taken in 1868, the first survey of a city slum.[2] Thomas Annan had also photographed and made reduced copies of David Octavius Hill's Disruption painting, and when Hill left his home at Rock House in Edinburgh the year before he died, the Annan family left Glasgow and moved into it, with the Hill and Adamson calotypes still stored there. Although James would have been only five or six years old at the time, he carried distinct memories of the aged, white-haired Hill. Back in west Scotland after only a year, James followed his schooling with the study of chemistry and natural philosophy. He joined the family firm, and in 1883, at nineteen, he went with his father to Vienna for instruction in the process of photogravure by its inventor Karl Klič. Thomas Annan bought the sole rights to the process for Britain.

In the early 1890s James Craig Annan brought his consummate skill to the making of prints from original Hill and Adamson negatives, which he lent willingly to exhibitions in Europe and America. He knew Hill and Adamson's work intimately, and he became known, and is still known today, primarily as their champion. Reverberations of Hill and Adamson's work can be felt in Annan's work, such as his portrait of the burly G. K. Chesterton. At this time Annan decided to practice photography as an artist in his own right, and by 1892 he held his first exhibition, in the new premises of T. and R. Annan at 230 Sauchiehall Street. It was a two-man show, the result of a journey made in the north of the Netherlands with his friend, the etcher D. Y. Cameron (1865–1945), a young artist on the fringes of the group known as the Glasgow Boys. Annan presented his photogravures, Cameron his etchings.

Annan's Dutch photographs recall the subject matter of the Hague School, particularly the work of Bernardus Blommers (1845–1914) and Jacob Maris (1837–1899). Their work hung in many Glasgow collections and Annan must have been influenced by the Hague style, but he brought an entirely fresh approach to the landscape. *The Beach at Zandvoort* shows a wide expanse of sand with people aligned in an irregular frieze along the top of the print. The crowd of *On a Dutch Shore* clusters together

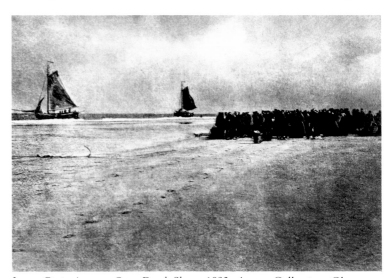

James Craig Annan, *On a Dutch Shore*, 1892, Annan Collection, Glasgow

for a fish auction, a dark mass balanced by fishing boats. In some cases Annan adopted a long narrow format as if the horizon had dictated it.[3] As Weston Naef has pointed out, these two pictures, along with *Sand Dunes*, influenced the earlier style of Alfred Stieglitz.[4] When, two years after Annan, Stieglitz visited the Dutch coast, he chose Katwijk, further south than Zandvoort, and adopted a long, narrow format for *The Landing of the Boats*.

Annan's second exhibition was held in 1893 in London at the first salon organized by The Linked Ring, a secession from the Photographic Society.[5] He showed his Dutch pictures, but it was his portrait *Miss Janet Burnet* that made the greatest impact. He printed it so that sometimes Miss Burnet looks to the right and sometimes to the left, perhaps inspired by James Abbott McNeill Whistler's *Arrangement in Gray and Black* (familiarly known as

The Artist's Mother) or by Hill and Adamson's *Mrs. Rigby,* which Annan would have known well since he had made both right- and left-facing photogravure copies of the negative.

In 1894 Annan went again on a trip with Cameron, this time to the north of Italy. Among the photographs he produced were two tiny images: *A Lombardy Pastoral* and *Ploughing on the Campagnetta.* "The teams of oxen with their drivers *happened* to occupy the fortunate positions they do in the picture," he later wrote of *Ploughing,* "but it was only after watching them plough furrow after furrow that I *chanced* to make the exposure."[6] Once it came time for the exposure, Annan had to act quickly. He demonstrated his alacrity by snatching a brilliant exposure of two monks, *The White Friars,* striding so vigorously along a road that even today's advances in instantaneous photography do not rob this print of its dynamism. When it was seen in New York six years later, in an exhibition in the New York Camera Club, where it was called *Monks Walking* and lent by Stieglitz, it was hailed as "one of the greatest pictures ever made by means of the camera."[7]

Annan's Italian photographs were shown at the second salon of The Linked Ring in 1894, along with a pictorial essay in the Pre-Raphaelite manner. Elected a Link on 6 February 1894, Annan was a member of the selection committee that accepted the first work by Stieglitz exhibited at the Salon.

Also in 1894 Annan burst onto the international photography scene in no uncertain way. Two of his works were purchased in New York, and in reviewing The Linked Ring exhibition for the American audience, Stieglitz wrote, "Here we deal with a true artist, and a decidedly poetical one at that. We have seen but a few pictures to equal that called *Labor—Evening.* . . . We can give it no higher praise."[8] Annan showed the largest number of prints at the first exhibition of the Photo-Club de Paris, and he gained a medal in Russia. During the next decade and a half he maintained what must have been a hectic exhibition schedule, showing regularly in London and elsewhere in Britain and adding to his list Calcutta, Brussels, Ghent, Liège, Antwerp, Munich, Berlin, Hamburg, Bremen, The Hague, Philadelphia, Wiesbaden, Dresden, Vienna, Turin, Florence, Budapest, Buffalo, and Amsterdam.

In March 1896 *The Amateur Photographer* published Annan's article encouraging the use of the hand camera.[9] A year later the *Bulletin de l'Association Belge de Photographie* quoted extensively from the translation, stating correctly that Annan, "in contrast to the usual practice of our British colleagues, has written very little for the photographic journals."[10] What Annan did write was widely read. When in 1897 Alfred Stieglitz wrote on the use of the hand camera for the *American Annual of Photography,* he paraphrased Annan's remarks about the hand camera being considered a "toy, good enough for the globe trotting tourist. . . . But *nous avons changé tout cela.*"[11] Elsewhere in his article Stieglitz did quote and credit "that able artist J. Craig Annan."[12] Stieglitz continued his admiration of Annan. At his death he owned sixty Annans, a number exceeded only by prints of Edward Steichen.[13]

In 1897 The Linked Ring held its annual exhibition in rented premises, the Dudley Gallery in Piccadilly. The Glasgow designer George Walton (1867–1933), an old friend of Annan's newly arrived in London, was commissioned to produce a scheme for the gallery. In typical Glasgow style Walton hung a broad green valance around the top of the walls beneath a stenciled frieze of buff canvas. Below that he ran a wooden shelf around the room

James Craig Annan, *G. K. Chesterton,* 1890s, Mitchell Library, Glasgow

and draped the hanging area beneath in canvas distempered to match the floor. The exhibits he hung in a decidedly asymmetrical way, in the larger spaces between the frames lightly stenciling a lily, lotus, or rosette.

In 1900 Annan was honored by the first one-man show mounted at the Royal Photographic Society. No matter that Annan was a member of the Secessionist rival Linked Ring. He spoke at the opening of the exhibition about the training of a visual awareness and much about the hanging of exhibitions and the framing of photographs.[14] His exhibition featured two exotic frames: around his frankly banal *The Church or the World* was a frame of white ivory; around his portrait of the girl *Molly* he put a Glasgow-style frame by Frances and Margaret Macdonald in hand-beaten aluminum, dated 1897, a design of sunflowers and butterflies more lighthearted than is usual in their work, suggesting it might have been commissioned for the photograph.[15]

To celebrate the opening of its new Art Gallery and Museum in 1901 Glasgow mounted an international exhibition. Whatever debates continued elsewhere, as far as Glasgow was concerned, the art of the nineteenth century included the art of photography.

Camera Notes praised "the invitation to exhibit [photographers] on equal footing with painters, sculptors, architects. . . . It was the first time in the history of Pictorial Photography that it found itself welcomed and officially recognized in the 'Cathedral' of Fine Art simultaneously with its older sisters."[16] As organizer for the photography exhibit, Annan brought together 500 photographs by 201 artists, a formidable roll call of names familiar in the Pictorial movement. The largest group came from France, represented by forty photographers. Annan drew heavily upon the English Links, including George Davison, Frederick H. Evans, and Frank Meadow Sutcliffe.

It was as a fellow Link that Annan wrote to Stieglitz in December 1893 to ask if he would select the American entries. Stieglitz agreed, but a moment of tension ensued when it appeared that F. Holland Day, Stieglitz's nemesis, was also arranging to send work to Glasgow. When the crisis passed, Stieglitz chose photographs by twenty-nine Americans, including himself, Gertrude Käsebier, Joseph T. Keiley, Steichen, and Clarence White. This group formed the basis of the exhibition Stieglitz was to mount at the National Arts Club in New York in 1902. Thus did Glasgow obtain a preview of the first Photo-Secession exhibition in America.

The firm of T. and R. Annan received the appointment as official photographers to the 1901 exhibition, and they set up a large studio in the park. The summer was especially fine, which no doubt helped business, perhaps leading to the firm's ability to build handsome new premises with studios and gallery two years later at 518 Sauchiehall Street.[17]

About this time Annan's own work came into maturity. *Stirling Castle* of 1903 expresses his own vision: the simplest of scenes imbued with a highly charged atmosphere. His view of a castle, a few farm buildings, and a white horse evokes an almost physical response. As Ian Jeffrey has suggested, "Annan shows himself to be susceptible to the extraordinary, to moments when commonplace material shows itself in an unusual light."[18] Further recognition of his international role came in 1904, when an article on his work illustrated by six examples appeared in *Camera Work*.[19] In the spring he was appointed by His Majesty's Commission to the St. Louis Exposition to represent Britain on the international jury for the photography section. Just before he left for the United States in the middle of August, he received a letter from Stieglitz, apparently suggesting that he might head a new international society of photographers. Back from his duties at St. Louis he received in January 1905 a copy of the proposed constitution of the society. A brochure showing the articles of agreement of the International Society of Pictorial Photographers shows Annan (unfortunately as from England) as a subscriber.[20] Although The Linked Ring also backed Annan for the presidency, it seems that nothing came of the affair.

Stieglitz expressed his warm appreciation of Annan's art once again with an invitation to show in March 1906 at Stieglitz's "291" Gallery in New York, along with Evans and Hill (no mention of Adamson). Hill's prints were either photogravure or car-

bon prints from original negatives by Annan. Annan's eighteen exhibits consisted of portraits, including *Miss Janet Burnet*, the superb *William Strang Esq., A.R.A.*, and *F. Holland Day*, together with Dutch and Italian pictures.

The mood of Annan's photographs, such as *The Thames near Henley, Bolney Backwater*, and *Stonyhurst*, becomes more somber, even ominous, by 1909. He produced a group of works taken on

James Craig Annan, *Miss Janet Burnet*, 1893, Mitchell Library, Glasgow

two visits to George Davison, one of the founders of the Ring, an old friend, now a rich man. The first visit in January 1909 must have produced the view of the snow on Harlech Castle, a subject Davison had himself tackled. In July, Annan joined Davison again at his house and houseboat (both designed by George Walton) at Shiplake on the Thames. Both these houses appear in the background of *The White House*, in which a well-groomed young man in white trousers drifts by in a punt. Once again Annan's sense of timing was superb. This photograph, with Paul Haviland's *Passing Steamer*, and Stieglitz's *Going to the Start* and *The Steerage* have been described as "seminal examples of the instantaneous snapshot wedded by vision into the formal concerns of modern art."[21]

In 1910 the Secession movement in photography in America and Britain came to a formal end. In America Stieglitz organized an impressive exhibition of 584 prints, including several by Annan, at the Albright Art Gallery, Buffalo, New York. Sadakichi Hartmann's informed analysis of the aesthetic views expressed in the show divides the movement into two groups: to one he assigned the Robert Demachy–Edward Steichen group with its painterly treatments. On the other he put Annan (with one hyphen too many) in the "Stieglitz–White–Craig–Annan class who flock around the standard of true *photographic themes and texture*."[22]

Annan's own view on "Photography as a Means of Artistic Expression" appeared in the October issue of *Camera Work* in 1910. He believed that the photographer should have the highest artistic abilities, citing the effect Rembrandt had had on etching.[23] That year The Linked Ring disbanded. Annan showed in May at the sole exhibition of the London Secession with Alvin Langdon Coburn, Stieglitz, and others.

Annan set off on another of his foreign trips in 1913, traveling in Spain with another etcher, William Strang (1859–1921). Annan's style noticeably changed. He asked his subjects to pose: a blind guitarist; smiling *gitanas* against a wall; a group on a hill road in Granada. Annan, now fifty, seemed to be slowing his pace. Stieglitz illustrated eight of these Spanish works in *Camera Work* in January 1914. He was in no doubt of their worth—"Annan has never done any finer work. His work is always a delight. . . . As an artist he continues to grow"[24]—but Annan never realized his intention to publish a folio of his Spanish photogravures, as he had done with his Italian series. He made just one more trip, to Egypt, in the spring of 1924.

Gradually Annan lessened his photographic activities. Most of his portraits[25] were now carried out to his direction by his assistants. He was missed. Stieglitz lamented in a letter to Hein-rich Kuehn in 1923, "I haven't heard anything of Annan for four years. He has his reproduction business in Glasgow—also a gallery where he exhibits and sells etchings. He no longer exhibits because there are no first-class photography exhibitions anymore. Annan is a fine person."[26] Annan, for his part, missed the stimulus of the early days in Glasgow. There was a great boom in etchings, and he took great delight in handling etchings by Rembrandt, Dürer, Whistler, his etcher friends Cameron, Strang, Muirhead Bone, and others. He left the firm just after the outbreak of World War II and died on 6 June 1946 in Lenzie near Glasgow.

Annan's reputation has suffered the fate that usually falls upon those who work apart from a main cultural center. Beginning in 1901, when his splendid international exhibition of Pictorial photography went unnoticed by the London press, he joined a list of Scots, like Sir Henry Raeburn and Charles Rennie Mackintosh, who stayed in Scotland, and who as a result were late in receiving critical attention. The brave days in Glasgow produced a group of lively painters in the Glasgow Boys, an important pioneering architect in Charles Rennie Mackintosh, and a major international Pictorial photographer in James Craig Annan.

NOTES

For their help in providing information, I am deeply grateful to the Annan family, who continue to run the firm.

Judgment on the quality of Annan's work, especially the delicate photogravures, is best made from original examples and not from reproductions. The reprint of *Camera Work* by Fraus (Nenlen/Liechtenstein, 1969) states that it does "not attempt to reproduce its visual quality, nor the caliber of its plates." Annan's work was reproduced in the following issues: October 1904; July 1907; April 1909; October 1910; January 1914. A useful reference is Marianne Fulton Margolis, *Camera Work/A Pictorial Guide* (New York: Dover, 1978).

1. For a history of the firm, see Margaret Harker, "Annans of Glasgow," *The British Journal of Photography* 12 (October 1973): 966–69. 2. See Anita Ventura Mozley, *Thomas Annan: Photographs of the Old Closes and Streets of Glasgow 1868–1877* (New York: Dover, 1977). 3. Annan wrote a short account of his visit to Zandvoort. See William Buchanan, "The 'Most Versatile and Artistic' James Craig Annan," a paper given at the symposium arranged by the Glasgow School of Art, *Scottish Contributions to Photography*, March 1983. The symposium papers are to be published in *The Photographic Collector*. 4. Weston J. Naef, *The Collection of Alfred Stieglitz* (New York: Metropolitan Museum of Art/Viking Press, 1978), p. 261. 5. See Margaret Harker, *The Linked Ring* (London: Royal Photographic Society Publication/Heinemann, 1979). 6. J. Craig Annan, "Picture-Making with the Hand-Camera; or, the Use of the Hand-Camera for Pictorial Results," *The Amateur Photographer* 23 (27 March 1896): 377–79. 7. J. T. K. (Joseph T. Keiley), "Loan Exhibition," *Camera Notes* 111, no. 4 (April 1900): 214. 8. Alfred Stieglitz, "The Seventh Annual Joint Exhibition," *American Amateur Photographer*, 6 May 1894: 209–19. 9. Annan, "Picture-Making": 337–79. 10. M. Vanderkindere, "James Craig-Annan [sic]," *Bulletin de l'Association Belge de Photographie* 24, no. 6 (June 1897): 401–4. See also in that issue Edmond Sacré, "Exposition des oeuvres de Craig-Annan de Glasgow": 405–17. I am grateful to Steven Joseph, Brussels, for this information. 11. Alfred Stieglitz, "The Hand Camera—Its Present Importance," *American Annual of Photography . . . for 1897*: 19–27. 12. Letters from Annan to Stieglitz are held in the Collection of American Literature, The Beinecke Rare Book and Manuscript Library, Yale University. I am grateful to David E. Schoonover and Aldo R. Cupo for their help. It is unlikely that Stieglitz's letters to Annan have survived. 13. Naef, *Alfred Stieglitz*, p. 261. 14. A verbatim report appears in "Mr. Craig Annan's Address," *The Amateur Photographer* 31 (2 February 1900): 83–84. 15. "The Photographic Exhibitions," *The Artist* (November 1897): 571–75, with an illustration of the frame. Christie's sale catalogue *Art Nouveau and Art Deco* (22 November 1982), lot 92, ill. p. 25. 16. Alfred Stieglitz, "Irreconcilable Positions—A Letter and a Reply," *Camera Notes* 5, no. 3 (January 1902): 217–18. 17. Alex Koch, ed., *Academy Architecture* 25 (1904), ill. p. 90; *The Builders Journal* 24, no. 616 (28 November 1906), ill. p. 263; illustrated and discussed in William Buchanan, "Mackintosh, John and Jessie Keppie," *Charles Rennie Mackintosh Society Newsletter*, Midsummer 1982, n.p. 18. Ian Jeffrey, *Photography: A Concise History* (London: Thames and Hudson, 1981), pp. 100, 104. 19. Joseph T. Keiley, "J. Craig Annan," *Camera Work* 8 (October 1904): 17–18. 20. Helmut and Alison Gernsheim, *The History of Photography* (London: Oxford University Press, 1955), ill. p. 332. 21. Jonathan Green, *Camera Work: A Critical Anthology* (Millerton, N.Y.: Aperture, 1973), p. 22. 22. Sadakichi Hartmann, "What Remains," *Camera Work* 33 (January 1911): 30–32. 23. In *Camera Work* 32 (October 1910): 21–24. This was a reprint from the *Transactions of the Edinburgh Photographic Society* 20, no. 267 (June 1910), itself abridged notes from a talk given by Annan to the society. 24. Alfred Stieglitz, "Our Illustrations," *Camera Work* 45 (January 1914): 44. 25. See George Oliver, *Glasgow Portraits by James Craig Annan (1864–1946) Photographer* (Edinburgh: Scottish Arts Council, 1967). 26. In *Camera* 6 (June 1977): 36.

174 JAMES CRAIG ANNAN, *The White Friars*, 1894, photogravure, 11.4 x 10.9 cm, VA

175 JAMES CRAIG ANNAN, *Stirling Castle*, 1903, photogravure, 19.3 x 28.3 cm, RPS

176 JAMES CRAIG ANNAN, *Venice from the Lido,* 1894, photogravure, 10.0 x 15.0 cm, RPS

177 JAMES CRAIG ANNAN, *Riva Schiavoni*, 1894, photogravure, 11.0 x 14.5 cm, RPS

*In an artist's hands, photography is capable of quite satisfactorily dealing with the
good drawing, good composition, proper management of light and shade that architecture
demands; and at the same time is able to place on record far finer and more abundant detail
than is possible to the draughtsman. . . . If we valued our great architecture as
we ought, we should not only have photographic records to scale, . . . but we should
also have every aspect of our great buildings . . . from the point of view of beauty.
Without such records, it will be impossible for succeeding generations
to form any proper idea of the wonders they find [in] our literature.*

Frederick H. Evans, address to the Royal Photographic Society, *Photographic Journal*, 30 April 1900

179 FREDERICK H. EVANS, "In Sure and Certain Hope," York Minster, 1902, platinum print, 26.9 x 20.7 cm, PMA

180 FREDERICK H. EVANS, *Crepuscle au Printemps*, before 1900, platinum print, 13.5 x 9 cm, RPS

181 FREDERICK H. EVANS, *Chancel Piscina in the Church at Little Snoring, Norfolk,* 1906, platinum print, 22.0 x 12.0 cm, RPS

182 FREDERICK H. EVANS, *From a Window at Kelmscott Manor*, 1896, platinum print, 18.8 x 12.9 cm, RPS

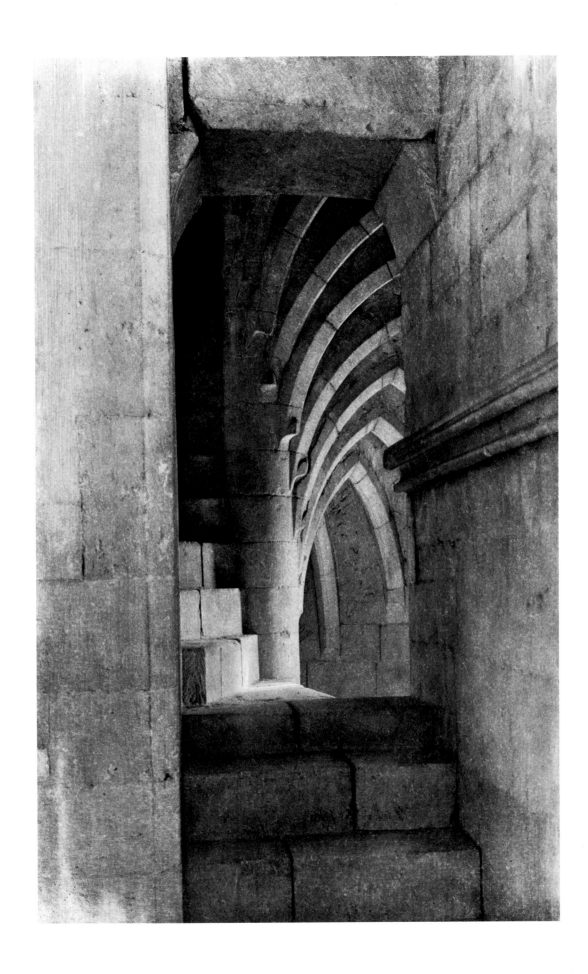

183 FREDERICK H. EVANS, *Lincoln Cathedral: Stairway in Southwest Turret*, 1898, platinum print, 20.0 x 12.5 cm, RPS

10. Paul Martin and the Modern Era

A great change occurred in photography at the end of the nineteenth century, and the consequences are still part of the medium's fundamental condition. Paul Martin (1864–1944) is a key figure in this moment of change. In 1880 Martin began his apprenticeship as a wood engraver. This craft sometimes translated original photographs, but more usually artist's drawings, into linear form for printing in books, magazines, and newspapers. In March of the same year *The Daily Graphic* in New York became the first mass circulation newspaper to publish an image printed by the new and still experimental halftone process. The technique provided shades of tone unavailable in wood engraving and in addition could be printed simultaneously with text. Wood engraving lost ground steadily to the new process during the next two decades. Paul Martin had apprenticed himself to a craft that was shortly to become obsolete. Mass production halftone printing arrived, like the cinematograph, before the turn of the new century of which both are characteristic.

What the new printing process took away from the wood engraver with one hand it gave to photography with the other. In the words of *The Photogram* (August 1900): "The most profitable new field lying open to photographers is in the supply of matter for reproduction in the illustrated press." Photographic technology had altered sufficiently to allow a new kind of photograph to be supplied to the illustrated press. The easy-to-use and rapid gelatin dry-plate negative could be coupled with new varieties of inconspicuous and rapid cameras, known as "hand" or "detective" cameras. Paul Martin took up

photography in the 1880s and acquired one of the new cameras in 1892.

With his camera disguised as a leather box, Martin made his photographs in the limited time he was away from his wood-engraving workbench, on London streets and when holidaying at seaside resorts. He was probably the most able photographer in what was becoming a significant genre of the 1890s, as titled in exhibition categories, "street characters and incidents of street life." In February 1896, entranced by the reflections of streetlights on wet pavement, he began to make experimental night photographs (as in the example above, an 1896 photograph of the Thames embankment). These experiments won him acclaim and earned him the admiration of the leader of American art photography, Alfred Stieglitz, who made his own famous night photographs of New York City in the following year. Martin's public success spelled the end of his night series—interested and impressed bystanders surrounded him when he went out with his camera—but Martin had pioneered a subject that was to be signal to the twentieth century—the city at night.

In the 1930s Paul Martin's snapshots from the 1890s became popular as illustration material in books and magazines, and he enjoyed renewed success as an entertaining talker about the days in which they were taken. The brave new world transformed by photography, described by Sir Frederick Pollock in 1855, was now a

reality. Photographs had become interchangeable parts of the material world. By the end of the nineteenth century the medium of photography had passed from the hands of aristocratic amateurs and the professional studios into the hand of anyone who wished to preserve the moments of his life and surroundings. In the new century photography maintained two of its earlier functions in the expanded roles of news reporting and photojournalism, and flash photography opened new interiors and the nocturnal life of cities. The very appearance of photographs changed dramatically, losing the early gemlike depth and intricacy, as the chemically developed and characteristically black-and-white gelatin silver print became the norm. In earlier days the photographic print, as finely made as was necessary for the photographer and his purpose, was the important unit. In the twentieth century the photographic print assumed a different role—as the starting point for graphic translation by process engraving. Only in the past dozen years has the perspective on photography so changed that the qualities of its "golden age" have been thrown into relief and seen to be markedly distinct from characteristics later acquired. An unexpected byproduct of the advent of television is the reclamation of a sense of the variety and subtlety of still photography and a sharpened awareness of the energies and motivations brought to the medium by its creators. As the image language of our own time is transformed, so the structure of the strange landscape of a past time can be discerned in new ways and with a fresh regard for its difference and achievement.

*What I have to propose may appear a dream; but it has at least the merit of being . . .
a realizable one. . . . It is the . . . representation of scenes in action—the vivid and life-like
reproduction and handing down to the latest posterity of any transaction in real life. . . .
I take for granted nothing more than what photography has already realized, or . . . will
realize within some very limited lapse of time . . . the possibility of taking a photograph,
as it were, by a snapshot—of securing a picture in a tenth of a second of time.*

Sir John Herschel, in The Photographic News, 11 May 1860

185 PAUL MARTIN, *Trippers at Cromer*, 1892, platinum print, 7.4 x 9.2 cm, VA

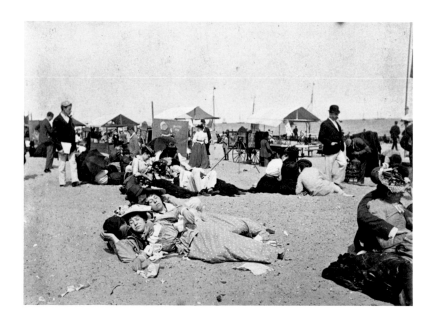

PAUL MARTIN, *Sisters at Yarmouth*, 1892, platinum print,
7.2 x 9.8 cm, VA (top)

PAUL MARTIN, *On Yarmouth Sands*, 1892, platinum print,
7.2 x 10.0 cm, VA (center)

186 PAUL MARTIN, *Gorleston*, 1892, platinum print,
7.2 x 9.5 cm, VA (bottom)

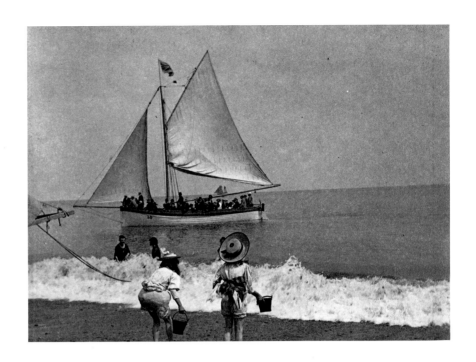

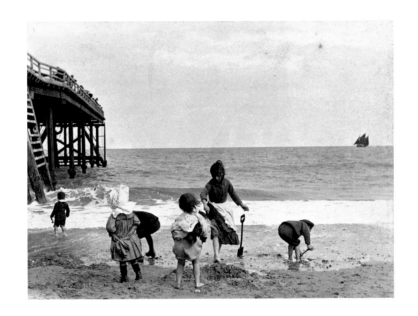

PAUL MARTIN, *Yarmouth*, 1892, platinum print,
7.0 x 9.7 cm, VA (top)

PAUL MARTIN, *Paddling at Yarmouth*, 1892, platinum print,
7.1 x 9.8 cm, VA (center)

187 PAUL MARTIN, *On Yarmouth Sands*, 1892, platinum print,
7.8 x 9.5 cm, VA (bottom)

Acknowledgments

Grateful acknowledgment is made to the following individuals and institutions for their contributions to the exhibition and catalogue:

David Allison and Lindsay Stewart, Christie's–South Kensington; Jane L. Arthur, curator, The Wisbech and Fenland Museum, for information on Chauncy Hare Townshend; Richard Benson; Carolyn Bloore for information on Calvert Richard Jones; Lord Brain, Chris Roberts, and Pamela Roberts, the Royal Photographic Society of Great Britain, Bath; Ialeen Gibson Cowan for information on John Thomson; Alistair Crawford, University College of Wales, for information on Robert Macpherson; Frances Dimond, the Royal Archives, Windsor Castle; the editors of the Pilgrim Edition of the *Letters of Charles Dickens* (The Clarendon Press) for information on Dickens and Chauncy Hare Townshend; Philippe Garner for information on Edward Fox; Arthur T. Gill for information on Antoine Claudet; Margaret F. Harker for information on Henry Peach Robinson; Tara Heinemann for information on David Wilkie Wynfield; C. M. Kauffmann, Keeper of Prints and Drawings & Photographs, Lionel Lambourne, Assistant Keeper of Paintings, and Margherita Abbozzo-Heuser, Graham Brandon, Sally Chappell, Odette Heideman, Halina Pasierbska, Gillian Saunders, Christopher Titterington, and Clive Wainwright, The Victoria and Albert Museum; Harry Milligan for information on J. B. Dancer; John Somerset Murray for information on Dr. John Murray; Colin Osman for information on James Robertson; Terence Pepper, National Portrait Gallery, London; Sara Stevenson and Duncan Thomson, Scottish National Portrait Gallery, Edinburgh; David Thomas, Science Museum, London; Laurence Whistler for information on John Whistler.

Photograph Credits

THE ANNAN FAMILY, GLASGOW
143 (Thomas Annan)

NATIONAL PORTRAIT GALLERY
83 (Frith), 119 (Carroll)

PMA PHILADELPHIA MUSEUM OF ART
163, 166 (bottom), 167–69: purchased with funds from the Lola Downin Peck Fund and with contributions from Mr. and Mrs. John Medveckis, Harvey S. Shipley Miller, J. Randall Plummer, and Marilyn Steinbright. 164: purchased with funds from the Lola Downin Peck Fund. 179: purchased with funds from Dorothy Norman.

ROYAL ARCHIVES, WINDSOR CASTLE
48: reproduced by kind permission of Her Majesty the Queen.

RPS ROYAL PHOTOGRAPHIC SOCIETY
OF GREAT BRITAIN, BATH
23 (Delamotte), 77, 80, 83 (Bedford), 94, 96, 98–103, 175–78, 180, 181: gift of Mrs Walter Bennington. 182: gift of Alvin Langdon Coburn. 183: bequest of J. C. Warburg, F.R.P.S.

SM SCIENCE MUSEUM, LONDON
8, 23 (Claudet), 37–39.

SNPG SCOTTISH NATIONAL PORTRAIT
GALLERY, EDINBURGH
40–43 (reproduced from prints in the Victoria and Albert Museum).

VA VICTORIA AND ALBERT
MUSEUM, LONDON
2, 78, 81: gift of Miss W. M. A. Brooke. 13, 16, 56, 57, 66, 67, 68 (top): bequest of Chauncy Hare Townshend; 25–27: gift of Major Ross. 28 (top left and right): gift of Miss Ethel Spiller, O.B.E. 28 (bottom), 29: gift of Mrs. E. R. Brown. 2, 82, 88: gift of Col. Willoughby Wallace. 108, 109: gift of Miss M. Harper. 111: gift of Dr. Hunter. 115–17: gift of the Foreign Office. 121: gift of Dr. R. Steele. 122–25: gift of Clementina, Lady Tottenham. 126, 127: gift of Mrs. W. G. Keyworth. 128, 129: gift of Lady Seymour. 137: gift of Miss Perrin. 138: gift of Alan S. Cole. 140: gift of Julia Margaret Cameron. 146–49: gift of Mrs. D. Crisp. 165, 166 (top): gift of P. H. Emerson. The remaining photographs from the Victoria and Albert Museum were purchased for the collection.

WALKER ART GALLERY, LIVERPOOL
152

References

1 THE DAGUERREOTYPE A NEW WONDER

Antoine Claudet, "Photography in Its Relation to the Fine Arts," *The Photographic Journal*, 15 June 1860: 259–67. Helmut and Alison Gernsheim, *L. J. M. Daguerre: The History of the Diorama and the Daguerreotype* (London: Secker and Warburg, 1956). Arthur T. Gill, "Antoine François Jean Claudet (1797–1867)," *The Photographic Journal*, December 1967: 405–9. R. H. Nuttall, "Andrew Pritchard, Optician and Microscope Maker," *The Microscope* 25 (1977): 25, 65–81. Helen Smaills, "A Gentleman's Exercise: Ronald Leslie Melville, 11th Earl of Leven, and the Amateur Photographic Association," *The Photographic Collector* 3, no. 3 (Winter 1982): 262–93. D. B. Thomas, *"From Today Painting is Dead": The Beginnings of Photography* (London: Arts Council of Great Britain, 1972).

2 THE CALOTYPE ERA

H. J. P. Arnold, *William Henry Fox Talbot, Pioneer of Photography and Man of Science* (London: Hutchinson Benham, 1977). Gail Buckland, *Fox Talbot and the Invention of Photography* (Boston: Godine, 1980); Heinrich Schwartz, *David Octavius Hill: Master of Photography*, trans. Helene E. Fraenkel (London: G. G. Harrap, 1932). Sara Stevenson, *David Octavius Hill and Robert Adamson: Catalogue of their Calotypes Taken between 1843 and 1847 in the Collection of the Scottish National Portrait Gallery* (Edinburgh: National Galleries of Scotland, 1981).

3 PICTURESQUE BRITAIN AND THE INDUSTRIAL AGE

Helmut and Alison Gernsheim, *Roger Fenton: Photographer of the Crimean War* (London: Secker and Warburg, 1954). John Hannavy, *Roger Fenton of Crimble Hall* (London: Gordon Fraser, 1975). Mark Haworth-Booth, "The Picturesque Eye: Benjamin Brecknell Turner's Album," *The Victoria and Albert Museum Album* 1 (1982): 135–39. Richard Morris, *John Dillwyn Llewelyn (1810–1882): The First Photographer in Wales* (Cardiff: Welsh Arts Council, 1980).

4 THE GRAND TOUR

Richard D. Altick, *The Shows of London: A Panoramic History of Exhibitions, 1600–1862* (London and Cambridge, Mass.: Belknap Press, 1978); Hector Bolitho, *Victoria, The Widow and Her Son* (New York and London: D. Appleton-Century, 1934). William Jay, "Francis Bedford (1816–1894): English Landscape Photographer of the Wet-Plate Period" (Master's thesis, University of New Mexico, 1974). Richard H. A. Jenkyns, *The Victorians and Ancient Greece* (Oxford: Blackwell, 1980). Julia van Haaften and Jon E. Manchip White, *Egypt and the Holy Land in Historic Photographs: 77 Views by Francis Frith* (New York: Dover, 1980).

5 HIGH ART PHOTOGRAPHY IN SEARCH OF AN IDEAL

Roger Fenton, "Introductory Remarks," in *A Catalogue of . . . Recent Specimens of Photography* (London: Charles Whittingham, 1852). Edgar Yoxall Jones, *Father of Art Photography: O. G. Rejlander (1813–1875)* (Newton Abbott: David and Charles, 1973). Beaumont Newhall, ed., *Photography: Essays and Images* (New York: The Museum of Modern Art, 1980).

6 EXPLORING THE EMPIRE

Mildred Archer and Ronald Lightblown, *India Observed: India as Viewed by British Artists 1760–1860* (London: Victoria and Albert Museum, 1982). Raymond Desmond, "Photography in India during the Nineteenth Century," in *India Office Library and Records, Report for the Year 1974* (London: Foreign and Commonwealth Office, 1976). Herman J. Deutsch, "A Contemporary Report on the 49° Boundary Survey," *Pacific Northwest Quarterly* 53 (January 1962): 17–33; John Falconer, "Photography and the Royal Engineers," *The Photographic Collector* 2 (Autumn 1981): 33–64. Pauline F. Heathcote, "Samuel Bourne of Nottingham," *History of Photography* (April 1982). Aaron Scharf, *Pioneers of Photography* (London: British Broadcasting Company, 1975).

7 ARISTOCRATIC AMATEURS

Colin Ford, *The Cameron Collection, An Album of Photographs by Julia Margaret Cameron Presented to Sir John Herschel* (Wokingham: Van Nostrand Reinhold, 1975). Helmut Gernsheim, *Lewis Carroll, Photographer* (New York: Dover, 1969). Helmut Gernsheim, *Julia Margaret Cameron, Her Life and Photographic Work* (London: Gordon Fraser, 1975). Margaret F. Harker, *Julia Margaret Cameron* (London: William Collins and Son, 1983). Bevis Hillier, "The St. John's Wood Clique," *Apollo* (June 1964): 490–95. Graham Ovendon, *Clementina, Lady Hawarden* (London: Academy Editions, 1974). G. A. Storey, *Sketches from Memory* (London: Chatto and Windus, 1899).

8 STREET LIFE

Graham Bush, *Old London, Photographed by Henry Dixon and A. and J. Bool for The Society for Photographing Relics of Old London* (London: Academy Editions and New York: St. Martin's Press, 1975). Anita Ventura Mozley, *Thomas Annan: Photographs of the Old Closes and Streets of Glasgow, 1868–77* (New York: Dover, 1977). William B. Thesing, *The London Muse: Victorian Poetic Responses to the City* (Athens, Ga.: University of Georgia Press, 1982). Raymond Williams, *The Country and the City* (London: Chatto and Windus, 1973).

9 THE ART OF PHOTOGRAPHY FULFILLING THE VISION

Margaret F. Harker, *The Linked Ring* (London: Heinemann, 1979). Beaumont Newhall, *Frederick H. Evans* (Millerton, N.Y.: Aperture, 1974). Nancy Newhall, *P. H. Emerson, The Fight for Photography as a Fine Art* (Millerton, N.Y.: Aperture, 1978). Peter Turner and Richard Wood, *P. H. Emerson, Photographer of Norfolk* (London: Gordon Fraser, 1974).

10 PAUL MARTIN AND THE MODERN ERA

Roy Flukinger, Larry Schaaf, and Standish Meacham, *Paul Martin: Victorian Photographer* (Austin: University of Texas Press, 1977; and London: Gordon Fraser, 1978). Paul Martin, *Victorian Snapshots* (London: Country Life, 1939).

PHOTOGRAPHS FROM PUBLISHED ALBUMS AND BOOKS

16, 56, 57: Philip Henry Delamotte, ed., *The Sunbeam*, 1859. 55: Philip Henry Delamotte, *A Photographic Tour among the Abbeys of Yorkshire*, 1856. 85–87, 89: Francis Bedford, *Photographic Pictures of Egypt, the Holy Land and Syria, Constantinople, the Mediterranean, Athens, etc.*, 1862. 113: Philip H. Egerton, *Journal of a Tour through Spiti*. 144, 145: Thomas Annan, *The Old Closes and Streets of Glasgow*, 1868. 145–49: John Thomson, *Street Life in London*, 1877–78. 163, 166 (bottom), 167–69: Peter Henry Emerson, *Life and Landscape on the Norfolk Broads*, 1886. 164, 165: Peter Henry Emerson, *Pictures of East Anglian Life*, 1888. 166 (top): Peter Henry Emerson, *Idyls of the Norfolk Broads*, 1887. 185–87: Paul Martin, *Yarmouth Holiday*, 1892.

Index

Page numbers in *italics* refer to illustrations.

Aperture

A DIVISION OF SILVER MOUNTAIN FOUNDATION, INC.
PUBLISHES A PERIODICAL, BOOKS, AND PORTFOLIOS
DEVOTED TO PHOTOGRAPHY AND THE VISUAL ARTS.
MILLERTON • NEW YORK • LONDON